W9-BVL-368

Northwest Coast Native and Native-Style Art

A Guidebook for Western Washington

Northwest Coast

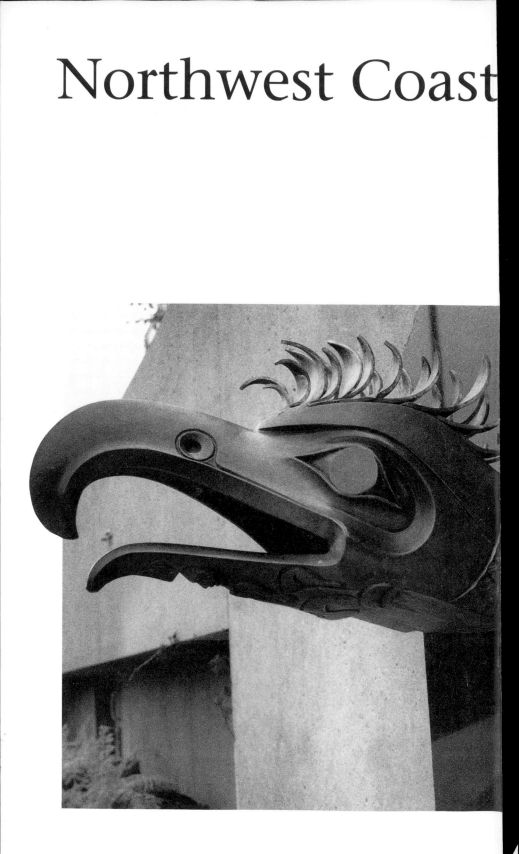

Native and Native-Style Art

A Guidebook for Western Washington

Lloyd J. Averill

Daphne K. Morris

University of
Washington Press

Seattle and London

Copyright © 1995 by the University of Washington Press
Printed in the United States of America

Maps are by Daphne K. Morris and Robert O. Hutchins; drawings by Daphne K. Morris. Unless otherwise credited, all photographs were taken by Daphne K. Morris.

All rights reserved. No part of this publication may be reproduced or transmitted in any form or by any means, electronic or mechanical, including photocopy, recording, or any information storage or retrieval system, without permission in writing from the publisher.

Library of Congress Cataloging-in-Publication Data

Averill, Lloyd J. (Lloyd James), 1923-
 Northwest Coast Native and Native-style art : a guidebook for western Washington / Lloyd J. Averill and Daphne K. Morris.
 p. cm.
 Includes bibliographical references and index.
 ISBN 0-295-97468-0 (alk. paper)
 1. Indian art—Washington (State)—Guidebooks. 2. Indians of North America—Washington (State)—Museums—Guidebooks. 3. Indian artists—Washington (State)—Guidebooks. 4. Indian art—Northwest Coast of North America—Guidebooks. I. Morris, Daphne K. II. Title.
E78.W3A93 1995 95-21962
709'.797–dc20 CIP

The paper used in this publication meets the minimum requirements of American National Standard for Information Sciences—Permanence of Paper for Printed Library Materials, ANSI Z39.48-1984. ∞

Cover photograph: Detail on wall panel by Greg Colfax at Tukwila City Hall (see entry 2.8). Photograph by Lloyd J. Averill
Title-page photograph: Detail of a panel by Doug Granum from the Perfomance Mask Installations in Tacoma (see entry 1.13). Photograph by Daphne K. Morris

In grateful memory of

Gregory S. Morris

and in present gratitude to

Bill Holm

Contents

Preface: *Epiphanies* ix

Acknowledgments xi

Introduction: *Learning the "Language" of Coastal Art* xiii

PART I

Where to Find the Art 3

1. South: Portland to Tacoma 9

2. Metropolitan Seattle:
 The Outlying Areas 31

3. City of Seattle 49

4. West: Kitsap and
 Olympic Peninsulas 95

5. North: Everett to Blaine 125

PART II

Sources of the Art 149

6. Artist Biographies 152

7. Native Tribes of
 the Northwest Coast 172

PART III

Resources 179

8. Where to See the Art
 in Use 181

9. Opportunities for Formal
 Learning about the Art 188

10. Annotated Guide to
 Selected Resources 200

Index 209

Preface

Epiphanies

"How did you first become interested in Northwest Coast Native art?" we asked the avid collector.

"It began on a vacation visit to Seattle while my wife and I were living in Florida," he said. "One day we walked wide-eyed through the collection of the Burke Museum at the University of Washington, seeing images we had never seen before. We were blown away by their elegance. However ancient the origins of that art may have been, there was nothing 'primitive' about it in the usual sense of that word. Even when we didn't know what its strange shapes meant, we saw in them an artistic refinement and sensed in them a spiritual power that are surely remarkable by any standard anywhere in the world.

"Later we browsed in the Burke Museum's gift shop, and there we saw what is called a bent-corner chest, its traditional Northwest Native shapes carved on all four sides in shallow relief and painted in traditional colors of black, red, and turquoise. I know it sounds a bit spooky, but that box seemed to reach out and take possession of us. We bought it and carried it back to our Florida home. It was only a few months later that we decided to leave Florida and make a new life for ourselves in Seattle.

"Afterward, my wife said, 'We didn't bring the box back. It brought us back.' I think she was right."

The presence and power that are experienced in the art of the Northwest Coast lay a claim on Native and non-Native alike, and they have drawn us, too, on the pilgrimage for which this book is the tangible record. The trails and roads we traveled on the way to many of the monuments described here led far beyond the sites at which we aimed. There have been few deadends along the coastal forest's edge. Rarely did an urban alley lead away from the city's prized "wooden statue" without taking us on to some-

thing else unguessed at. Always there has been the promise of more lore, another looming figure, a song rarely heard.

We have heard stories said to be too private to relate, and we have seen carvings said to be too sacred to view. Yet, nowhere did words and works captivate us more than those we are permitted to tell and picture here.

Our travels themselves have been worthy of telling, of picturing. One dusty afternoon, as insect clouds swarmed against the hot hood of our car, we pressed through breathless air in anticipation of a rendezvous with a couple of figures out of the past. Our guide, a tribal official, had instructed us to meet him at a designated spot, from which he would lead us to two ancient welcome figures, carvings long secreted in a nearby prairie home.

We waited. Insects and dust swirled in the dry afternoon, but no guide appeared; no ancient epiphany was opened to us. We saw only popsickle-sticky children, who slammed the screen door of a nearly deserted smokehouse-grocery-Lotto agent.

But that was not the end.

Months later, rain pelted the windows of the immaculate new Special Collections reading room in the University of Washington library, which had become our research headquarters. Suddenly the image of the two wel-come figures, unintroduced by our truant guide, sprang from the micro-fiche viewer. Though they and we did not meet, an encounter with those two mysterious figures happened. If this is all there is, it will be enough. But if we should ever really see them, touch them, be truly touched by them, their "welcome" will have been consummated.

And, at another time . . .

The morning fog clouded the windshield as we slowed. The Native cem-etery was a lonely place, ill-marked and remote. Only by accident had we come upon its neglected entrance as we looked for a place to turn around on a country road that was seeming to lead us nowhere. Through misty in-advertence, we found a kind of Presence there: two poles that stood at the far end of the cemetery, each carved, Salish, shamanic. Each had a single, solemn, arresting figure. Each hunkered, hands on ankles, knees drawn to chest. The eyes of one were open, the other's closed.

We wondered: Was the open-eyed one wiser for having looked, unblink-ing, at death through long, lonely nights at this undistinguished *terminus ad quem?* Had the mystery of the end yielded its secret to the close-eyed contemplative who had brooded, undisturbed for years, over aboriginal graves? Sphinx-like, they did not say.

Later our questions were turned back by tribal guardians: "Do not remember what you have seen." How can we forget?

Acknowledgments

The authors express special appreciation to Bill Holm, Jeanette Mills, and Sarah Mitchell for their careful, critical, and helpful reading of the manuscript; to the staff of the Special Collections Division of Suzzallo Library, University of Washington, for diligent support of our research; to John J. Kenny for the loan of his rare, signed copy of Chief William Shelton's book *The Story of the Totem Pole* (1923); to E. Marcus Westby for sharing with us his intimate knowledge of La Push and Forks; and to more people than we can possibly name—artists, gallery owners, collectors, friends, and colleagues—for their warm encouragement throughout the three years of research, writing, and publication and for their eager anticipation of the appearance of the book.

Our deepest gratitude must go to the artists, past and present, known and unknown, whose work has grasped and moved us and set us on a journey of discovery for which this book is only a way station.

What is supposedly "needless to say" nevertheless needs to be said: that, although we have consulted widely with artists and scholars, and with museum and tribal authorities, we as authors are solely responsible for the accuracy of the facts and the adequacy of the judgments contained in this guidebook. If it helps to bring some of its users to a larger understanding of Northwest Coast Native and Native-style art, and generates in them something of the enthusiasm that we feel for this magnificent tradition, it will have served its purpose.

Should readers discover omissions or errors in entries in any of the sections that follow, we will be grateful for information to that effect. Write to us in care of the publisher.

Lloyd J. Averill
Daphne K. Morris

Introduction

Learning the "Language" of Coastal Art

Artifacts and images associated with Northwest Coast Natives have in-
trigued visitors to this coastal region for centuries. Shells from the waters
of Vancouver Island, attractive to Native peoples of interior America, were
bartered along ancient trade routes. Exotic artifacts were taken back to
Spain by Juan Pérez in 1774, creating the first documented collection re-
sulting from European exploration. Later in that century and on into the
next, European collectors and dilettantes were fascinated by a steady
stream of Native art works brought back to their collections of curios and
scientific specimens by early traders and explorers.

Trespassing outsiders have always challenged the continuity of Native
cultures and their arts. In the eighteenth century, Native artists responded
quickly and creatively to intrusions, utilizing European trade materials to
embellish their masterful works celebrating their own culture—works laden
with myth and tradition. They carved, painted, sewed, and wove vigorous
and mysterious works, statements of pride and social status.

Native artisans of the following century witnessed even greater intrusion
by a domineering people whose Western religion, devastating illnesses, and
capitalist economy imposed an alien order, which nearly extinguished an-
cient traditions and their artistic expressions. The result, in 1884, was the
anti-potlatch law imposed by the Canadian government on its First
Peoples, a law that was not removed until 1951. Prohibited to engage in
their ancient ceremonies, they lost the major purpose for creating their dis-
tinctive art; and in many places on the Northwest Coast, the art languished
and the ability to produce it was lost. Least disrupted was the art of the
Kwakiutl or Kwakwaka'wakw, among whom the anti-ceremonial law was
most vigorously, if surreptitiously, defied. The present vigor of the tradition
is primarily an achievement of the last forty-five years.

During the present century, Native artists have taken full advantage of

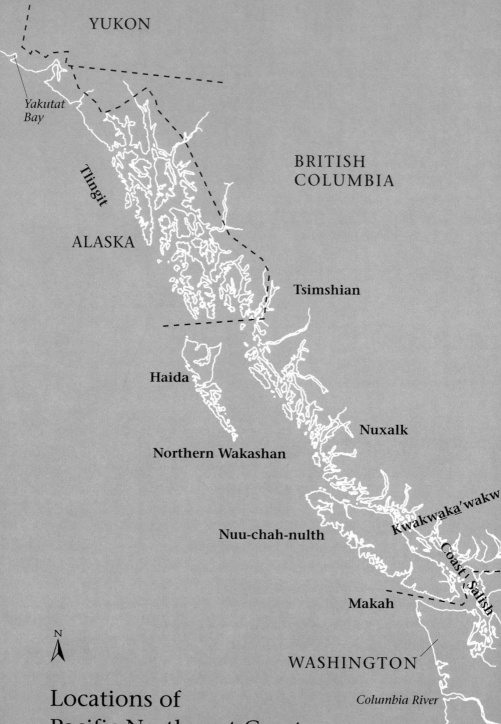

YUKON

Yakutat
Bay

Tlingit

BRITISH
COLUMBIA

ALASKA

Tsimshian

Haida

Nuxalk

Northern Wakashan

Kwakwaka'wakw

Nuu-chah-nulth

Coast Salish

Makah

N

WASHINGTON

Columbia River

Locations of
Pacific Northwest Coast
cultural groups

the resurgence of ceremony, research in art and culture, new technologies, museum collections, and the memories of elders to renew and refresh their heritage. Native arts have flourished, a development which, not unlike other profound artistic movements, is too substantial to be regarded as a mere "period" or "phase."

This guidebook serves to introduce readers to notable, accessible art works in the western Washington area. These treasures are neither buried nor far from their origins. Some exist in situ; others have been shuffled from their places in the past to a time and space into which we can peer. Some works look silently out from forest settings; others share a perpetual twenty-four-hour watch with a coterie of homeless inner-city dwellers.

Many of the outings to view the art are short; the routes are frequently enveloped in mist, saltwater spray, and the scent of cedar, which have been the permanent milieu of this art and its makers.

For cultural purposes, the Northwest Coast includes the interactive cultures that ranged from Yakutat Bay, at the north end of the Alaskan Panhandle, to the mouth of the Columbia River between Washington and Oregon, from the coastal range west and including off-shore islands. In general, Northwest Coast Native art can be divided into three broad regions. The Northern coastal peoples encompass Tlingit; Haida; and Coast Tsimshian, Nishga, and Gitksan. Central coastal groups include Kwakwaka'wakw (formerly called Kwakiutl), Nuu-chah-nulth (formerly called Nootka, or WestCoast), and their Makah relatives on the northwesternmost tip of Washington's Olympic Peninsula.

The Northern Wakashan, including Haisla, Heiltsuk, Haihais, Bella Bella, Oowekeeno, and Nuxalk (formerly called Bella Coola), form a kind of transition area, often resembling Northern styles in two-dimensional art (for example, house fronts and prints) and Central styles in sculpture (for example, totem poles and house posts).

Southern coastal groups and art styles are represented by the Coast Salish. More detailed geographical definitions of all of these groups are provided in chapter 7.

One of the difficulties in making clear geographical or tribal distinctions is that, historically in the Northwest, art styles were exchanged, borrowed, traded, and captured along ancient trade routes up and down the coast, as well as into the interior. Intertribal marriages and slave exchange also accounted for stylistic diffusion.

Aesthetic Characteristics

Before addressing the details of the aesthetic "language" employed by
Northwest Coast Native artists or distinguishing some of the differences
among tribal styles along the coast, it is useful to identify some important
larger elements that characterize the coastal tradition as a whole, which
will add to the understanding and appreciation of objects to which the
reader may be guided by this book.

Primitiveness

Is Northwest Coast Native art "primitive"? If that term means "early," even
"ancient," the answer is clearly yes. With two notable exceptions, the earli-
est extant Northwest Coast objects in museums around the world were col-
lected in 1774, and that collecting continued with active European explora-
tion of the region into the next century. Many of the earliest collected
objects were old at the time they were acquired, which means that many of
them must date in the early 1700s. It is obvious from the advanced state of
aesthetic development of those earliest collected objects that the art tradi-
tion from which they came was already probably hundreds of years old.

The eighteenth-century barrier was created by the fact that most Native
art objects were made of wood and had a relatively brief life, suffering even-
tual deterioration in the coastal climatic conditions. Archaeological activ-
ity, especially over the last thirty years, has made it possible to pierce that
barrier and to establish new evidence of the real primitiveness of the
Northwest Coast's artistic traditions. Digs throughout coastal British Co-
lumbia have produced artifacts in bone and stone, and occasionally in pre-
historic copper, that demonstrate what George MacDonald has called the
"crystallizing" of a distinctive coastal style from about 1500 B.C. onward.[1]
Among the most dramatic archaeological finds are stone sculptures, made
by laboriously pecking at one lithic object with another that is harder.
These sculptures have been found in sites down the length of the coast,
from north of Ketchikan to near Bellingham. Though the dating of stone
objects is risky, it is clear that some of these are hundreds of years old. Two
things, among many others, are striking about them: (1) in their design ele-
ments, they show clear connections with the design elements found to be
firmly in place by the coast's eighteenth-century explorers; (2) some of the
objects are so "modern" in their aspect that one could be excused for as-

1. George MacDonald, "Prehistoric Art of the Northern Northwest Coast," in *Indian Art
Traditions of the Northwest Coast,* ed. Roy L. Carlson, p. 101 (Burnaby, B.C.: Archaeology
Press, 1978).

suming that they have come from a museum of twentieth-century design in New York or Copenhagen.

Closer to home, the eighteenth-century barrier was broken by an archaeological dig at Ozette on the Washington coast, just south of Neah Bay. Five hundred years ago a mudslide obliterated a Makah village there, creating a "wet site" and under those conditions preserving a priceless cultural record. The site has been excavated, and some 50,000 separate items are being processed, identified, and catalogued at the Makah Cultural and Research Center in Neah Bay. When evaluated in years to come, these materials will add substantially to our knowledge of the life and art of coastal people in the fifteenth century.[2]

Primitive, Northwest Coast Native art assuredly is when measured on a time scale; primitive, it most assuredly is not when measured by the aesthetic sophistication, the intellectual conceptualization, and the technical refinement of its practitioners. Famed French anthropologist Claude Lévi-Strauss has said that "the culture of the Northwest Indians produced an art on a par with that of Greece and Egypt."[3]

Ambiguity and Transformation

One of the most delightful and most characteristic aspects of Northwest Coast Native art is its ambiguity; its seeming on the one hand to be this, and on the other hand to be that. Does this sculptural bowl (see figure, pages xviii and xix) represent a whale or an eagle? The answer is both. Viewed from one end, it is a whale, identified in part by the pectoral fins carved along the sides of the bowl; yet viewed from the other end, it is plainly an eagle, and from that perspective they are not fins at all but wings. So it is Whale transforming into Eagle, or Eagle transforming into Whale.

Is this two-dimensional painting a wolf or a whale? Again, the answer is yes to each. The distinctive head of each creature is clear, but other features are ambiguously entwined; what appears to be the tail of the wolf is, seen in another way, the spout coming out of the whale's blowhole. So it is Wolf transforming into Killer Whale, and vice versa.

Edmund Carpenter has called these deliberate ambiguities "visual puns," and says that early anthropologists, not practiced punsters, thought there must be some mistake when told at one time that the bowl was a whale

2. For Northwest Coast archaeology, see Carlson, *Indian Art Traditions;* for more on lithic art, see Wilson Duff, *Images Stone B.C.: Thirty Centuries of Northwest Coast Indian Sculpture* (Seattle: University of Washington Press, 1975).

3. *Time* magazine, p. 16, April 4, 1969.

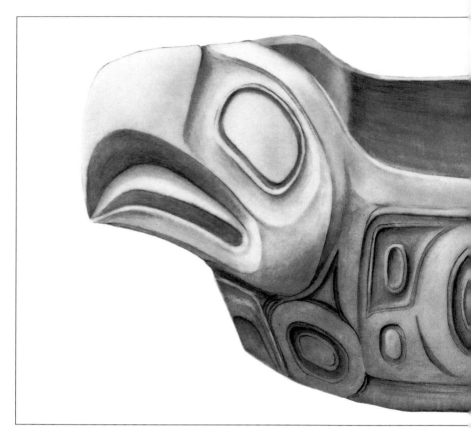

Carved wooden bowl, Haida, with a shared design of Whale fin and Eagle wing

and at another that it was an eagle. But, says Carpenter, early in this century European Surrealists, refugees in New York City and practiced in their own kind of "punning" ambiguity, understood very well and became avid collectors of Northwest Coast art.[4] The artistic vision shared by Northwest Coast masters and the Surrealists is what Claude Lévi-Strauss has called the "dithyrambic gift of synthesis, the almost monstrous faculty to perceive as similar what all other men have conceived as different."[5]

Sometimes the theme of transformation takes dramatic masked form, in which the outer face of the mask—perhaps a human face—is suddenly opened by the mask's dancer to reveal an inner face, perhaps of the sun or of some mythical creature. And sometimes there is even a third face inside the second.

4. Carpenter's "Introduction" to *Northwest Coast Indian Art: A Dialogue on Craftsmanship and Aesthetics,* Bill Holm and Bill Reid, pp. 9-10 (Seattle: University of Washington Press, 1975).

5. Quoted by Carpenter, in Holm and Reid, p. 11.

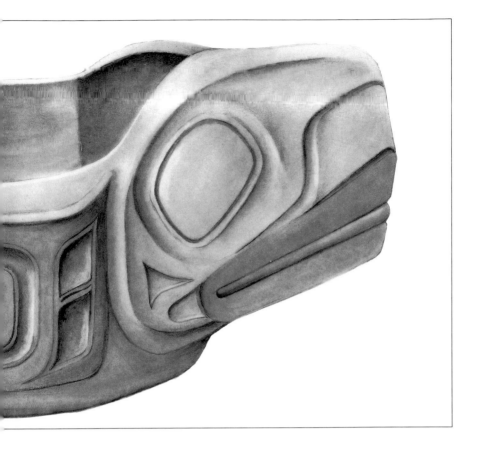

Behind these artistic inventions, this preoccupation with transformation, lies a unitary notion about the nature of things: everything—the human, the animal, the supernatural—is connected in a great chain of being. In fact, Northwest Coast mythology held that animals are really costumed men and women. If, for example, one were to follow Beaver to his longhouse under the water and watch what went on inside, one would see him taking off his furry outer garment and emerging as a man. The practice of identifying individuals and clans by means of animal crests and the claim to have received special powers from animal spirit guides demonstrate the indissoluble connections that are celebrated in the studied ambiguity of Northwest Coast Native art.

Symmetry and Asymmetry

One of the characteristics of Northwest Coast design—especially of two-dimensional design—is its apparent symmetry. The clearest examples are

Chilkat blankets. In fact, the man who made the painted patternboard, from which the woman wove the blanket, painted only half of the design pattern, from the center to the right-hand edge, because the left side was simply to be the mirror image of the right.

The fronts of bent-corner chests and boxes were commonly designed in complete symmetry (though occasionally one can find a lapse where the artist failed to match on one side a small detail of carving or paint that is complete on the other side).

One source of this symmetry is in the typical perspective of Native artists—a perspective that is found well beyond the Northwest Coast. In the conventional European tradition, perspectival requirements did not permit one to depict both sides of an object at the same time—at least not until the Cubists came along. Native artists felt no such limitation, and the "split image" is one of the most characteristic features of Northwest Coast art. An animal is shown as if split down the middle, with both sides displayed. In some instances the sides emerge from a single head; in others, the head too is divided, giving a double profile.

This section began with a comment about the "apparent" symmetry of coastal art. Another characteristic of the art is that sometimes designs that appear to be symmetrical are not. Balanced, they surely are; but a careful examination of the two halves of the design may indicate ways in which the artist has cleverly and subtly altered the design elements to provide variety under the guise of uniformity. (See figure opposite.)

Visual Focus

In his classes on Northwest Native art at the University of Washington, Bill Holm was fond of quoting this bit of anonymous doggerel:

As you travel through life, brother,
Whatever be your goal,
Keep your eye upon the doughnut,
And not upon the hole.

Raised to the level of aesthetic principle, this means that, in viewing Northwest Coast art, one must learn to distinguish between the primary or "positive" design elements, on the one hand, and the ground or "negative" spaces (uncarved or unpainted surfaces between design elements), on the other; and to ignore the latter while concentrating on the former. With careless or uninformed viewing, it is possible to mistake the negative spaces for the primary design. According to Holm, this confusion "is most easily

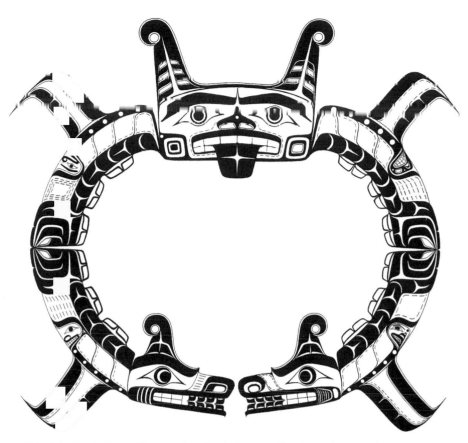

Sisiutl design by Barry Herem, showing balance without exact symmetry.
Reproduced courtesy of the artist

seen in a Chilkat blanket, where the negative shapes [which predominate because of their color] are often taken for the positive primary design by those not familiar with the fact that the primary design is black."[6]

Confusion is also possible with Salish carvings—bowls and spindle whorls, for example. Says Holm, "In pieces from the Columbia River and in certain Nootka things, we see little rows of [cut out] triangles interlocking with other rows of triangles. If we quit looking at the triangles and look at the spaces between . . . the triangles, suddenly the whole bird hops right out at us with tail feathers, wing feathers, and feet, all connected to the central nose."[7] For more about this, see the discussion of the Northern formline system (page xxxiv) and entry 1.9.

6. Bill Holm, *Northwest Coast Indian Art: An Analysis of Form,* p. 80 (Seattle: University of Washington Press, 1965).

7. Holm and Reid, pp. 58, 60.

Design Elements

Several design elements appear with such consistency throughout the coast region that they are virtually style signatures. We can "read" that style— even talk about it—if we pay special attention to these elements, which are illustrated in the figure opposite.

Ovoids

Ovoids, often the most noticeable elements of a design, are bilaterally symmetrical oval shapes, flattened or slightly concave on the bottom. When asked about their first impression of an art work, novices frequently voice bewilderment at so many "eyes." Although ovoids do look like eyes, and eyes are almost always a form of the ovoid, they also represent joints in hands, arms, shoulders, feet, wings, and fins. At times they serve to relieve or lighten the heaviness of the formline grid (see discussion, page xxxiv).

Although the definition given above is a useful generalization, the actual shape of the ovoid varies according to the artist's overall design plan. Ovoids may be squished into circles or elongated into near-rectangles, turned upside down, even filled with peculiar face designs. A simple, open ovoid sometimes contains an inner ovoid, which may be solid or solid except for a nonconcentric relief element (for example, a crescent).

Ovoid styles become customized and are often telltale clues to the authorship of an art work. Robert Davidson's later work often has his distinctive bubblelike ovoid. Some Nuu-chah-nulth work is recognized by the artists' use of ovoids that are elongated.

U Forms

Design elements in the shape of a U, in which the legs of the U taper and join other contiguous design elements, are called U forms. They differ in use and style more than other elements: for instance, they may be as long and angular as a wolf's tail or be flattened to nearly rectangular dimensions to represent a bear's eyebrow. U forms can denote anatomical features such as ears, nostrils, and teeth, and they can also be part of the entire body contour, such as the fins of a whale or the wings and tail of a bird. Rapacious talons and claws may be fashioned from graceful and gentle U forms.

S Shapes

Like the U form, the S shape closely resembles its alphabetical counterpart. A series of sinuous, elongated S forms, placed side by side, naturally sug-

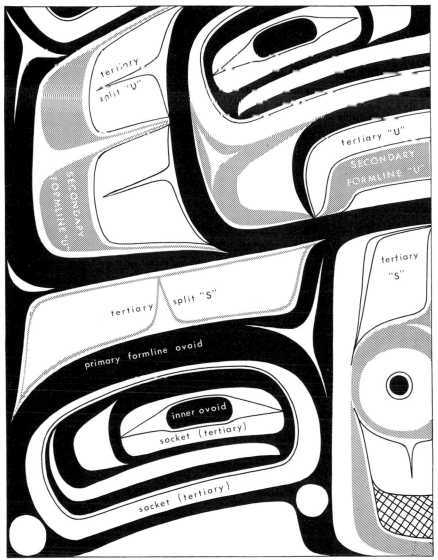

Bill Holm's illustration of the Northern formline system. *Reproduced courtesy of the artist*

gests ribs. Sometimes an S shape is a negative rather than a positive design element: a space that results once the surrounding design elements have been laid down.

Salmon-trout's Head

The "salmon-trout's head" is an elaborate, stylized design that often appears within a larger ovoid (see lower left of figure above). The image is composed entirely of formlines and has its own anatomical rules. Facelike,

its components are designated as "eye," "jaw," "cheek," and "nose." The salmon-trout's head is often a special form of the inner ovoid.

The origin of the term "salmon trout's head" is an enigma. Ask an artist where it came from and the response is likely to be, "It has always been called that" or "It resembles a fish's head." The early ethnologist Lieutenant George T. Emmons reported that the term first came into use among Chilkat weavers.

Relief Elements

Negative or "cut-out" relief shapes contribute to the balance and fluidity of the formline designs. They are inserted into the formline itself, where the thickness of the primary or secondary grid would appear overbearing or disruptive, such as where elements of those grids join each other. The actual shapes of the reliefs—circles, crescents, T shapes, S shapes, or even an entire eye shape—depend on what is going on around them.

Images

Once we have considered design characteristics and design elements, we are ready to move on to more wholistic images. Many of the figures—human, animal, mythical, cosmic, material—in both two- and three-dimensional Northwest Coast art have certain relatively consistent features that permit reasonably ready identification, even with allowance for individual artists' styles and differences in tribal conventions.

The images described below are among the most frequently encountered in viewing Native art. Some are found throughout the Northwest Coast; some are characteristic only of specific tribal traditions, as noted, but since they are commonly encountered, the ability to identify them is important to the fuller appreciation of the art. In the text of chapters 1 through 5, some descriptive terms are used without explanation (for example, "watchmen" and "copper"); we offer the explanations here in preparation for your viewing of specific objects.

Human Figures

Generic humanoids. Human figures may be generic or specific individuals or legendary heroes, in complete form or in fragmentary images. Facial features are fairly realistic: eyebrows, eyes, noses, and mouths are less abstracted than in some animal imagery. Rarely do they have ears, except

on masks. Human hands are distinct, sometimes indicating an opposable thumb. They may hold objects of personal significance by which the figure can be identified, such as a speaker's staff, a blanket, or a copper. In the Southern style, figures are likely to be robed in distinctive garments.

Women. Women can be distinguished from men in Northern-style art by a lower lip ornament called a labret. Sometimes breasts are indicated.

Shamans. Long-haired shamans, with their healing implements and amulets—and among the Tlingit, with their unique oyster-catcher rattles—appear on poles, in prints, and as masks. Sometimes their eyes are nearly closed, as if in a trance. Throughout the coastal region, they may be associated with the marten or the land otter, usually regarded as the most powerful supernatural entities.

Watchmen. Watchmen sometimes crouch atop Haida poles or peer out from two-dimensional art. They may be one to three figures, sitting with knees drawn to their chests and arms at their sides. Each wears a tall hat with a series of conical rings. One account says that Raven transformed himself into a beautiful woman and that these men fell in love with her, but there the myth trails off incompletely, the love presumably unrequited. In any event, the watchmen also represent alertness to danger.

Legendary figures often have both human and animal attributes (for example, Mouse Woman and Salmon Woman). Certain natural phenomena, such as rainbows, clouds, and fog, may be given quasi-human or creaturely representation. Even inanimate objects are sometimes endowed with human attributes; for example, a river snag or an animal trap (for the latter, see entry 2.13).

Animals

The list below provides some of the identifying features of animals that commonly populate the imaginative domain of Northwest Coast art. Identification is easier if preconceived notions about the placement and numbers of anatomical parts are relaxed (for example, whales may surface with several dorsal fins; birds may sprout "ears").

Baleen whale. Small dorsal fin, no teeth, tail flukes, blow hole; Kwakiutl baleen whales have white spots on the body.

Bear. Ears, large rounded nostrils, large mouth, conspicuous teeth that may include canines, paws with claws, knees drawn to body, often lacks tail.

Beaver. Two large incisor teeth, U-shaped tail marked with crosshatching, usually shown flat against the body; forefeet often clutch a "chewing stick."

Dogfish (Shark). Gill slits in the cheek or forehead area, domed head

(representing the fish's snout), asymmetrically lobed tail, spines on the back or fin ends, vertical pupils in rounded eyes, downturned mouth, pointed teeth.

Dragonfly. Segmented body, four crosshatched wings, curled proboscis.

Eagle. Short, sharp, downturned beak, ears or crests on head, feathered wings, talons.

Frog. Wide mouth with thick lips and no teeth, toed feet; lacks tail and ears.

Halibut. Mouth set off to one side, often with teeth; both eyes visible; oval body and flared tail fin, long dorsal fin, shorter ventral fin.

Hawk. Short, recurved beak (sometimes touching the face or lower jaw), feathered wings, talons.

Killer Whale. Large rounded head, large toothed mouth, blow hole, prominent dorsal fin (occasionally more than one); hole or circle usually centered in the dorsal fin or diagonal white stripe across it, pectoral fin, symmetrical tail flukes. Kwakiutl killer whales have long-lidded eyes; Northern (especially Tlingit) ones have round, lidless eyes. (See figure opposite.)

Mosquito. Long beak or snout, two sets of wings, insect legs.

Octopus (or Devilfish). Eight tentacles, series of circles depicting suction cups, bulbous body appearing like a head, short "beak."

Owl. Large prominent eyes in rounded eye sockets, often with tufts on head, short beak.

Raven. Straight long beak, blunt or slightly downturned tip, often with a tongue in which a disk (the sun) is held; feathered wings, talons.

Salmon. One large and one small fin on the dorsal side, fairly large mouth, sometimes without teeth, often with a hooked snout.

Sculpin. Large head, spines on dorsal fin.

Sea Lion. Large fore and hind flippers, often short tail between, small ears, teeth, sometimes whiskers; Northern-style sea lions usually have round eyes.

Sea Otter. Long tail, whiskers, often depicted on its back.

Seal. Short fore and tail flippers, often depicted on its stomach with tail and head raised.

Serpent. Long sinuous body, often with teeth and ears, ribs or scale pattern sometimes depicted.

Shark. Same as Dogfish.

Wolf. Long snout, prominent curved nostrils, large teeth and ears, long tail, often curled.

Images of transformation also combine attributes. One example is a "Raven-finned Killer Whale," a traditional Haida crest depicted by artist

Howkan Killer Whale replica by Bill Holm, Thomas Burke Memorial Washington State Museum

Robert Davidson; another is Nuu-chah-nulth artist Joe David's "Supernatural White Wolf Transforming into Killer Whale (Ka-Ka-Win-Chealth)." Such surprises appear most often on masks or on silkscreen prints.

Mythical Creatures

The traditions of Northwest Coast people are filled with supernatural creatures. Moody, somber hags prowl about, ready to snatch up errant children; men, spirit-possessed and wild, and flamboyant cannibal birds move dramatically through the Hamatsa dance. These and other supernatural actors in Native histories exist beyond temporal boundaries. Some appear quite credibly spiritual, others outrageously bizarre. In art, as in real life, it is hard to know just when one is encountering a bonafide supernatural.

It is important to note that the mythical creatures described here are

manifestations of the supernatural within a culturally attuned system of belief. As non-Native appreciators of the aesthetic see them—as mask, on totem pole, in print—they are abstracted from that system in which they have function and meaning and are displayed as if, by themselves, they were *Art*. In truth, for the peoples of the Northwest Coast, art is the totality of the beliefs, ceremonies, and traditions that surround these images.

Supernatural beings have recognizable attributes. Like legends, they surface in various traditions with surprising similarity, though often with different Native names. Their number is legion, and we can do no more than describe a few representatives, most of them chosen because they will be met in the objects described in chapters 1 through 5 and because they are common in Northwest Coast art produced for sale.

Bukwus. This Kwakiutl "Wild Man of the Woods" skulks about the edges of the forest, carrying a cockleshell rattle, and tries to lure the unsuspecting to eat his ghost food, which would turn them into beings like himself. His forest home is the place where the spirits of the drowned gather. His distinctive image is skull-like and includes heavy brow ridges, round eyes, deep eye sockets, a birdlike hooked nose, and thick lips. Traditions other than those of the Kwakwa̱ka'wakw have similar creatures with their own names, some of which (for example, the Tsimshian Ba'wus) may have been derived from the Kwakwala language of the Kwakwa̱ka'wakw.

Dzoonokwa (or Tsonokwa). This Kwakiutl creature is a "bogey woman" to many young Kwakwa̱ka'wakws. She is ready to slip children into the basket she wears on her back and carry them off to her treasure-filled house, where she will devour them. She is typified by large, protruding red lips, sleepy eyes in sunken eye sockets, shaggy hair, and pendulous breasts. In masks, her face is typically glistening black with graphite paint. In spite of her horrific appearance and bloodthirsty reputation, she sometimes bestows wealth on chosen families.

A male counterpart is represented as a giant of great strength and wealth-giving power. He is frequently depicted with facial hair, but his other facial characteristics are similar to those of the female.

There are similar beings with their own names in other cultures. For example, among the Salish the legendary, fearsome giantess Sway-Uoch is alleged to chase and gobble up unruly children. Her cannibalistic propensity sometimes results in the loss of a tooth or two.

Komokwa. Komokwa is the "King of the Undersea World," the symbol of enormous wealth and well-being. Myths tell of a young man in need, who leaves his village to seek help and meets Salmon or Killer Whale who conducts him to Komokwa's house beneath the sea, with the result that

later the young man returns to the village with a canoe full of the gifts conferred by the wealthy king. Komokwa is also known as "Coppermaker," the copper being the Northwest Coast's highest symbol of wealth and power. This Kwakiutl figure has its counterpart in other traditions.

Pook-ubs. A favorite image of the Nuu-chah-nulth, Pook-ubs is the spirit of a drowned whaler. With a wrinkled and stark white face, mouth open in the drowning, and with pursed lips, in carvings or prints this figure is unmistakable.

Sea Wolf. In creating this mythical creature, artists customarily add flukes and fins to the characteristic long-snouted head and body of a wolf, but, in typical Northwest Coast style, the body parts are not always where they are expected. On one Alaskan pole, the Sea Wolf's tall dorsal fin projects from between its ears and supports the column of other figures on the pole. Sea Wolf also appears on the cast-concrete poles over the Deschutes River in Tumwater (see entry 1.4). Without knowing the artist's intent, it is sometimes difficult to differentiate between Sea Wolf and a whale/wolf transformation image. Among the Haida, Sea Wolf is known as Wasco.

Sisiutl. One of the most dramatic supernatural images, Sisiutl is a double-headed creature. Centered between its two serpentlike heads, with their protruding tongues, is a face possessing humanoid features and sprouting remarkable horns (see figure on page xxi). Fins and snaky scales adorn the serpent's body. This image is often curved into a circle motif in prints, snapped open in dancing transformation masks, and carved with moveable and dramatic accessories. Sisiutl represents a warrior's power; its blood renders men invulnerable, but its gaze brings them death. This image is found primarily among the Kwakwa̲ka'wakw, sometimes in Bella Bella and Bella Coola art.

Salish legends refer to a two-headed lizard that is also associated with invincible power. In contrast to Sisiutl, the lizard is rendered quite realistically without the imaginative flamboyance of the more northerly styles.

Sxwaixwe (or Sxwayxwey). The only ceremonial mask used by the Coast Salish, the Sxwaixwe is hard to mistake: its round face has peglike eyes; in place of ears, on its head there are two carved projections in the shape of animal heads; the nose projects outward as an elaborate animal head; the figure lacks a lower jaw, and in its place is a flat, downward-projecting, tonguelike grooved piece nearly the width of the mask itself. While their precise meaning is unclear to outsiders, these masks are used in purification ceremonies, traditionally performed by men in summer potlatches. When the mask is in use, feathers and other implements are stuck into its crown or attached to a ruff at the dancer's neck. The masks are purposefully designed to be impressive and mystifying without revealing their cultural

significance. A related Kwakwa̲ka'wakw figure, Kwekwe, was thought to cause earthquakes.

Thunderbird. This auspicious creature lives on mountain heights and symbolizes power and prestige, primarily among tribes of the Central and Southern coast. Frequently he is the most dramatic emblem, with great outstretched wings atop totem poles (see figure opposite). Thunderbird is similar to Eagle but, unlike Eagle, he has two curved appendages on his head, sometimes referred to as "horns." A magnificent curved beak and exaggerated talons confirm his powerful reputation. Occasionally he descends from his aerie to perform monumental deeds.

Among the Nuu-chah-nulth and the Makah, both whaling people, Thunderbird is often depicted in thunderous encounters with whales: he stuns them by hurling lightning serpents at them, while his eyes flash and his wings stir up the seas with wind and thunder. Among the Kwakwa̲ka'-wakw, it is often Kolus, a sibling of Thunderbird, who has the power to lift whales from the sea. Legend has it that both Thunderbird and Kolus have helped Kwakwa̲ka'wakw families by lifting and setting their heavy, longhouse frames into position.

Winter Dance Bird Creatures. A ferocious trio of supernatural birds appears in the Kwakwa̲ka'wakw Hamatsa dance ceremony. They are the representatives of that ultimate symbol of evil Bakbakwalanooksiwae (pronounced just as it is spelled), "Cannibal Who Lives at the North End of the World." The masks of these cannibal birds are characterized by great, flaring nostrils, awesome clacking beaks, and long, red-dyed cedar bark "hair." In the twentieth century, masks and images of the three have been brilliantly colored with flashy design elements. The Cannibal Raven mask has a long, heavy beak with red nostrils and "lips." The beak of the HokHok is elegantly narrow and elongated, facilitating its skull-crushing and brain-devouring habit. The bizarre mask of Crooked Beak of Heaven, the third avian, sports a large, laterally flattened beak, the top of which curls preposterously under its chin. The masks of these three are spectacular in museum displays, but their true impact is realized in the firelight and the eerie dramatics of the Hamatsa ceremony itself.

Cosmic Images

Moon. Circular or crescent shape, human face; lacks sun's radiating rays.

Sun. Rays radiating outward; circular face, sometimes human, sometimes a hawk or some other creature.

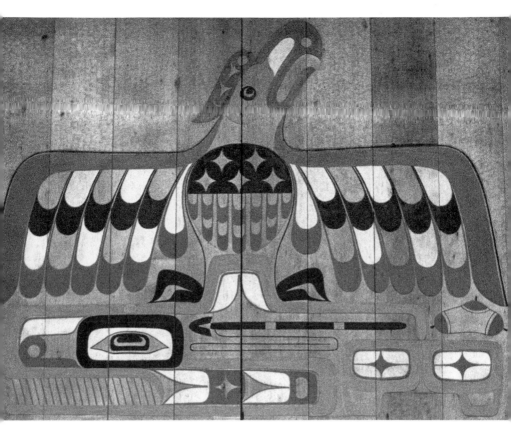

Painted wooden panel, Thunderbird and Whale, by Davey Stephens (4.26)

Material Objects

Bent-corner box or chest. The complex technique of kerfing, steaming, and bending a single cedar plank to form the four sides of a chest or box is the unique and ancient invention of Northwest Coast woodcarvers. The resulting objects were used for mortuary purposes; as drums to accompany singing and dancing; as seats; for storing every type of item, from household effects to ceremonial clothing; and, since they were water-tight, even for cooking by placing hot stones in the water and immersing the food to be cooked. Because a chest or box is a valued personal possession, it is occasionally replicated in art pieces. The figure at the bottom of an Occidental Park pole (entry 3.8) straddles a finely carved bent-corner box, an instance of a carving of a carving.

Copper. This shield-shaped object, originally beaten out of naturally occurring metallic copper, was later made of commercially available copper sheeting. It has a T-shaped ridge centered in the lower half of the shield. Usually a pattern or design is painted or engraved on its face, and each cop-

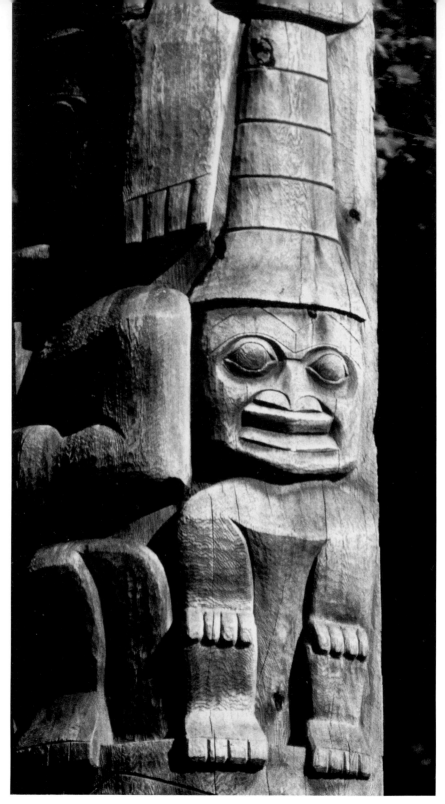

Potlatch rings on watchman's hat; detail from pole carved by Bill Holm (3.30)

per is given a unique name that boasts of its great purchase price. It has been its owner's most-prized object, ceremonially displayed and sometimes purposefully destroyed as a challenge to another wealthy chief. Images of coppers on poles and on button blankets are sometimes depicted in "bro-ken" form, indicating partial ceremonial destruction. A copper's prov-enance includes historical events at which it has been displayed and at which pieces were cut from it and distributed as a show of extreme wealth and privilege. For a fuller explanation, see entry 3.13.

Potlatch rings. Prestigious ceremonial hats of the Northern groups are crowned by a tall column of woven basketry cylinders, called potlatch rings (see figure opposite). There is no set number of rings, but it is believed that in early times the height of the column advertised the hat-owner's wealth, since the common (but probably specious) interpretation is that each ring represents a potlatch given by its wearer. A hat ornamented with four or more rings would be an impressive piece of property. Replication of the ring-adorned hats occurs in various media. The "watchmen" at the tops of poles wear ringed hats (see Burke Museum pole in entry 3.30). It is not un-usual to find the high rank of a legendary or crest animal signified by a col-umn of rings. The four rings atop Beaver's head on the Beaver Lake pole (entry 2.13) denote his chiefly status. Potlatch rings are of such importance that they may be part of a museum collection or be a design element, with-out the accompanying hat. Sometimes Northern-style poles are carved with rings extending upward more than half of the pole's height.

Spindle whorl. This elaborately carved disk was used by Coast Salish weavers in spinning the wool yarns used in their famous blankets. The whorl served as a fly wheel for the spindle, or staff, on which the wool was wound. The unpainted circular designs on the disks—often bird or animal figures that may have been associated with ritual purification—were formed by carving away the negative spaces with relief shapes (crescents, Ts, circles, triangles) to outline the images in an intricate style that sometimes seems to prefigure the work of contemporary artist M. C. Escher.

Variations in Coastal Styles

Although variations exist from artist to artist and from subgroup to sub-group within the Northern, Central, and Southern Northwest Coast traditions, and although there is some inevitable overlapping at their inter-sections, some observations may be helpful in identifying the coastal prov-enance of a given art work.

The Northern Coast

The identifying characteristic of Northern coastal art is its adherence to the *formline* system, a set of design elements and of aesthetic principles for relating those elements to each other, that gives the art its distinctive look (see pages xxii and xxiv). This system was first formally codified by Bill Holm in his landmark *Northwest Coast Indian Art: An Analysis of Form* (1965), and was drawn from an exhaustive study of 392 specimens of all kinds and sizes of two-dimensional art from Northern cultural groups.

Because of a common misapprehension, it is important to stress the fact that while artistic traditions other than the Northern may make use of some of the design elements that appear in formline art, the full formline system is found only in Northern art and is not an appropriate measure of Central and Southern styles.

The most important design element is the primary formline itself: a grid or continuous network of curvilinear, swelling, and tapering lines, usually painted black, that outline the major features of an image—for example, head, body, and ears. The primary formline has been compared to the interstate highway system, in the sense that, once you set your imaginary vehicle down on its "map," you can reach every other location on the continuous grid from that starting point.

Secondary formlines, usually painted red, are contained within the primary network. They too conform to the rules of continuity and curvature, and usually represent such lesser features as tongue, nostrils, and cheeks.

In his study, Holm found that about half of the time arms, hands, and feet were included in the primary formline, and half of the time in the secondary. Although primary formlines are most often black and secondary most often red, occasionally an artist may choose, for his or her own aesthetic reasons, to make the primary red, in which case the secondary are rendered in black. Inner ovoids—ovoids within ovoids—are always black, irrespective of primary and secondary colors.

Tertiary elements, such as eye sockets and other design areas within the primary and secondary forms, are commonly painted blue or blue-green. Background spaces (the ground or negative elements in the design) are painted white or are left unpainted, and on prints are left uncolored.

What give shape and content to these three design patterns are the ovoids and inner ovoids, the U forms, the salmon-trout's heads, described in the section on "Common Design Elements," above. Taken together, out of these elements mythical and magical creatures emerge.

In spite of common characteristics that mark individual creatures in the Northern iconography, their identity in two-dimensional art is not always

easy, depending on the artist's intention. In his 1965 book, Bill Holm identified three different degrees of realism in Northern art: *configurative,* in which the animal is presented in recognizable profile or in an undistorted frontal view, with body parts in relatively normal relationship to each other; *expansive,* in which the image is split or distorted, perhaps to fill available space (as on the conical surface of a woven hat, or around a rattle), but where the animal is still identifiable by the relative placement of its body parts; and *distributive,* in which the natural relationships of body parts are broken up in the interest of filling the design field completely, thus creating an abstract representation (typically seen on Chilkat blankets).[8]

The "rules" of formline art may appear rigid and limiting, but in fact the opposite is the case. Haida artist Robert Davidson has compared the formline system to the alphabet: after learning its essential individual elements, the artist can use them expressively and articulately in an endless number of combinations and recombinations. The only limitation is the creative imagination of the artist, not the system.

Monumental formline art, especially in the form of outdoor totem poles and indoor house posts, was a characteristic expression of the peoples of the northern Northwest Coast, who are, indeed, the "people of the totem." Their poles contained crest figures that served as public testimony to the lineages, legends, achievements, powers, and prerogatives of the families that owned the poles. Outdoor poles also traditionally served mortuary purposes, as a memorial to a deceased high-ranking person and sometimes as that person's coffin as well.

Indoor house posts often supported the beams of the traditional longhouse and bore the same elaborate crest carvings. The carving on both outdoor poles and indoor posts was characteristically stylized in the Northern tradition, adapting formline rules to the cylindrical shape of poles and posts and representing crest figures by means of a usually recognizable iconography of the sort described in the lists of images above.

The Central Coast

Although Central coastal art—Kwakwa̱ka̱'wakw, Nuu-chah-nulth, and Makah—does not adhere to formline rules, it does often make use of formline design elements (for example, the ovoid and the U form). It uses a wider range of colors, adding yellows and greens to the standard reds and blacks and blues of the Northern style; and, most especially in the case of

8. Holm, pp. 11-13.

the Kwakwa̱ka'wakw, is more flamboyant and fantastic, as for example in the Crooked Beak of Heaven and the HokHok, masked cannibal creatures in its high-ranking Hamatsa ceremony. Art of the Nuu-chah-nulth and the Makah often has a narrative, or storytelling, character.

While the Kwakwa̱ka'wakw are people of the totem—their poles are less stylized, more deliberately dramatic than their more restrained neighbors to the north—the Nuu-chah-nulth and the Makah are like their Coast Salish neighbors to the south, in that they have no tradition of monumental outdoor sculpture. More about that below.

The Southern Coast

Coast Salish art from traditional times seems much more restrained in both design and color (with the exception of its Sxwaixwe ceremonial mask, which has its own distinctive flamboyance) than art of the central coast region. Coast Salish spindle whorls and bowls often appear at first glance to be composed of unconnected crescent and T-shaped reliefs, which are, in fact, the negative spaces in the design. It is perhaps easiest to see the intended image by squinting and focusing on the spaces between the crescents and T shapes; in other words, to ignore the "hole" and focus on the "doughnut." When viewed in this way, the design yields the heads, wings, ribs, gills, and the like, which constitute the creature that the artist intended to portray.

Painted and carved Coast Salish works are sometimes punctuated by rows of dots and parallel lines. The dots most frequently are "song dots," mnemonic references to Native songs, and the lines often represent designs originally woven into baskets or rendered as stylized versions of salmon gills.

In contrast to the preoccupation with crest figures in the north and among the Kwakwa̱ka'wakw, Southern coastal art often has a narrative intent, a characteristic demonstrated in "story poles," the South's counterpart to the North's totem pole. In traditional times, there were no totem poles among the Nuu-chah-nulth, the Makah, and the Coast Salish. Their monumental art was indoors: house posts with both a structural and a spiritual purpose—as supports for the beams of their plankhouses and as representations of spirit guides and power beings related to those who lived in the house (see figure opposite). Spirit posts were most often carved on planks, rather than in the rounded forms of Northern-style house posts.

In the twentieth century, Coast Salish people began to create outdoor monumental sculptures, partly in imitation of their Northern neighbors, but with significant differences:

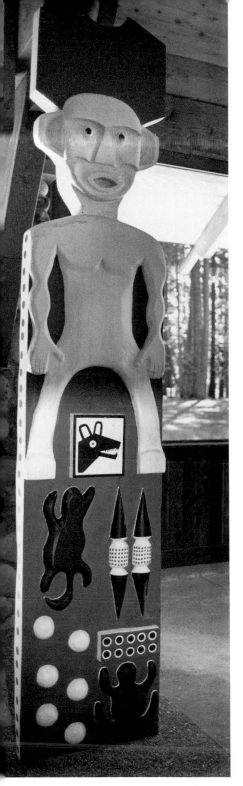

Salish house post replica by David Horsley (2.13)

1. In contrast to the North, where images were drawn from a recognized iconography and designed specifically for public "reading," the South's images are often idiosyncratic, cryptic, and private, only partly intended for open public "reading." Even when images are realistic in their shapes, they may still mystify, defying easy identification. A two-headed lizard and a snake with ears are creatures of personal or cultural significance, but they belong to the private world of artist and client rather than to the public world most often addressed in Northern art.

2. In contrast to Northern poles, Southern poles were usually designed, not to demonstrate inherited crests and privileges but to recount a legend, to recount sometimes unconnected parts of more than one legend, to celebrate events in the lives of important members of the community, or to represent power and spirit figures with local significance. Spirit figures were personal supernatural helpers, who assisted with hunting, fishing, gambling, or weaving. Initially they appeared accidentally in dreams, or as the result of a specific spirit quest. Still today it is considered inappropriate and meddlesome to inquire into the exact meaning of house-post or story-pole images, since it would be spiritually harmful to disclose the specific nature of one's spirit helper.

Pan-Coastal Influences

The distinctions sketched above are most useful in viewing older art, much less useful when approaching more recent pieces. Many contemporary Native artists do not feel limited to their own inherited traditions, but freely adopt a different style on occasions when the mood of invention strikes, or adopt a style from another part of the coast as their predominant style. Now and then Nuu-chah-nulth artists have produced works inspired by Northern influence, as well as by Salish traditions to the south. Marvin Oliver, living in western Washington and of mixed Salish and Pueblo heritage, early adopted the Northern formline as his predominant style. Non-Native Duane Pasco, though often thought of as having a Bella Coola signature, ranges in styles from the Tsimshian to the Salish.

A Special Note about Terminology

Although there are technical orthographies that use special symbols to represent the sounds of Native words, the more popular and informal process over time has been simply to transliterate Native words into English, seeking the combinations of English sounds that best approximate the Native pronunciation. That has been an arbitrary process at best, and not everyone has agreed on the approximations. Consequently, different spellings for the same word often appear in the background sources used by the authors, which will account for occasional differences in the spelling of Native words in the text that follows.

Moreover, the terms used to designate cultural groups have changed over the years. People on the west coast of Vancouver Island, mistakenly called Nootka by early European explorers, were later known as WestCoast people and currently call themselves Nuu-chah-nulth. Natives on the east coast of that island, on the smaller islands nearby, and on the adjacent mainland were popularly gathered under the Kwakiutl or Kwagiulth names and now call themselves Kwakwaka'wakw. Depending on the source of the information used by the authors here, any of these designations may appear in the text.

Conclusion

To one schooled in the tradition of Western European, Renaissance-based art, images and patterns on ancient and contemporary Native works may

seem alien at first. They reflect aesthetic precepts outside the scope of our normal seeing, bound as we often are by the rules of perspective given to us by sixteenth-century Italian painters. Painted portraits of European patriarchs, with which as Westerners we are so familiar, bear no resemblance to "family portraits" carved in cedar by Northwest Coast Native artists whose ancestors were Bear and Beaver.

Ironically, the coastal images may seem exotic or foreign precisely to those of us who live where the images are native, and where we ourselves are the real foreigners. So perhaps Northwest Coast Native art is an invitation to a new way of seeing and, with seeing, a new way of being—one less insistent on definition, more tolerant of ambiguity; less confident of differences (nature versus human nature, the natural versus the supernatural, the real versus the surreal) and more open to continuities.

If our Western predilections are at first confounded by the strange shapes of supernatural and mythical creatures—by fantastic cannibal birds from the Hamatsa dance, performed during the Red Cedar Bark ceremonies of the Kwakwaka'wakw; by Tsonoqua, the wild giantess of the woods; even by a personified River Snag—they are nevertheless impressive in spite of, or perhaps because of, their confusing guise. Nor need confusion be the last word. An attentive and patient person can learn to parse the artistic language of the Northwest Coast and begin to make sense out of its ancient vocabulary. Cedar Man, Bear Mother, Mouse Woman can become familiar as their legends are learned and as our imaginations are honed. We can find rare satisfaction in recognizing the threatening image of Bukwus, the forest-dwelling ghost, and Pook-ubs, the spirit of the drowned whaler, as they haunt painted, carved, and woven surfaces.

But the ancient aesthetic "languages" illustrated in the chapters that follow can reveal their power and meaning only to those who are willing, first, to allow themselves a measure of awe and wonder—before the parsing begins.

Northwest Coast Native and Native-Style Art

A Guidebook for
Western Washington

PART I

Where to Find the Art

Until now, no resource guide has existed to inform visitors to western Washington, as well as those who live here, of the rich heritage of Native arts, traditional and contemporary, that is a major feature of this area. *Northwest Coast Native and Native-Style Art: A Guidebook for Western Washington* is designed to meet the need for such information.

Sites covered here range from Portland, Oregon, to the Canadian border and from the western slopes of the Cascades to the Pacific coast. Our intent has been all-encompassing, seeking to include every publicly accessible Northwest Coast art object physically located within that area, whether the cultural tradition it represents originates in western Washington, British Columbia, or southeastern Alaska—the region customarily defined for Native art purposes as the Northwest Coast.

Objects known to us in two physical locations have usually been omitted: one location is tribal cemeteries, where the intrusion of the public— even an appreciative public—would be inappropriate and unwelcome; the other is public schools, where such intrusion would be inconvenient for teachers and administrators.

A word of explanation is necessary for the distinction between "Native art" and "Native-style art" in the title of this guidebook. One of the features of the Northwest Coast, perhaps distinctive among all of the Native traditions of North America, is that some of the really fine, authentic examples of its art tradition are the work of non-Native artists. This is particularly true of the art produced by western Washington artists; it is also true, but less so, in British Columbia. Because the subject of the guidebook is art and not ethnography, both Native and non-Native works and artists are included here. The introduction to Part II, Sources of the Art, addresses this unique circumstance more fully.

A few words about the format of what follows in Part I will facilitate its

use. For the purposes of this guidebook, western Washington is divided into five geographical areas, with a chapter in Part I devoted to each. The areas are:

1. *South,* which runs from Portland north to Tacoma;
2. *Metropolitan,* which circles the City of Seattle and includes outlying locations, from Highline in the south to North Bend in the east and Richmond Beach in the north;
3. *City of Seattle;*
4. *West,* which includes Kitsap and Olympic peninsulas; and
5. *North,* from Everett to Blaine.

Each of the five geographical chapters has a three-part format that includes (a) locations and descriptions of accessible sites where individual instances of Native and Native-style art can be seen; (b) museums and tribal centers within each area, with locations and collection descriptions; and (c) galleries and shops where information about the art can be obtained and where the art can be seen and purchased. A brief introduction to that three-part chapter format follows.

Sites. Persons in western Washington who want to see Northwest Coast Native and Native-style art up close will not have far to go. From Portland and Kalama in the south to Blaine in the north, from the western slopes of the Cascades in the east to Neah Bay and Kalaloch and Taholah in the west, the area abounds in easily accessible sites. Some objects are in interior but public spaces, where access may be limited to certain hours and days. Most of them are in the out-of-doors, inviting exploration at the whim of the explorer. All of them reward thoughtful inquiry.

In general, the progression of sites within and among chapters 1, 2, 3, and 5 is from south to north, beginning with Portland in chapter 1 and concluding with Blaine at the Canadian border in chapter 5. The progression in chapter 4 is from east to west, beginning with Agate Passage, between Bainbridge Island and the Kitsap Peninsula, and concluding with Taholah, near the Pacific coast.

Because our subject matter is the arts of the coastal peoples—arts that display a significant cultural continuity from the mouth of the Columbia to Yakutat Bay—we have not included any of the admirable works located in western Washington that derive from Native people from the Plateau or the Plains, or from south of the Columbia. They deserve a guidebook of their own.

Our aim is twofold: to provide enough descriptive information that

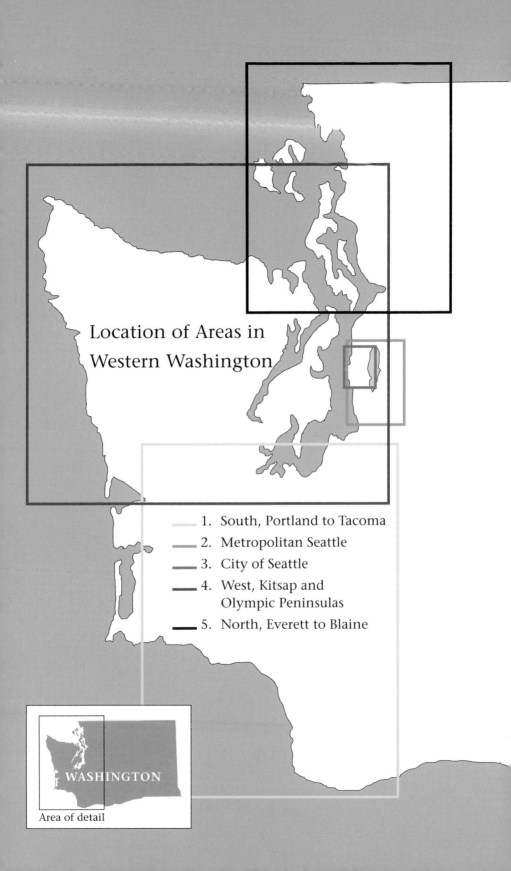

Location of Areas in
Western Washington

1. South, Portland to Tacoma
2. Metropolitan Seattle
3. City of Seattle
4. West, Kitsap and
 Olympic Peninsulas
5. North, Everett to Blaine

WASHINGTON

Area of detail

readers may decide in advance whether or not they want to view an object, and to provide them with a handy travel-companion to enhance that viewing. More detailed understanding will require both wider viewing—one of the purposes of this guidebook—and some study of the tradition beyond the information we have provided in the Introduction. For those who want to begin that larger study, the chapters in Part III offer suggestions of basic books and other resources that will enlarge understanding and identify places where more formal instruction on Northwest Coast Native art is available.

In some instances, although objects are publicly accessible, they are in inside spaces—for example, in the King County branch library in Carnation or in the branch library in Seattle's Broadview neighborhood. Since open days and hours change without notice, we have chosen not to list them here. Our advice is to call in advance to determine accessibility.

Museums and Tribal Centers. It is the great good fortune of this region to have a number of museums, some under state and local auspices and a few created by tribal entities, that have their own permanent collections of Northwest Coast Native art; that create special exhibits from time to time, drawn from private collectors in the region; and that sometimes host traveling exhibits from museums elsewhere. The list of such places in the following chapters promises many hours of productive viewing. A telephone call for information about hours, days, and fees is advised in advance of a planned visit.

Galleries and Shops. Objects that bear some relation to the aesthetic traditions of Northwest Coast Native art—that purport to be authentic instances of that style—are widely available in galleries, independent shops, and museum shops in western Washington, though the objects offered for sale vary widely in quality and authenticity.

Some objects are precisely what they purport to be: authentic expressions of the Native tradition, whether executed by Native or non-Native artists. Some are attempts to copy or imitate Native styles, crafted by persons who do not understand those styles; some are designs that have been pirated from established artists by imitators who have no originality of their own. As in the purchase of any piece of "art," the best rule is, "Let the buyer beware!"

Under most circumstances, the best way for a prospective buyer to be sure of the value of what is bought is to make the purchase in a retail outlet that discriminates between quality and kitsch, and that will provide the buyer with reliable information about an art object and its artist.

The retail outlets listed in each chapter are some of the places, in Portland and in western Washington, where such discrimination and information are available. Others may exist that have not come to our attention. The absence of any retail outlet from this list should not be interpreted as a negative assessment of the quality of its merchandise or of the competence of its staff.

Persons interested in Northwest Coast art are encouraged to use the shops and galleries as a major resource, both for viewing the art and for obtaining information about the art and the artists. Shop and gallery proprietors welcome browsers.

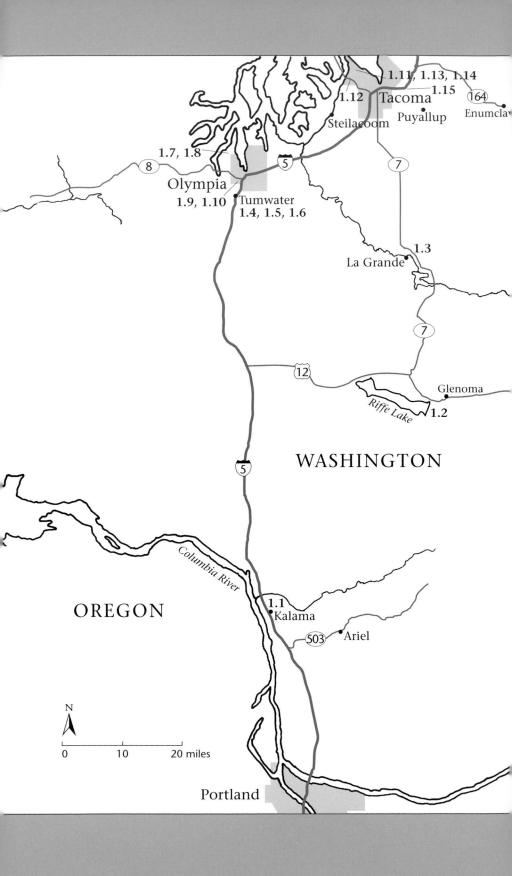

1. South

Portland to Tacoma

Sites

All locations are within twenty-five miles on either side of Interstate 5.

1.1 Kalama, Four Totem Poles

1.2 Taidnapam Park, Tacoma Public Utilities Interpretative Center

1.3 La Grande, Nisqually Story Boards

1.4 Tumwater, Bridge Totem Poles

1.5 Tumwater, Falls Park Pole and Petroglyphs

1.6 Tumwater, High School Pole and Wall Panel

1.7 Olympia, South Puget Sound Community College Column

1.8 Olympia, The Evergreen State College Welcome Figure and Longhouse

1.9 Olympia, Salish-Style Lighted Panels

1.10 Olympia, State Capitol Campus Totem Pole

1.11 Tacoma Public Utilities Skokomish Display

1.12 Point Defiance Zoo Murals

1.13 Tacoma, Performance Mask Installations

1.14 Tacoma, Fireman's Park Totem Pole

1.15 Puyallup Tribal Health Authority, Takopid Health Center

Kalama

1.1 Kalama Marine Park, Four Totem Poles; take the Kalama exit from Interstate 5, cross the railroad overpass and go south on Hendrickson Drive, turning onto Marine Drive at the brewery, and hence to the park just beyond. Over time, various locations have been given credit for having "the world's tallest totem pole"; and at the time it was raised, each pole may have been the tallest. But when any such claim is made, it is merely a challenge to someone somewhere else to make something "taller." Hilary Stewart reports that the tallest pole in the nineteenth century was 80 feet. But with equipment available in this century, a 100-foot pole was erected in Vancouver, British Columbia, a 103-foot pole in Tacoma (see entry 1.14 below), and a 127-foot pole in Beacon Hill Park, Victoria. In 1974, when the tallest of a group of four poles was raised near Kalama on the bank of the Columbia River, its 140 feet 2 inches gave it world honors. Even if it was then the tallest, however, it is no longer, although the sign leading visitors to the site still makes the claim. Kake, Alaska, has a pole that rises to 150 feet; and the Nimpkish village of Alert Bay, on Cormorant Island off the northeast coast of Vancouver Island, has a 173-foot pole that, until recently, was certifiably the tallest in the world. But, in August of 1994, a pole standing approximately 180 feet (55 meters) was raised above the harbor in Victoria, British Columbia. It was given the name "Lekwammen" (land of the winds) and was carved by a team of artists representing all of the British Columbia tribes.

It was difficult enough for the Weyerhaeuser Company to find suitable candidate trees for the tallest of these Kalama poles, even more difficult to fell such a tree into a specially prepared bed of sand to keep it from shattering. Six were felled before one tall enough and straight enough was selected. The pole was carved by Chief Lelooska, whose studio is in nearby Ariel (see entry in "Galleries and Shops" below, and chapter 6), and is a copy of two old Tsimshian poles from the Nass River in northern British Columbia: the pole of the Mountain Chief and the pole of the Flying Frog. The originals are now housed in Canada's Royal Ontario Museum in Toronto. Fifteen figures decorate the Kalama pole, and an interpretive text in the shelter at its base lists them. The pole was commissioned by William J. Weinberg of Vancouver, Washington, as a memorial to his wife Janet.

The three companion poles, all Kwakiutl in style and of varying heights, were carved by Lelooska in 1960, fourteen years before they were raised here. The tallest—rising perhaps more than 50 feet—faces west and is topped by Raven, with wings extended; then a human figure riding a triple-finned sea creature (apparently a fish since it has pectoral fins); then Wolf,

with a copper in its mouth and an upside-down human between its legs; then Bear, with faces in its paws; and, finally, what may be Eagle—its broken beak making identification more difficult—with what looks like the head of a seal between its "ears." Next in height is the pole facing north, which appears to rise some 40 feet. It is topped with a human figure wearing potlatch rings, followed by twin quadrupeds of uncertain identification; then Eagle (or Hawk), Beaver, and Bear. The shortest of the four poles faces south. Again, a human-appearing figure is at its top, with a copper in each hand. Next comes Raven, with a face in his tail feathers; then Sun, with a hawk's face and corona; and finally Whale.

Adjacent to the totem poles is a Salish-style plank canoe, perhaps 25 feet long and raised some 10 feet off the ground by four posts in a manner that in traditional times served mortuary or memorial purposes. For comparison, see the two canoes raised over the grave of Chief Sealth in the village of Suquamish (see entry 4.5).

This immaculately kept Marine Park, with its broad greensward, its promenade along the Columbia River, and its picnic facilities, will be a delightful destination for any who want to combine interest in Northwest Coast Native art with a family outing.

Taidnapam Park

1.2 Tacoma Public Utilities Interpretive Center, east from Interstate 5, Exit 68, on State Highway 12 to Glenoma, then south to east end of Riffe Lake. Increasingly in recent years, Tacoma Public Utilities (TPU) has been reaching out to the Native people on whose hereditary lands it does its power-gathering work. Other examples of art sponsored by TPU are in entries 1.3 and 1.11.

When TPU discovered that what is now Taidnapam Park in Lewis County had once been a primitive site, the company hired archaeologists to excavate and recover what remained of the human record. What the scientists found, at the lowest level, were remnants of stone tools that date from 2500 B.C., buried by an eruption of Mount St. Helens 3,400 years ago. In a layer above the volcanic ash, they found artifacts that were 700 to 2,500 years old, indicating the return of human inhabitants to this land.

TPU opened Taidnapam Park in 1993 in recognition of the importance this land has had for the Upper Cowlitz people, who were often called Taidnapam, and installed six interpretive boards. In addition, Seattle-area artist Duane Pasco was commissioned to carve a shovel-nose canoe of the sort used by local Native people on nearby rivers and wetlands for hunting, fishing, and transportation. The canoe is a permanent part of the interpre-

tive center. Camping, boat-launching, and fishing facilities are available nearby.

La Grande

1.3 Tacoma Public Utilities Station Story Boards, 46502 Mountain Highway East. The TPU installation in this village east of Tacoma is located at a dramatic overlook high above the valley of the Nisqually River. Beside the overlook, the Nisqually Indian Tribe has placed carved and painted story boards representing its traditional and intimate association with the surrounding countryside.

One panel of the board contains a poem, written by tribal member Cecelia Svinth Carpenter, which reads:

Ta-co-bet, Majestic Mountain, silhouetted against the sky
Guardian over the land of the Nisqually people
Who sends the rains to renew our spirits
Who feeds the river, the home of our salmon
Who protects an eagle in her flight
Who reaches upward through the floating clouds
To touch the hand of the Great Spirit,
Ta-co-bet
We honor you
The People of the Nisqually Indian Tribe

An adjacent panel, carved in shallow relief, illustrates the poem, with images of Ta-co-bet (an Indian name for Mount Rainier), the forested slopes and valleys, the river and its salmon, and a representation of the people themselves.

The story boards were installed in 1993 with appropriate ceremony and feasting that were participated in by tribal elders and members and public officials.

Tumwater

1.4 Cast-Concrete Totem Pole Figures, intersection of Custer Way and Capital Boulevard. Said to be the only cement totem poles in the world, these four sentinels, bathed in a malt aroma from the nearby Olympia Brewery, guard the north and south ends of the Capital Boulevard Bridge over the Deschutes River, at what was once the entrance to Olympia. The poles are identical. Figures, in descending order, appear to be Thunderbird

(with a street light concealed beneath its hefty protruding beak),
Wasco (mythical Sea Wolf), Raven,
and Bear. Northwest anthropologist
Viola Garfield once commented on
the artistic merit of the poles, which
were placed on the bridge in the
1940s. If she were to see them today,
she might be surprised that the tail
of Wasco has been mistakenly
painted as if it were the headdress of
Raven, and that the last repainting
has left them in nontraditional, pastel Easter-egg colors.

Each of the four poles has one of
these phrases at its base: "Entrance
to the City of Olympia, Capital of
the State of Washington," "Site of
the First American Pioneer Settlement in Washington, 1845," "South
Gateway to the Puget Sound Country and the Olympic Peninsula," and
"Beginning of the Inside Passage to
Alaska and British Columbia."

1.5 Falls Park, on the west side of
the Deschutes River, just below the
North Street Bridge. Two objects of
Northwest Coast interest, located
under a shelter beside Tumwater
Falls, provide an additional reason
to visit this very attractive park, operated by the private Olympia Tumwater Foundation. By far the more
important of the two is a rock, originally located on the north shore of
Hartstene Island, twelve miles north
of Olympia, on which ancient inhabitants of the island incised figures—known as petroglyphs—by
pecking them with other rocks. The

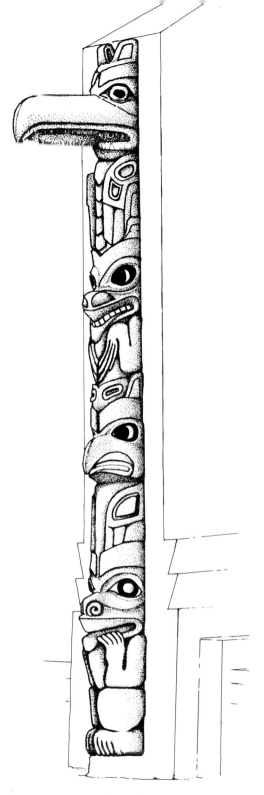

Concrete totem pole on the Tumwater
Bridge (1.4)

central figure is identified as Bear; others represent lesser animals, mountains, the sun, and a bow and arrow, all entailed in ancient Puget Sound Native legends. Although there are a great many petroglyphs in Washington State—on the coast and in the Columbia Gorge—most are in remote locations, difficult to reach. Here is the authentic item, easily at hand.

Of less interest in this shelter is a small totem pole, garish and graceless, copied from what one must assume was a more impressive Kwakiutl original at Alert Bay in coastal British Columbia (not in Kingcome Inlet, as the accompanying plaque alleges). It represents Thunderbird and Grizzly Bear holding a human figure on its body.

1.6 Tumwater High School, 700 Israel Road (360/586-9359). A wall panel in the corridor outside of the school's administrative offices is a good example of Northern formline design. The carving represents Eagle, and, in characteristic Northwest Coast fashion, the head of the creature is as large as the rest of its body. The torso is represented by a smaller eagle's head; the wings extend out from the torso and down the side of the panel; the tail joints are represented by two ovoids and three upside-down U forms; and red legs end in black talons. This is an early Marvin Oliver from 1977.

The commons area of the school has a totem pole, of unknown provenance, unceremoniously attached to its wall. Three figures constitute the pole: Thunderbird, Whale (really quite interesting, with prominent dorsal fin and with flukes curled over its body), and Bear. Hardly a great piece, it nevertheless deserves better than the indifferent setting the school has provided for it.

Olympia

1.7 South Puget Sound Community College Column, Crosby Road, just south of Exit 104 on Highway 101 (360/754-7711). Building 32 on this handsome, wooded campus on the southern edge of Olympia houses the Natural Science classrooms and laboratories, a fitting location for a striking column by Marvin Oliver that features the salmon, one of Oliver's favorite motifs, and one of the chief natural resources of the Pacific Northwest.

Some 8 feet tall and 24 inches in diameter, the column makes a striking impression just inside the building's entrance. Those who know Oliver's work will recognize the swarming salmon, ten of them, in carved designs that alternate black and red primary formlines. The salmon are separated by nine small bronze hemispheres representing salmon eggs. Similar arrangements are found on Oliver prints, and a flat panel of almost identical design hangs behind the seats of City Council members in the Issaquah

City Hall. (See entry 2.12.) The building in which the Oliver column is located is not open on weekends.

1 8 The Evergreen State College Welcome Figure and Longhouse, 2700 Evergreen Parkway Northwest (off Highway 101 in or of Olympia) (360/ 866-6000). On Charles J. McCann Plaza, at the main pedestrian entrance to the campus, one meets a handsome, carved female figure, her broad face recognizably contemporary Makah or Nuu-chah-nulth, standing perhaps 8 feet tall, hair braided, dress decorated with black and pink figures on the cuffs of her short sleeves and at her skirt hem. She holds in her left hand a drum, on whose surface a traditional hand design is painted, and in her right hand a drum stick. Students festoon her respectfully from time to time. This traditional welcome figure, carved by Makah artist Greg Colfax, Skokomish artist Andy Wilbur, and members of the Evergreen College community, was raised in June of 1985, "presented in sacred ceremony . . . by the Native American Studies Program" and intended to signify hospitality and dignity. It succeeds.

In fact, it succeeds so well that the original plan to move this striking figure from the entrance to an interior campus site, once a new longhouse was built there, has been delayed indefinitely because of strong sentiment in the college community for keeping this valued welcoming image right where she is.

The Longhouse Education and Cultural Center, a major, new practical and aesthetic resource, opened on the campus in the fall of 1995. A 10,500-square-foot building, it strikingly combines contemporary architectural influences and materials with a design that strongly evokes the traditional Native big house. The building's wooded setting on the campus enhances the traditional effect. The lead architect, John Paul Jones, of Choctaw and Cherokee heritage, has been a design consultant for the Smithsonian Institutions's new Museum of the American Indian in Washington, D.C.

The Center will house art from a variety of Washington tribal sources, including a collaborative work on the theme of "Creation" by Makah artist Greg Colfax and Skokomish artists Andy Wilbur and Bruce Miller. Two potlatch poles carved by Andy Wilbur—a male figure holding a feast dish and a matching female figure holding a salmon—are located in the Longhouse Welcome Hall. Circular fireplaces, performance facilities, a communications room providing computer access to the Internet, and a kitchen are among the building's features.

The Center can be reached from Charles J. McCann Plaza by turning left in front of the main library entrance onto a broad brick avenue and following it to the end.

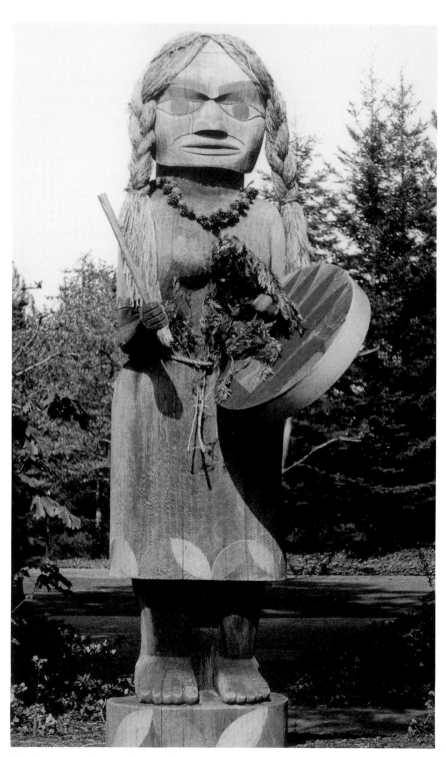

The Evergreen State College welcome figure, carved by Gregory Colfax and Andy Wilbur (1.8)

1.9 State Capitol Campus, Salish-Style Lighted Panels, over the entrance of the parking garage, front of the Natural Resources Building, 11th Avenue between Washington and Jefferson streets. This installation, put in place in the late summer of 1993, was designed by British Columbia artist Susan Point; it resembles the traditional Salish style for which she is so well known. It consists of five identical panels, each 11 feet long and 2 feet wide, with rows of fish-head designs cut out of stainless steel. The upper and lower borders of the panels are formed by a series of cut-out triangles alternated in such a manner that the spaces between them form a zigzag motif.

This design style is commonly seen in art of Columbia River and Coast Salish groups. Here it provides an opportunity to illustrate the "doughnut and hole" principle—the relation between positive and negative design elements described in the Introduction. The fish heads, the central design elements, are positive spaces on the metal surface of the piece. Their eyes, gill slits, and mouth areas, cut out of the metal, are negative spaces. Likewise, the zigzag surface borders are positive design units, defined by the cut-out negative triangles.

Although the five panels are identical, for visual variety the second and fourth have been placed in an obverse relation to the other three. Behind the upper border of each panel is a light-blue transparent material, with a turquoise-blue transparency behind each center section, and light green behind each lower border. Internal lighting provides for an even more vivid statement at night than during the day. But the negative spaces, through which the colored illumination shines, boldly command the night-viewer's attention, perhaps even overpowering the positive elements of the design.

1.10 State Capitol Campus Totem Pole, Columbia Street and 11th Avenue West, across from the General Administration Building. This 71-foot pole, carved by Snohomish Chief William Shelton, owes its location on the Capitol Campus to a successful campaign in 1937 that asked every school child in Washington State to contribute one penny to a fund for its purchase and installation. The availability of the pole, and the strategy for its purchase, had first been suggested by Seattleite Jane Dillon, who offered her daily KJR radio program, sponsored by the Bon Marché, to publicize it. Adopted as a project of the Parent-Teacher Association of Snohomish County, the project finally came to fruition when the pole was dedicated in an impressive ceremony on May 14, 1940, in the presence of Chief Shelton's widow and daughter and assembled business and government dignitaries, with formal acceptance on behalf of the state by Governor Clarence D. Martin and "Entertainment by Northwest Indians" concluding the program.

This is a Salish story pole of the kind for which Chief Shelton had become famous (see, for example, entry 5.1 for the Everett Pole); and, typical of Shelton, the "story" was said to have "a character-building motif." But unlike Northern poles, which are plainly designed for the public display of lineages, privileges, and spiritual powers, the spiritual meaning of Salish poles is often kept by the artist. So, here, the "story" itself was never specified and the identities of the figures on the pole were never detailed. The dedication program guide reproduced an ominous image from the pole and was only able to say in vague explanation, "Friend or foe? This is a close-up of one of the characters on the totem pole. It, like other characters, symbolizes some facet of Indian lore, with its own individual meaning." Both sides of the many-featured pole are carved and painted. Since speculation about their identity and meaning would be arbitrary at best—and, given the artist's reticence, perhaps inappropriate at worst—we propose that viewers simply come to the pole unpredisposed and let the "mystery" speak to them, if and as it will.

Tacoma

1.11 Tacoma Public Utilities Skokomish Display, 3628 South 35th Street, 98409 (206/502-8759). The placement of this display in one of TPU's high-security facilities restricts public access, but making the effort to see it will be worth the trouble for anyone with a special interest in the art and culture of the Puget Sound Salish. Titled "End of the Ancestors," it was conceived and executed by Bruce Miller, a leader among the Skokomish Twana (see his entry in chapter 6), in obedience to the ancient law to "keep the knowledge and memories of our ancestors alive."

The exhibit consists of two main panels, each dominated by two tall spirit boards, with the figure of an old man between the two on the left and of an old woman between the two on the right. They wear Hudson's Bay blankets and trade beads, and at their feet are bits and pieces of the past, both ancient and more recent. The man's spirit boards represent Owl, hovering over the red ochre mountain where the first man was made, and the reptilian Ayahos, head of the healing powers. On the man's right are the tools upon which the ancestors depended for survival: bow and arrows and fishing spears.

The woman's spirit boards represent a warrior who had the ability to swallow arrows and thus to confound the enemy and assure survival, and a *squed-alich,* an implement used in soul-recovery ceremonies and for finding what was lost. On the woman's left are representations of her survival skills: bear grass and sweetgrass, materials for her basketmaking, and a

loom with a chief's blanket representing wealth.

Much more can be said of the symbolism Bruce Miller has put into this complex piece, and those who visit will want to pick up his four-page interpretation, reproduced by Tacoma Public Utilities.

Because of the high security status of this building, viewers may be admitted only by special arrangement in advance. Call the TPU Office of Community and Media Services at the number that appears at the beginning of this entry.

1.12 Rocky Point Marine Mammal Exhibit, Point Defiance Zoo. In 1982, artist Tom Speer was commissioned to paint two murals in the lower observation level of this exhibit house. It is likely that many visitors have failed to notice them, partly distracted by beluga whales, walruses, seals, and sea otters disporting themselves in the water behind the big windows, partly because the paintings themselves are high up on the walls.

One mural is of a young male fur seal with its recognizable features of pronounced forehead, flippers, flippered hind claws, and stubby tail. The "face" on its breast symbolizes the spirit of the animal. The second is a female sea otter characteristically floating on her back, with flippered hind paws and tail, and holding a large clam to feed on. A baby otter is shown in her womb. Both images are presented in classic Northern formline style. Each has a nearby plaque that provides additional information.

The images themselves, painted all in white, appear to be pockmarked and in need of repainting.

1.13 Performance Mask Installations, Broadway Theater District. Anyone who has not visited downtown Tacoma lately has a treat in store. During recent years, the Broadway Theater District Task Force raised $12.4 million to provide space for Tacoma's performing arts organizations and to make its downtown a physical and cultural showplace—an aim achieved with remarkable success. The project, slightly more than two blocks in length and width, has Broadway as its axis. At its heart are major building renovations—the Rialto Theater at 9th and Court C, and the Pantages Theater and the Theater on the Square on Broadway—and a handsome public park, also on Broadway. Not surprisingly, these public developments have influenced nearby private structures, and the area is marked both by renovation of old buildings and by recent construction.

Not least among the Theater District's classy features are the Performance Mask Installations, sponsored by the Broadway Center for the Performing Arts. These are twenty masks, cast in bronze with colorful embellishments, arranged in pairs and mounted on panels of stainless steel

and black granite, and distributed in ten locations throughout the district. Each mask represents an ethnic tradition that gives Tacoma its cultural richness—Native American, African, Asian, Latin American, European, and Caribbean—and on each panel are etched cultural symbols related to its pair of masks. Braille identifications appear on each installation.

While all of the images merit thoughtful viewing, four of the masks represent Northwest Coast Native cultures: a Kwakiutl Seal, on the front of the Tacoma Financial Center, 13th and Broadway; a Tlingit shaman, on the front of the Columbia Bank Building, 11th and Broadway; a Haida Eagle (shown in frontispiece, page ii), in the spacious park on Broadway between 9th and 11th; and a Kwakiutl Sun, on the front of the Rialto Theater, at 9th and Court C.

In addition to the masks, there are banners of thin-gauge stainless steel, installed high up on light standards at several intersections throughout the District. Of the two banner designs, one is in the Northwest Coast Native style and represents the Kwakiutl Sun depicted on the mask in front of the Rialto Theater.

A further feature of these imaginative installations is a set of basalt rock sculptures on both sides of 9th at Broadway, some carved with cultural symbols and glyphs, one embellished with handprints of Tacoma residents who participated in the project, and one bearing a spiral of quotation fragments from persons both famous and obscure.

The Tacoma design firm of Stone McLaren coordinated the project, artist Douglas Granum produced the masks, panels, and rock sculptures, and Charlee Parker Glock composed the poetic text that accompanies each of the twenty masks. "A Walking Guide" of the Performance Mask Installations is available at the Box Office of the Broadway Center for the Performing Arts, 901 Broadway.

1.14 Fireman's Park Totem Pole, Ninth and A streets. This is yet another of the totem poles that at one time were touted to be the tallest in the world. It was raised in 1903, with an impressive 76 feet looming above the ground and at least 10 feet anchoring it beneath ground level. Traditionally, communities in Southeast Alaska vied with one another as claimants to the tallest or most noteworthy totem monuments. In that spirit of competition, the Tacoma pole's height was an attempt to rival the notoriety of a neighboring village's pole: namely, the Seattle totem pole, which had been acquired by nefarious means four years earlier (see entry 3.6).

Like many other century-old poles, the carvers of this pole are largely unknown to those in the village where it now stands, but contemporary records indicate that the two chief carvers were members of the Kagwantan

clan of the Tlingit from near Sitka. During their work on the pole, the carvers, along with their families and assistants, were all temporarily housed at Quartermaster Harbor. The log was purchased from the St. Paul and Tacoma Lumber Company, and the completed pole was presented to the city by W. F. Sheard, fur merchant, explorer, hunter, and traveler, and by Chester Thorn, president of the Tacoma Bank.

In the 1950s the pole was moved from in front of the old Tacoma Hotel to its present site. It was painted then in exotic shades of pastel pink and blue. In 1959, when an alert ten-year-old named Wendy Barde notified the authorities that the colors were unsuitable, it was repainted in black, green, brown, and white. The pole was taken down in 1975 to make way for Schuster Parkway, and restoration work was done by Doug Granum (of North Dakota Mandan heritage) and Jean Ferrier. Granum and Ferrier cleaned it, recarved Bear's head and claws, and replaced the top 12 feet of the pole, replicating the original Eagle figure there.

Identification of the pole's figures and an explanation of their significance were attempted in the 1930s, long after the carvers (for whom there was, indeed, a clear significance) had vanished into the Alaskan wilderness. Published records of those attempts differ; none seems to match fully a current visual scrutiny with binoculars. Here we offer one description, probably as satisfactory—and unsatisfactory—as any, from a WPA-project leaflet written in 1936 by Alfred Smith. The figure at the top is Eagle, followed in descending order by Killer Whale, Crow (or Wolf or Wolf-Raven) with two Young Crows, Great Raven Woman, Chief's hat, HokHok (a supernatural cannibal bird) holding a magic cylinder said to contain the power that first caused land to erupt from primordial waters, then Grizzly head (or Wolf-Raven), Grizzly Bear with a human between its ears, and Wolf.

This much is clear: the most remarkable features of the pole are the detailed Chilkat motifs on the apron and wristlets of Great Raven Woman and on the apron of HokHok, which were added by Jean Ferrier in the 1975 restoration.

A pleasant lunch hour could be spent at Fireman's Park with a picnic basket and binoculars. The picnicker's serendipitous musings may come closer to the intended message of the pole than those of the earlier "experts"!

1.15 Takopid Health Center, Puyallup Tribal Health Authority, 2209 East 32nd Street (206/593-0232). This building represents a stunning marriage of the healing powers of the spirit and those of medical science. Primarily a state-of-the-art, 36,576-square-foot polyclinic, it is also an eloquent affirmation of an ancient culture, from the Puyallup basketry designs incorporated

in the brick of the exterior walls and the longhouse shape of the structure to the "legend circle" near the entrance, designed as a place for storytelling and as a symbol of both the cycle of the salmon's return and the togetherness of the community. Brick-designed salmon flank the main entrance.

The central reception area is set within open posts and beams that echo the larger building's longhouse shape. Its carpet preserves the legacy of the shaman in a sacred "medicine circle" design, oriented toward the north, embodying traditional colors—gold for east, black for south, red for west, and white for north—and symbolizing wholeness and equality. In the center of the carpet is a white star, within which, after closing time, the medicine man may perform healing ceremonies.

The cedar-plank interior wall of the reception area resembles the painted house front and entrance pole of a traditional longhouse. Commissioned of Seattle artist Jay Haavik, the central image on the post is Thunderbird, here representing wealth and healed wounds; on its head is Loon, respected as a fisher; and below Thunderbird is Black Bear, chosen to symbolize introspection, holding a salmon (staple of the Puyallup Tribe's livelihood). The painted wall behind is an extension of the pole, providing Thunderbird's large wings. Beneath the wings is the formline face of Eagle, intended here to represent nobility and kindness. On the left side of Eagle is a round salmon egg and Chipmunk, a healer. On the right side is a salmon egg and Blue Jay, a schemer and politician. Above Thunderbird's wings are waves and U shapes representing Mount Tahoma (a Native name for Mount Rainier).

Display cabinets of wood and glass, on both sides of the main reception area, contain old and new expressions of Native art, some of Puyallup origin, some from other Northwest Coast and North American tribes. Wooden wall plaques in adjacent spaces imitate Northern coastal styles. The work of one Bill Snyder, of whom no further information is available, they were created by sand-blasting, once decorated the Tacoma Salmon House, and were donated to the Tribe by Food Services of America.

The building, which opened in the fall of 1993, is the creative achievement of architect Robert Weisenbach of Tsang Partnership, Inc., Seattle, with the active participation of tribal elders and in spite of the bureaucratic resistance of federal authorities.

Puyallup Tribal Health Center interior wall by Jay Haavik.
Photograph by Robert G. Weisenbach (1.15)

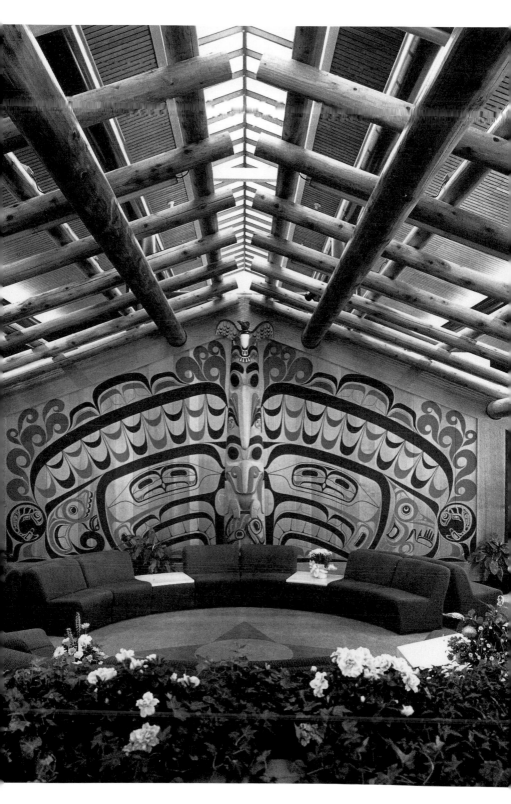

Museums and Tribal Centers

Portland

No, the "City of Roses" was not annexed to Washington when you weren't looking. But the presence there of major museum and retail establishments and their easy access just across the Columbia River state boundary make Portland a ready resource for Washington residents and visitors that deserves inclusion in a regional guidebook.

Portland Art Museum, 1219 Southwest Park Avenue, 97205 (503/226-2811). Three major collections in this important regional museum are devoted to Native American arts. Of special interest to this guidebook is the Rasmussen Collection, acquired in 1948, featuring 1,200 pieces from the Pacific Northwest, including religious and ceremonial paraphernalia, costumes, tools, and equipment and representing a wide range of tribal lifestyles along the coast. Among the gems in the collection are two pairs of Tlingit house posts—large cedar posts painted with totemic designs in red and black; a handsome, realistic Tsimshian portrait mask of a young woman, with a small wooden eagle pendant attached to her hair on either side; a Kwakiutl transformation mask, the outer face representing the mythical forest giant Tsonoqua, and the inner face, a portrait mask, unadorned except for black eyes, eyebrows, mustache, and red lips; and a remarkably fine tunic of Chilkat weaving, with fur on the side seams and cuffs.

The Butler Collection, numbering more than 1,800 pieces from the eighteenth through the twentieth centuries, ranges across virtually every tribal and geographic region in the United States. It encompasses a wide array of objects, including ceremonial regalia, clothing, implements, masks, toys, games, textiles, weapons, musical instruments, and carvings.

A pre-Columbian collection includes textiles and ceramics from Central and South American cultures. Figures from the Olmec period in Mexico and Mayan ollas are included, as are artifacts from Western Mexico and Vera Cruz.

The museum also has a small number of prehistoric stone sculptures from the Columbia River basin. Other permanent exhibits feature African art from the Cameroon and Ethiopia, European and American paintings and sculpture from the sixteenth through the twentieth centuries, prints and drawings, Chinese furniture, classical antiques, and English silver.

Oregon Historical Society, 1200 Southwest Park Avenue, 97205 (503/222-1741). In "Oregon: Land of Promise, Land of Plenty," the long-term gallery

devoted to the history of the state, artifacts are exhibited that reflect the diverse cultures of the state's First People. The basketry skill of both coastal and inland tribes is represented, as are unique Lower Columbia River artifacts that range from small decorated tools to larger petroglyphs several feet in diameter.

A replicated cedar bark house interior, typical of the Oregon coast in traditional times, is furnished with baskets, boxes, utensils, and tools that would have been in daily use by coastal Natives. Nearby is a cedar plank canoe.

With the coming of horses to the Columbia Plateau, some of the arts of the Plains Indians were adopted into the Northwest Native cultures. Intricate beadwork was used by Columbia Plateau people to decorate trappings for their horses. Beautiful mid-nineteenth-century cruppers and accessories are exhibited.

Throughout the building, several contemporary Northwest Coast–style carvings by Lelooska and his brother Tsungani, artists from nearby Ariel, Washington, are displayed, evidence of the ongoing practice of the arts among Northwest Native people today.

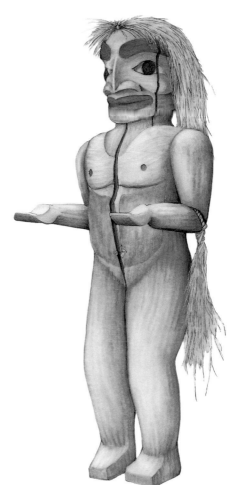

Washington State Capitol Museum's "The Healing Pole That Welcomes." Drawing from a pole carved by Andy and Ruth Wilbur

Olympia

Washington State Capital Museum, 211 West 21st Avenue, 98501 (206/753-2580). Established in 1942 "for the preservation of early Washingtoniana," this mu-seum displays a strong interest in the state's First People, especially the seven South Puget Sound Tribes: Chehalis, Cowlitz, Nisqually, Puyallup, Skokomish, Squaxin Island, and Steilacoom. Its permanent collection of 40,000 objects includes some 3,000 artifacts of Native origin, such as baskets, wood carvings, and stone tools. There are three permanent exhibits: "The Healing Pole

That Welcomes," a large, traditional welcome figure, carved by Andy and Ruth Wilbur (Skokomish), with a grant from the Washington State Arts Commission; "The Hunter," a settee whose back depicts Crane and Wolf, painted and carved in shallow relief, also by the Wilburs; and a "hands-on" replica of a Salish winter house by Greg Watson.

The museum offers docent tours and occasional lectures, and has a gift shop with books, note cards, cedar boxes, baskets, and jewelry. Although there was a merger in 1993 of the Washington State Capital Museum with the Washington State Historical Society in Tacoma, this museum is retaining its Olympia location.

Steilacoom

Steilacoom Tribal Cultural Center and Museum, 1515 Lafayette Street, 98338 (206/584-6308). One of a very few tribally run institutions in Washington State, this Cultural Center and Museum opened in 1988, after a four-year effort, and includes three exhibit areas. Gallery I offers a changing exhibit on a Native American theme, which may last from two to six months. Gallery II is a permanent exhibit detailing the history and contemporary lifestyles of the Steilacoom people, beginning with the first European contact in 1792. Gallery III is also a permanent exhibit, originally produced for Washington State's 1989 Centennial, and is an archaeological representation of the prehistory of the Tacoma Basin, traditional home of the Steilacoom people. A lower level includes a gift shop, selling handcraft items and books, and a snack bar. The museum works with schools to provide education on the local Salish culture. Arranged tours may include a lunch of traditional foods.

Tacoma

Washington State History Museum, 1911 Pacific Avenue, 98402 (206/593-2830). Entering the museum's state history exhibit area, a visitor encounters a First Peoples theme that is carried throughout. In a southern Coast Salish–style winter home (built by Makah artist Lance Wilkie), visitors "hear" grandmother talking to granddaughter as they make baskets, uncle as he mends his net, and two sisters-in-law as they cook fern-root cakes in a basket. The "talking" figures in the house are life-size sculptures. Farther along, in a re-created petroglyph-wall outcropping, is a theater where visitors can see video presentations of storytelling and other examples of local oratory by contemporary Native elders. A special gallery tells of the devas-

tation experienced by Native people as a result of epidemics through time. Masks by contemporary Washington State artists addressing this theme are incorporated in the presentation.

The museum's most ancient artifacts are a rare set of bone tools and points, more than 11,000 years old, recovered from a Wenatchee orchard, the only known Washington site of the Clovis culture. The museum's Native American collection is especially strong in turn-of-the-century artifacts. An exhibit of basketry includes two examples of Nisqually-Puyallup coiled baskets in pristine condition, each some three feet in height. Photographs are displayed throughout the exhibit area, one notable set showing Native students at the Cushman school in Puyallup. Another set, portraits taken by Indian agent Frank Morse beginning in 1896, depicts Native people on the Olympic Peninsula.

The story of the region's First People is spread throughout the entire state history exhibit, which occupies some 20,000 square feet in the new museum. Its unifying theme is the relationship between human inhabitants and the natural environment and the consequent development of the human communities that have become Washington State.

Puyallup

The Paul H. Karshner Memorial Museum, 309 Fourth Street Northeast, 98372 (206/841-8748). Owned and operated by the Puyallup School District, this small museum plays an important role in acquainting school children with the Native American heritage. Through organized class visits to the museum itself and through circulation to the local schools of its fifty-one "Discovery Kits," which contain original Native artifacts or their exact replicas, the museum provides hands-on contact with the material culture that was in place when the first Euro-American settlers arrived in the area. Every elementary-school child in the district visits the museum at least once each year. A tipi and several modest dioramas give a touch of realism to the experience.

Although the collection numbers among its 10,000 items objects from Southwest, Plains, and Eskimo cultures, it is especially rich in objects from western Washington: baskets, tools, clothing, drums, hunting equipment, model canoes, and blankets, among others.

The museum is open to the public on the first Saturday of each month. Call for hours, monthly program events, and admission fees.

Galleries and Shops

Portland

Quintana's Galleries. There are two Quintana branches, and in combination they probably represent the largest inventory of quality Native American art to be found in any retail outlet in the Northwest, including Seattle, Victoria, and Vancouver. The original Oldtown branch, called **Quintana Galleries,** is at 139 Northwest Second Avenue, 97209 (800/223-1729). Owned and operated by Cecil, Rose, and Cecily Quintana, it specializes in contemporary Northwest Coast, Inuit and Eskimo, and Southwest Native arts. Its inventory includes paintings, wood carvings, stone sculpture, graphics, and jewelry. Among the many Northwest Coast artists regularly represented are the Hunt and Henderson families, distinguished Kwakwaka'wakw lineages, and Tsimshian David Boxley. Eskimo and Inuit sculptures, wall hangings, and graphics are here from such well-known artists as Larry Ahvakana, Simon Tookoome, Jessie Oonark, Iyola Kingwatsiak, and Kenojuak. Specially featured are the masks and sculptures by Abenaki artists Tsonakwa and Yolaikia. Theme exhibits and artist lectures are scheduled throughout the year. This gallery specializes in commissioning hard-to-find works and offers art consulting, appraisals, and installation services.

The related **North American Indian Gallery,** located in the Yamhill District, is at 818 Southwest First Avenue, 97204 (800/223-4202). Owned and operated by Cecil Quintana and John Kirkpatrick, this gallery specializes in antiquities dated before 1940, including basketry, beadwork, and jewelry, and photography by Edward S. Curtis. Art appraisals, consultations, and installation services are offered here as well.

Ariel

Lelooska Gallery and Museum, 165 Merwin Village Road, 98603 (360/225-9735 or 360/225-8828). The gallery in the Lelooska family's compound offers art representing Native styles from Florida to the Yukon. Their extensive inventory includes many of their own creations and those of more than fifty other artists. Northwest Coast-style jewelry, masks, drums, prints, baskets, and paintings are featured in the main room of this rambling "trading post." Traditional and contemporary Indian–style clothing—fiesta skirts, Navajo shirts, Seminole patchwork, hand-knit sweaters—and consignment pieces from private collections are specialties of the gallery. There is a lot for browsers to see, and a wide price range for buyers. The museum,

located in another part of the compound, contains Native art and artifacts collected over the years by Lelooska and his family.

To get to the gallery from Interstate 5, drive ten miles east of Woodland on Highway 503 (the route to Mount St. Helens). The gallery and the museum are open limited days and hours. Call for information.

Enumclaw

MacRae's Indian Book Distributors, 1605 Cole Street, 98002 (206/825-3737). Row upon row of tables covered with books fill the floor space once occupied by the First National Bank of Enumclaw, and the walls of the former bank lobby are covered with shelves crammed with still more books. Ken MacRae maintains a unique, specialized inventory of publications on Native American culture approaching 2,500 titles, from the latest to the long-out-of-print. Some reprints of older classics carry his own publishing imprint. In spite of its size, he knows his inventory intimately and delights in helping both the random browser and the visitor who is looking for some particular book or magazine. A relatively few non-Indian volumes relate to the Old West, but MacRae does not carry fiction. He publishes an annual catalogue, which interested persons may request.

MacRae can be available from 10 A.M. to 10 P.M., seven days a week, but visitors are asked to make arrangements by telephone in advance. He is frequently away with a truckload of books at Indian and western shows, especially in California.

Tacoma

Curtright Gallery of Tribal Arts, 759 St. Helens Avenue, 98402 (206/383-2969). Jack and Jane Curtright's compact gallery specializes in pre-1930 North American Indian material, much of it woven, beaded, or carved. Also in stock are old photographs, paintings of the Westward Movement, cowboy memorabilia, and antiques. The gallery offers conservation services for wood items, manufacture of custom-made display stands, and restoration for woven baskets. Many of the vintage pieces have unique and interesting provenances, so it takes some time to view them all. The gallery's hours are limited, but the Curtrights accommodate appointments.

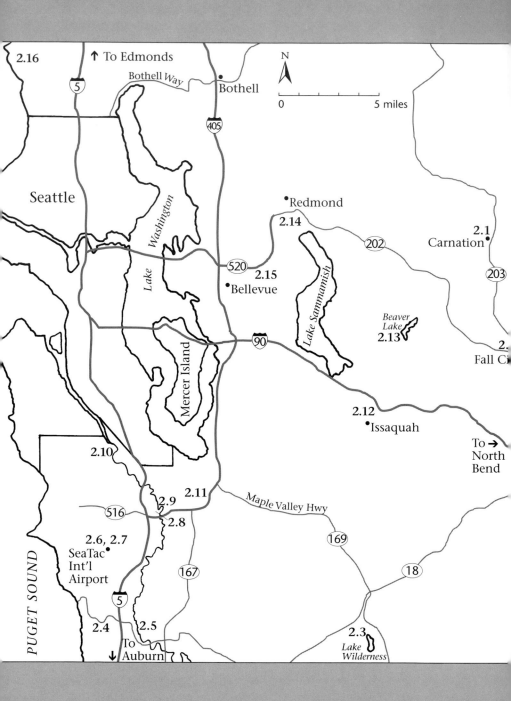

2. Metropolitan Seattle

The Outlying Areas

Sites

All locations are within twenty-five miles of Interstate 5 south and north of the city limits, and of Interstate 405 east of the city.

2.1 Carnation, County Branch Library Murals

2.2 Fall City Totem Pole

2.3 Maple Valley, Lake Wilderness House Post

2.4 Midway, Highline Community College Totem Poles

2.5 Kent, Old Fishing Hole Park Totem Pole

2.6 SeaTac International Airport Satellites, Multiple Objects

2.7 SeaTac International Airport, Gift Shop Panels and House Post

2.8 Tukwila, City Hall Panel

2.9 Tukwila, Fort Dent Park Panel

2.10 Tukwila, Fishing Weir Sculptures (projected)

2.11 Renton Center Totem Pole

2.12 Issaquah, City Hall Panel

2.13 Redmond, Beaver Lake Park Totem Poles and House Posts

2.14 Redmond, Marymoor Park Totem Pole

2.15 Bellevue, Highland Community Center Sculpture

2.16 Richmond Beach County Park Sculpture (projected)

2.1 King County Branch Library, 4804 Tolt Avenue (206/333-4398). When the county library branch was opened in Carnation in March 1976, it boasted several adornments in the Northwest Coast Native style by Steve Brown, one of the most highly regarded practitioners of that art in the area. Nearly twenty years later, these adornments still have a fresh look. Approaching the library from the street, the visitor sees, on a wall to the left of its entrance, the image of a large eagle that seems about to pounce on the nearby salmon, on which it has obviously set its desire. To the right of the entrance is a more complex painting that could have been the design for the face of a drum. Killer Whale is displayed in circular arrangement: its body split with two heads facing in opposite directions, dorsal fins flattened around the design arc, pectoral fins pointed inward toward the circle's center, flukes divided at the bottom.

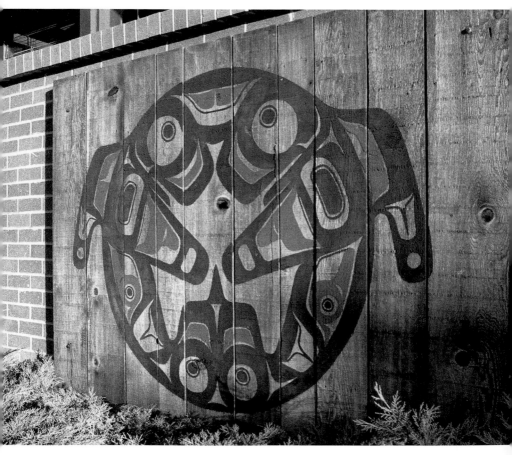

Carnation branch, King County Library, exterior wall panel by Steve Brown (2.1)

It would be easy to miss the next instances of Native-style art to be encountered here. Doubtless many people do. In shallow relief on the push panels of the entrance doors are two carvings on the outside of the library's outer doors, two on the inside of its inner doors. The combination of shallow carving and the absence of color gives the panels' somewhat abstract bird design (perhaps an eagle) a very quiet presence.

Inside the library, three paintings speak a bit more loudly. Over the stacks to the right is a bird with a double aspect: viewed in one way, the head of the bird is in frontal view, with wings extended on either side; viewed in another way, two bird profiles meet, head to head, with a wing extended behind each head. Nearby, over high windows, is what appears to be the grinning head of a Northwest Coast–style Bear. Next to the door that leads from reading room to restrooms is a framed print by Marvin Oliver, with the figure of Loon rendered both in formline style and in embossed reflection.

Once books have been selected, a visit to the circulation desk brings yet another painting into focus. Over the desk is one of the Coast's mythical creatures: a double-finned Killer Whale. Adjacent to the desk is a meeting room that has seven old Native baskets on an extended shelf over the room's entrance.

Fall City

2.2 Totem Pole, intersection of Southeast Redmond Fall City Road and Southeast 42nd Street. This pole at the west end of town has a quirky history. It was originally carved by a Salish Native in 1982, as a copy of a pole created by a Euro-American in 1934, depicting an age-old Haida or northern Northwest Coast legend.

Seattle structural engineer Hugh H. Hinds carved the original 45-foot pole, but when the pole required restoration, the Fall City Business and Professional Association arranged instead for a copy to be made by Herman Williams of Tulalip. Williams carved the replacement at the Tulalip Reservation, and it was trucked to Fall City for a 1982 dedication.

The story told by the pole is another tale of Raven, the legendary hero, bringing light to the world. Here, he procures a canoe from the Old Man of the Waterfall in order to rescue Moon Child, who was held captive by a very selfish deity. Raven is accompanied by Flying Frog, and together they snatch the Child and fling him into the sky, from which he lends light in the night to hunters and fishermen. The pole at the site is topped by Eagle and has images of Raven, his canoe and magic paddle, and a demon grasping Moon Child.

Maple Valley

2.3 Lake Wilderness House Post, 22500 Southeast 248th Street (206/296-4281). Once the centerpiece of Gaffney's Lake Wilderness, a private resort, this building is now the southeastern district headquarters of the King County parks system. Its house post, carved by Dudley Carter when the place was a resort, is in the structural center of the building and serves as one of its load-bearing elements. It is integrated into the system of roof columns, and two of the building's steel beams are inserted into the pole, which weighs ten tons and stands 35 feet tall and 5 feet in diameter.

It does not appear that Carter had any particular story to tell with this house post. The objects on it seem to be arbitrarily chosen, having in common that they are all associated with the general Northwest environment. Carter himself identified the figures as follows: the large humanoid figure at the top he called, enigmatically, "the Host and Founder," who gazes out upon Lake Wilderness and wishes he could give up his load-bearing responsibility and go fishing. The Mountain Hawk "keeps away evil," including "high-pressure salesmen," said Carter. Next are friendly and playful Mountain Goat twins. The Mourning Dove is a symbol of peace, and the Firebird keeps fire under control, subduing flames that rise between the horns of Mountain Ram, immediately below. Chipmunk is perched in one of Ram's great horns, reflecting on why the artist has left him tailless.

The rear of the column is also carved. At the top, by Carter's account, is Trillium, first flower of spring, and the eggs of Loon, whose behavior on the lake signals rain or sun. Frog is in the act of devouring Horsefly and, having done so, for some reason, feels equal to Mountain Lion in their common task of supporting the building's structure. Two abstract, mythical birds fill in spaces among the other figures.

Carter's description of this house post gives substance to our assertion, in the entry for Carter in chapter 6, that he often created his own world of myth.

Midway

2.4 Highline Community College, South 240th and Pacific Highway South. In 1975 carver Jim Ploegman, then and now a member of the staff of this college, supervised a group of Native American students in carving the totem pole that stands outside the Student Services Building (Building #6) near the entrance to the Highline campus. It was a training project, intended by non-Native Ploegman to pass on to those students the skills in

Native-style carving that he had learned during two years in residence at Taholah, the headquarters of the Quinault Nation. At the top of this impressive 30-foot entrance sculpture is Thunderbird, with a 26-foot wingspan, followed by a human face and the images of Bear and Frog.

In the interior of the campus, adjacent to the Artist-Lecture Center (Building #7) is a second pole, also supervised by Ploegman, bearing the images of Eagle, Killer Whale, and Bear. Around the perimeter of the building are four short posts, each bearing the wooden image of a copper and designed for the posting of notices. Unfortunately, the copper design is flawed: on traditional coppers there is a T-shaped ridge in the lower half of the shield; on these, the T has been turned upside down and placed in the upper half of the shield.

Between the Artist-Lecture Center and the Student Services Building is a covered walkway with two house post–style supports, one bearing the images of Eagle and Beaver, the other of Killer Whale (the dorsal fin is missing) and Bear.

In the foyer of the College Library (Building #25) is yet another Native-style carving, and this one is perhaps the most notable of the three in design and execution. It is a house post, perhaps 7 feet tall and 4 feet across its slightly convex surface, with a shallow notch at its top, where, in traditional use, it would have supported the beam of a longhouse. Unpainted, its shallow relief presents the complex image of a large bear, a human face between its ears and a humanoid figure on its body.

Kent

2.5 Old Fishing Hole Park Totem Pole, off the Kent-Des Moines Road at Meeker Street, just east of the Interstate 5 interchange. In 1989, "Crossroads of Continents: Cultures of Siberia and Alaska," a major exhibition of Northern Pacific Native arts and artifacts, stopped at the Seattle Center for several weeks, under the local auspices of the Museum of History and Industry (MOHAI). During its stay, artist David Boxley was commissioned by MOHAI to carve a totem pole as a public demonstration of one of the arts in progress. The pole completed and the exhibition concluded, MOHAI sold the pole to the City of Kent, which placed it in this attractive park, where it looks down on a large pond.

"Salmon and Cedar" is the name Boxley has given to the pole, which embodies elements of three unrelated legends. One concerns Eagle and Young Chief; a second, Raven's theft of a salmon supper; and a third, the origin of the mosquito.

In his strong Tsimshian style, Boxley has placed Eagle at the top of the

pole, obtruded wings pointed downward at the pole's sides, with a small human head atop Eagle's head and Salmon clasped against Eagle's chest. Below Eagle is Raven in human form, holding onto the tail of a large, downward-facing Salmon, as he rides the fish to its home beneath the water. Tsimshian legends frequently tell of humans who visit animal villages, successfully crossing the boundary into the animal world.

Below the human Raven is another humanoid figure, with black eyes and eyebrows, a black band across the nose and cheeks, and tiny figures representing mosquitos speckled across the band. This is a legendary cannibal spirit, the sparks of whose incineration became the ravenous mosquito. There may be something peculiarly appropriate about this image, given the pole's location in a wooded area near a pond!

The final figure is a man holding an adze and a mask, Boxley's tribute to the cedar and to all who transmute it into forms at once utilitarian and magical.

SeaTac International Airport

2.6 North and South Satellite Cafeterias and Cocktail Lounges. It would be interesting to speculate on how many of the people patronizing these airport cafeterias during the course of a given week are aware of the strange carved shapes that occupy the centers of the two dining areas. In spite of their spatial prominence—some three feet across, they reach to the ceiling—their very strangeness may make them virtually invisible to patrons who are primarily interested in a snack or a quick meal before boarding a flight.

In fact, these carvings are among the most accessible examples of really fine Northwest Coast Native-style art in western Washington. In 1972, Host International, Inc., the operator of the food and beverage facilities for the airport, commissioned Duane Pasco to create the house posts and panels that adorn these two cafeterias, as well as the smaller posts and panels that decorate the cocktail lounges. Someone else added the ersatz frosted-glass designs in the walls that separate lounges from cafeterias and attempt, quite unsuccessfully, to imitate the Northern formline style.

Unlike house posts that supported beams in a traditional longhouse, which were carved only on one vertical hemisphere of a cedar log, these have carvings all around. Each cafeteria post has major carved figures on each of its opposite sides, with additional smaller and vertical carvings between those major shapes.

In the North Satellite cafeteria, for example, one face of the post shows Raven taking off in flight from the head of Bear, with Frog on Bear's body.

The opposite side depicts Raven taking off from the single figure of a much larger Raven. Between the two main surfaces are narrow vertical panels, with two "diving" Ravens on either side. One wall of the cafeteria has a large floor-to-ceiling, carved and painted panel, depicting the formline figure of a bird.

The adjacent cocktail lounge has a single-sided house post against one wall, depicting Beaver with Eagle on its head. Six small, carved and painted panels, perhaps 20 by 24 inches, are recessed in the wall on either side of the post, each with a single compact formline figure. Partly obscured behind the working bar is a floor-to-ceiling, carved and painted panel of formline design.

In the South Satellite, the main figure on one side of the cafeteria house post is Dogfish (or Shark), identified by gill slits on what appear to be its forehead. Above that forehead is the horizontally extended figure of Halibut, serving as a kind of canopy over the shark. A smaller fish is held against Dogfish's body, and at the bottom of the pole is the upside-down figure of a man who appears to be getting a wild ride on the shark's tail. The large figure on the opposite side of the post is a Sculpin, again with a halibut canopy over its head, and on either side of Halibut are the heads of what appear to be two small harbor seals. The dorsal spines that usually identify Sculpin are located along the sides of the body, and there is a face in its tail at the bottom of the figure. Devilfish (or Octopus) is held in the sculpin's mouth and hangs against its body. Between the two main surfaces are narrow vertical panels with three "diving" salmon on either side. One wall of the cafeteria has a floor-to-ceiling, carved and painted panel of Northern formline design.

The adjacent cocktail lounge has a single-sided house post against one wall, depicting Man riding Killer Whale, with Octopus on his chest and a small Dogfish on either side of him. Eight small carved and painted panels are recessed in the wall on either side of the house post, each with a single compact formline figure (Octopus, Whale, Man, Seal, Dogfish, Starfish, Sculpin, Crab). Partly obscured behind a working bar is a floor-to-ceiling, carved and painted panel that appears to be Whale with a man on his body.

2.7 Northwest Gift Shop Panels and House Post, near Concourse B, Main Terminal. Considerably the worse for wear, vertical panels on the main entrance doors depict bird figures in Northern formline style. A large house post, displayed in the round in the center of the shop, is largely obscured by racks of note cards and shelves of souvenir kitsch. Again carved and painted in Northern formline style, one side represents a large bird (per-

haps Eagle), with a smaller bird between its "ears" and a human figure on its body. On the other side the main figure is Dogfish (Shark), with a human figure on its body. Like the North and South Satellite carvings, these are the work of Duane Pasco.

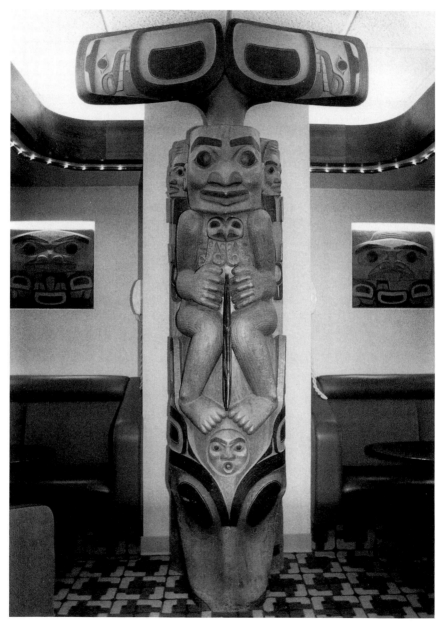

Duane Pasco's totemic figure of a man riding Killer Whale, SeaTac South Satellite (2.6)

2.8 Tukwila City Hall Panel, 6200 Southcenter Boulevard (206/433-1800). This panel by Makah artist Greg Colfax is one of the most striking pieces of contemporary public Native art in the area. It is also in one of the most obscure sites, likely to be seen primarily by motorists who are ticketed by Tukwila police and drop by the City Hall to pay their fines. The panel is located on an outside wall behind the City Hall building, just off a lower level drive and along a walk that leads to the police department's entrance.

The work, perhaps 35 feet long and 7 feet tall, done in characteristic contemporary Makah or Nuu-chah-nulth style, was commissioned by the Tukwila Arts Commission for this specific location. According to the Commission, Colfax chose three symbols—Eagle, representing Peace in its capacity to rise above an approaching storm; Sun, representing Truth revealed by the light of day; and Wolf, symbolizing Justice in the maintenance of law and order and of loyalty to leaders. If the symbolic connections seem a bit shaky, the piece itself is very strong. The three main figures were cut out and applied to the flat surface of the wall, creating a shallow-relief effect. In the center of the Eagle section to the left and of the Wolf section to the right, a striking three-dimensional humanoid mask protrudes, each part with hair and braids fashioned from rope fibers. Colfax has used red and black paint for some of the design elements and has chosen to leave some surfaces unpainted.

2.9 Fort Dent Park Panel, east end of Southcenter Boulevard. At the entrance to this attractive municipal park is a panel, raised on two posts, depicting a large Eagle of Northwest Coast design. Produced by artist Marvin Oliver in 1978, it is one of his earlier pieces, now in somewhat neglected condition, giving shelter to nesting starlings. Whatever the strength of its original colors may have been—and Oliver's colors are characteristically strong—they are now faded into pastel shades of pink and aquamarine within their black formlines. This panel might resemble the front of a Northern-style bent-corner chest, except for the fact that all of the spaces on the panel are not filled. Panel corners above the wings are devoid of design elements, and Northern artists characteristically filled the entire design field. The broad wings and the proportionally much smaller body of the bird are carved in shallow relief, but its head extends three-dimensionally out from the plane of the panel, a feature that was common on Northern chests.

2.10 Northwind Fishing Weir Myth Sculptures (projected), on the Duwamish River between Highway 99 to the west and the intersection of

Wall panel by Gregory Colfax, Tukwila City Hall. *Photograph by Lloyd Averill* (2.8)

East Marginal Way South and South 112th Street to the east. At this location are the remains of a fishing weir used in earlier times by the Duwamish Tribe. The King County Arts Commission is installing sculptures here that will re-tell the Duwamish myth of the Northwind Fishing Weir. In summary, the myth tells how Southwind's son and mother destroyed Northwind's village and weir, thereby creating the warm Puget Sound summer months. The white ice of winter stopped the people from fishing and symbolizes today's lack of Native fishing rights. The Southwind people are the Duwamish, fighting for their existence, their right to fish, and the survival of their culture in the face of the "white ice" (the non-Native culture) that covers the land that was once their patrimony.

Five artists were selected by the Commission to commemorate the weir. Susan Point plans to install a set of six 50-inch-high replicas of "spirit planks" that were traditionally used by shamans to recover lost souls. Along the east side of the river, Roger Fernandes will place three large boulders, carved with petrographic images representing the myth, related ceremonies, and the destruction by the builders of Seattle of the fishing site and the people it sustained. Caroline Orr and Jon Gierlich will install cedar-on-concrete benches with metal backs of basketry designs and text, recalling Grandmother, who, in the myth, kept alive the vision of restoration. Work by Jaune Quick-to-See Smith will focus on the continuing quest of the Duwamish people for federal recognition of their tribal status. The project is incomplete as of this writing.

Renton

2.11 Renton Center Totem Pole, Rainier Avenue South and South Third Place. The Duwamish people were, as the plaque accompanying this pole says, "Renton's original citizens." The Renton Center Merchants Association commissioned artist Jim Ploegman to carve this 30-foot pole, located in an open court in the middle of the mall, to honor Henry Moses (1903-69), who was Chief of the Duwamish, and by extension to honor the area's First People. Figures on the pole (reading down) are Eagle, with a small copper (symbol of wealth or prosperity) on its chest, Bear, Killer Whale, and Beaver.

Issaquah

2.12 Issaquah City Hall Panel, 135 East Sunset Way (206/391-1000). Seattle artist Marvin Oliver is understandably taken with the image of the leaping salmon, given the importance of the genus Oncorhynchus in the Native life and culture. Seven red-and-black leaping salmon, interspersed with three uncolored, embossed circles representing salmon eggs, filled one of his largest limited-edition prints. A very similar design is reproduced here on a large wooden panel, installed on the wall behind the chairs and above the heads of Issaquah City Council members as they deliberate in formal session. The embossed salmon eggs of the print have been reproduced here in bronze, with the same effect of adding a raised third-dimension to the flat two-dimensional surface of the primary design.

Redmond

2.13 Beaver Lake County Park, Southeast 24th Street and West Beaver Lake Drive Southeast. Two hundred years ago, the territory in which this site is located belonged to the Upper Inland Salish Indians. During the last hundred years it has been, in succession, a Weyerhaeuser Company holding, the C. L. Bartells's family home site, Dick Anderson's recreational resort, and a Catholic youth camp. Now as King County property, the mature coniferous forest and delicate wetlands in this place again reflect a Native presence. Five carved, Native-style art works were installed in December 1992, as a "1% for Art" project of the King County Arts Commission.

Two poles by Tsimshian artist David Boxley, assisted by Robert Leask and Wayne Hewson, depict Alaskan legends of the Beaver People and the Salmon People. Boxley's 35-foot Beaver pole features creatures of the Beaver and Bear legend, demonstrating how a tiny animal can defeat a stronger

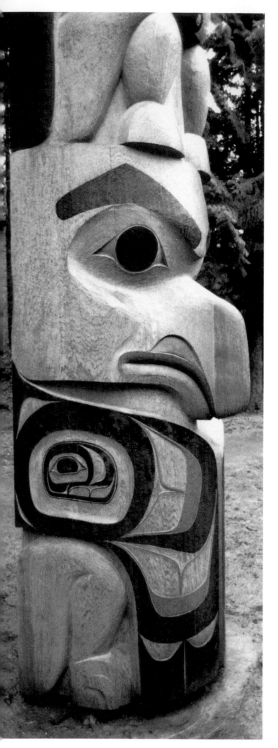

Detail of Salmon pole by David Boxley
at Beaver Lake County Park (2.13)

enemy by using her wits. The top
figure is Little Beaver herself, the
sole survivor in a village ravaged by
Grizzly Bear. The next figure is Trap,
excavated by Little Beaver, into
which she lured Grizzly Bear. Trap's
identifying characteristics are its
masked eyes and lack of a nose. Be-
low is Bear itself, biting a beaver.
The lower two figures are a hunter's
wife, who became a beaver, and
Chief Beaver. They are significant in
a legend in which the wife of the
hunter chose to spend her life toil-
ing in a stream rather than enduring
her husband's thoughtless neglect.

Boxley's 40-foot pole depicts inci-
dents from three salmon legends.
The top two figures are Eagle and
Young Chief. In one legend, Young
Chief thoughtfully rescues Eagle
trapped in bushes near a beach.
Eagle repays Young Chief's villagers
in a time of famine by dropping
salmon and other game animals for
them to feast on. The third figure is
Salmon Boy, whose legend teaches
that only when people honor the
salmon, and treat even its bones and
eyes with respect, will the annual
salmon migrations be assured. The
round face peeking out of a hole
below Salmon Boy is Mouse
Woman, a helpmeet to the Boy and
to all young people. Below her is the
image of the Boy on the back of
Salmon as he is being taken to the
Salmon People's village.

A third legend is that of Salmon
Woman, creator of Salmon, in
which Raven loses all of his posses-

sions, including his beloved wife, his storehouses of dried salmon, even his own handsome appearance, all because of his pride and boastfulness. Salmon Woman is the figure immediately below the Boy on Salmon's back. The bottom image is that of Eagle, a family crest of David Doxley's family, which the artist uses as his signature on this pole.

Three house posts were carved for the Beaver Lake Project by David Horsley and his assistant Lee Barr. The 10-foot posts, fashioned in the less-familiar Salish style and similar to the vertical beam-supports in early Salish longhouses, are installed inside the Cabrini Lodge picnic shelter. Not all that long ago, such posts stood at the south shore of nearby Lake Sammamish. The significance of the Salish images on the posts is somewhat more cryptic than that of the images on the Northern-style poles, even though the images themselves are easily recognized. One post, called "Man-Who-Eats-Lots-of-Fish," shows a man who has devoured one fish and is apparently ready to dispatch another. According to Horsley's explanation, its message pertains to the power to make things, perhaps troubles, disappear. Four images at its base are Bear, the symbol of power; Rabbit, a playful creature; Mouse or Rat, a destructive creature; and Spirit Board, an object of importance in Salish Winter Ceremonies.

A second post represents "Man-That-Becomes-the-Moon." As a child, the man was a star. Kidnapped by the Dog Salmon people, upon his return he created many changes. Below his crossed arms are four carved images: Eagle, symbol of leadership; Mountain Goat, a guide in daily life; Elk, a food giver; and Deer, a good-luck emblem.

The third post (see figure, page xxxvii) is an image of Soul, who is much like a white cloud. Below Soul are Drum, a square, percussive instrument decorated with a wolf's head; Otter, representing strong power; *tuhstud* (or *tust-ed*) poles, ceremonial stick implements; Hail, a teacher of bravery; song dots, mnemonic devices for recalling songs; Frog, an indicator of spring; and Wolf, a kinsman to elders.

The back of each post is patterned with song dots. The posts are painted in startlingly bright but traditional colors of red, black, and white. In modern art works like these, created to represent an ancient culture, it seems incongruous at first that images of solemn primeval figures should be painted in such shiny, titanium-based paints, but this practice is neither new nor without thought. Ages ago artists used whatever was at hand to capture the attention of their audiences. Native artists of the Northwest Coast eagerly acquired shiny mirrors, pearl buttons, and coins with which to enhance their costumes. Older, more subdued hues of ochre, cinnabar, and hematite pigments were quickly replaced by Chinese vermilion as soon as the early traders introduced it. Today many artists representing traditions

of the Zulu, Iñupiat, Navajo, and Maori infuse their works with high-tech and startling devices.

2.14 Marymoor Park "Legend of the Moon" Pole, east entrance. In 1978 the King County Arts Commission arranged for Dudley Carter to carve this 35-foot cedar work for the Marymoor Park site. It appropriates part of the legend of "Moon the Transformer," in which Moon creates peoples, transforms animals, and creates light. The tall, hollowed column represents a hole in the sky through which two granddaughters of Moon descended, with a baby, back to earth after the women had married two stars in the night sky. One of the star husbands had a white eye, the other a red eye, and their faces are carved on the outside of the column. Not done in traditional totem-pole style, this sculpture is one of Carter's own interpretations of the Indian lore that fascinated him. It is significant in its depiction of a myth belonging to the people who fished, hunted, and gathered along the Sammamish waterway where it now stands.

Bellevue

2.15 Highland Community Center Sculpture, 14224 Bel-Red Road. Salmon, Raven, and Woman gracefully posed between the fir trees and the log building on this busy road reflect the artist's keen sense of ecological and artistic balance. Tom Jay spent over two years in his Chimacum studio casting this 17-foot bronze sculpture representing the legend of Salmon Woman and Raven. As a founding member of Wild Olympic Salmon, an organization dedicated to the restoration and preservation of native salmon, Jay is sensitive to the implications of the legend, in which Salmon Woman bestows the gifts of wisdom and of salmon when she finds Raven lost and bereft in his canoe. The loving connubiality that develops between them is eventually jeopardized by Raven's greed and carelessness of this sacred gift, and Salmon Woman gathers up her precious bounty and disappears into the mists from which she came.

In this sculpture, Tom Jay has situated Raven (often referred to as the Transformer) with precision and skill. Approaching from the direction of the canoe's stern, the viewer discovers Raven paddling his Nootka sealing canoe, seemingly enraptured by Salmon Woman. With a step toward the bow of the canoe, a human presence is revealed within Raven's mask. Fantasy yields to bold and convincing realism. Before the masked paddler, Salmon Woman appears effortlessly to wield a magnificent ring of 132 salmon, representing the six species of the Pacific Northwest Coast Salmon. The delicately balanced scheme of the bronze artwork captures the precari-

ous nature of natural resources and romances and sleek canoes.

Richmond Beach

2.16 Richmond Beach County Park (projected), entrance at 20th Avenue Northwest and Northwest 191st Street, unincorporated King County. Nine young Salish Natives danced in a wide circle on a beach at the edge of Puget Sound, brandishing canoe paddles and evoking with their song the spirit of a water-borne culture. The scene might have been in the eighteenth or nineteenth century, but in fact it was in 1992, and the dancing was an anticipatory dedication of a place where ancient Salish traditions are to be commemorated. Richmond Beach, in the northwest corner of King County, was a Salish site until encroachment by white settlers and subsequent removal of the Salish to reservations. In respect for that Native claim, the King County Arts Commission will install on the beach a 10-foot welcome figure to be entitled "A Meeting of Cultures." Carved in semitraditional Salish style, it will in fact be two figures rather than the customary one: a woman, who carries a canoe paddle; a man, who stands behind her, wearing a woven cedar-bark hat, from which protrudes a small, headdresslike canoe. The original is to be carved in cedar and then cast in gypsum acrylic composite, chosen to resist vandalism in this sometimes lonely spot. The Arts Commission selected Joe Gobin (Tulalip), Jerry Jones (Tulalip), and Tony Johnson (Chinook) to carve the cedar original, with Steve Brown of the Seattle Art Museum as the coordinator. "A Meeting of Cultures" is expected to be in place early in 1996.

Museums and Tribal Centers

Auburn

White River Valley Historical Museum, 918 H Street Southeast, 98022 (206/939-2783). Finely woven baskets, utilizing readily available natural materials—shredded cedar bark, native grasses—are one of the fine achievements especially of Salish women. This small museum features a collection of some one hundred such baskets, mostly from the collection of Mrs. Charles Reynolds, who was the wife of the last Indian agent at the nearby Muckleshoot Reservation. A photographic display shows Native portraits and early Native activities, such as hop-picking, which took place in the fields nearby. As a community institution, the museum makes available a "Native Americans of Puget Sound Heritage Study Kit" for use in area class-

rooms. The kit includes a videotape on Native life in the Puget Sound region; audio tapes of traditional Native stories; a collection of artifacts (for example, beads, drum, model canoe, traditional clothing, a doll in a cradleboard); interactive lesson plans; and art lessons (for example, for braiding, painting a drum design, or making fruit leather). A museum shop carries books on local history.

North Bend

Snoqualmie Valley Historical Museum, Gardner Weeks Park, 98045 (206/ 888-3200). Local hop fields made the Snoqualmie Valley, at the turn of the century, a harvest-time gathering place for Native people from as far away as Alaska. Early migrant laborers came to pick the crop, traveling in families by canoe, down Puget Sound and up the rivers throughout a large area southeast of Seattle. Although the primary motive was economic, there was a serendipitous cultural consequence of these annual migrations. At a time when reservation life had tended to isolate groups of Native people from each other, these intertribal encampments near the hop fields provided the occasion for engaging in traditional activities: gambling, racing, singing, perhaps even potlatching (though the historical evidence for that is not clear), and simple socializing.

The museum, located as it is in the valley where some of these encampments occurred, has vintage photographs of the hop-picking activities, such artifacts as the metal tags given to identify pickers according to their productivity, and account books that record purchases made by Native people in nearby trading posts. The museum also has items related to the indigenous Snoqualmie people: baskets; local lithics (projectile points, hammers, a mortar, a stone club); and a copy of a Native doctor's rattle, carved by Jerry Kanim, last of the hereditary Snoqualmie chiefs. A shovel-nose river canoe, used by a local farm family and probably commissioned from a Native carver, is on display.

A museum publication, *28 Historic Places in the Upper Snoqualmie Valley,* by Kenneth G. (Greg) Watson, reports research that has identified some local sites that are associated with Snoqualmie creation myths. A few items—Puget Sound and Makah baskets, for example—reach beyond the valley. Although many of the museum's holdings relate to the farming and logging activities of white settlers in the area, persons interested in the Native culture are invited to call for an appointment, since most of the Native materials are not regularly on display.

Galleries and Shops

Edmonds

The Old General Store, *[illegible]* (206/771-2561). The store is located within the historic Old Milltown complex, a cluster of specialty shops made up to look like small-town America in the 1890s. Creaky wooden floors lead to the "General Store," with its contemporary Northwest Coast–style carvings and silver jewelry, as well as rare baskets and older artifacts. Work by Edward S. Curtis is featured, along with other old photographs and photogravures. Owners Bruce and Linda Colasurdo do appraisals on baskets and Curtis works and arrange for basketry repairs. The inventory of items, including folk art from other cultures, reflects the wide-ranging interests of the Colasurdos.

Bothell

Backstrom's Indian and Eskimo Art, 10716 Northeast 197th Street, 98011 (206/486-0541). The late Alan Backstrom and his wife Jeanette have been dealers in American Indian and Eskimo art since 1973, working out of their home in conditions that are informal and comfortable for their clients as well as for themselves. Jeanette Backstrom is continuing to serve those clients, specializing in basketry but often with other items in her changing inventory, including beadwork, trade beads, ivory, wood carvings from rattles to totem poles, occasional weapons, and Edward S. Curtis photographs. Most items are old, with contemporary works the rare exception. Purchase of individual items and collections will be considered, and appraisal services are available. All contacts with clients are by appointment.

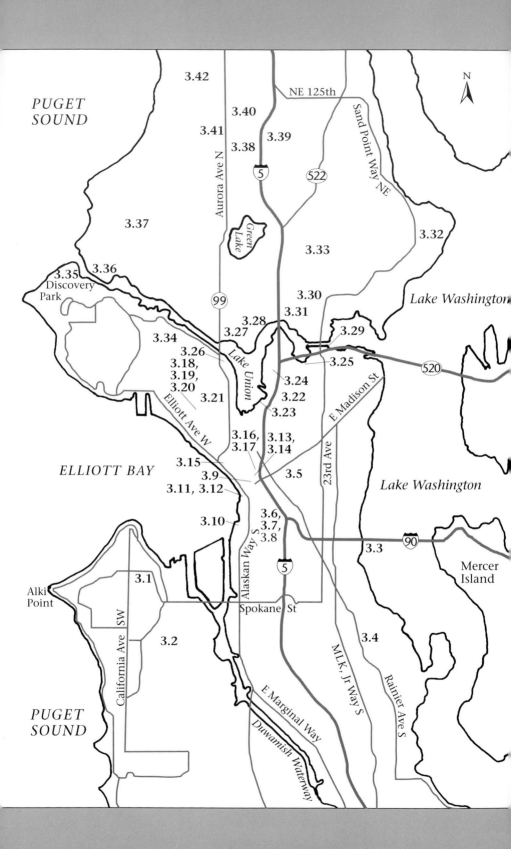

3. City of Seattle

Sites

All locations are within the limits of the city.

3.1 West Seattle, Belvedere Viewpoint Totem Pole

3.2 West Seattle, Rotary Vista Park Totem Pole

3.3 Interstate 90 Tunnel Facade Designs

3.4 Columbia City, Branch Library Sculpture

3.5 Youth Service Center Sculpture

3.6 Pioneer Square, Seattle Totem Pole

3.7 Pioneer Square, Bust of Chief Seattle

3.8 Occidental Park, Totem Poles and Figures

3.9 Various Downtown Locations, Salish-Design Tree Grates

3.10 Pier 48, Alaska Square Totem Pole

3.11 Pier 54, Ye Olde Curiosity Shop Entrance Poles

3.12 Pier 55/56, Blake Island Tillicum Village

3.13 Key Tower, Sculptures of Kwakiutl Coppers

3.14 Bank of California Collection

3.15 Steinbrueck Park, Pike Place Totem Poles

3.16 Washington State Convention and Trade Center, Totem Pole and Display Case

3.17 Various Downtown Locations, Hatchcovers

3.18 First Avenue and Denny, Metro Bus Shelter Painted Panels

3.19 Seattle Center Totem Pole

3.20 Seattle Center, Center House Panels

3.21 Seattle Public Schools Administrative and Service Center Totem Pole

3.22 Volunteer Park, Seattle Art Museum "Rivalry of the Winds" Sculpture

3.23 NOAA Pacific Marine Center Totem Pole

3.24 Eastlake Avenue East, Carved Cedar Panel

3.25 Boyer Avenue East, Totem Pole

3.26 Continental Plaza Motel Murals

3.27 Girl Scout Administrative Offices, Carved Figure

3.28 Ivar's Salmon House, Multiple Objects

3.29 Montlake Cut Totem Pole

3.30 University of Washington, Burke Museum Outdoor Sculptures

3.31 University of Washington, Ethnic Cultural Center Mural

3.32 Sand Point Naval Air Station Totem Pole

3.33 20th Avenue Northeast, Tlingit House Post

3.34 Seattle Pacific University Totem Pole

3.35 Discovery Park, Daybreak Star Indian Center, Multiple Objects

3.36 Ballard, Totem House Fish and Chips Totem Pole

3.37 Ballard, Ormbrek House

3.38 College Place North, Metro Bus Shelter Painted Panel

3.39 Northgate Mall Totem Pole

3.40 Northwest Hospital Campus Sculpture

3.41 Evergreen Washelli Cemetery Totem Pole

3.42 Broadview Branch Library, Wall Panels

3.1 West Seattle Totem Pole, Belvedere Viewpoint, Admiral Way and Olga Street. The original pole, perhaps 18 feet tall, which was raised on this site in 1939, was "one of the most photographed objects in Seattle," according to the pole's obituary in *The Seattle Times* in 1966, the year it was permanently removed because of irreparable decay. Originally presented to the City of Seattle in the late 1930s by J. E. Standley, founder of Ye Olde Curiosity Shop on Elliott Bay, it was then said to have been carved at Bella Bella in the middle of the nineteenth century. Experts now consider that it was probably a Southern coastal carving made for sale in the early decades of this century. In any event, it is highly unlikely that the successor pole, raised in 1966 and still at the Belvedere Viewpoint today, has received the same attention from photographers as did the original. If we were taking nominations for the ugliest pole in Seattle, this one would make the final cut, partly because of its graceless carving, partly because of its neglected condition. This replacement, carved by two Boeing engineers and intended to be a copy of the older pole, was dedicated on August 10, 1966.

Because the original pole allegedly came from the Bella Coola Beaver Clan, the new pole is topped by the figure of Beaver, depicted in traditional manner with a crosshatched tail and a chewing stick in its mouth. Next is what appears to be Bear, holding a fish in its paws and sitting on a small Killer Whale. Emerging from beneath Bear is Frog. Finally, there is a bug-eyed creature of undetermined identity (possibly a large frog) holding two small human figures.

3.2 West Seattle Rotary Vista Park Totem Pole, 35th Avenue Southwest at Southwest Alaska Street. In the Pacific Northwest, places that have awesome, sweeping views are favorable sites for commemorative monuments. They are also subject to the ravages of wind-driven rain, thoughtless visitors, and more wind-driven rain. The Rotary Vista monument, an 18-foot totem pole on just such a site in West Seattle, was only sixteen years old when it had to undergo cosmetic reconstruction because of the harsh environment at this scenic knoll. The original carving was completed in 1976 by Robin Young, whose heritage extends to the Cheyenne River Sioux, Gros Ventre, and Mandan Native nations. He chose to express his admiration for the art of the Northwest Coast here by carving the familiar images of Thunderbird, Killer Whale, Beaver, and Hawk. In 1992 the Seattle Arts Commission arranged to take the pole down, patch the dry rot, and apply protective substances. A new dorsal fin for the whale and fresh paint were paid for by the West Seattle Rotary Club. The pole now appears much as it did when it was originally presented to Seattle by that group.

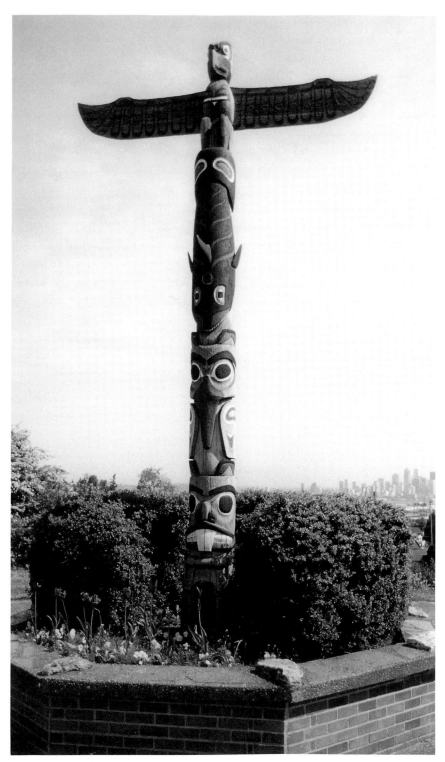

Rotary Vista Park totem pole, carved by Robin Young (3.2)

3.3 Interstate 90 Tunnel Facade Designs, west end of the Mercer Island Floating Bridge. Traveling at the usual speeds across this bridge span, if you look quickly—preferably with someone else driving—you will see relief designs of Northwest Coast Native derivation on the tunnel facades as you enter Seattle. It is easier to see James Schoppert's 1988 creation, directly ahead as you enter the tunnel westbound, than James Fitzgerald's 1938 shapes over the tunnel's opposite side, which are virtually invisible to the receding traffic exiting the tunnel eastbound.

Fitzgerald was one of Seattle's most prominent and popular sculptors, particularly known for his fountains, which are found all over town (for example, at the Intiman Theater in the Seattle Center and at the downtown Plymouth Congregational Church). His panel on the north side of the eastbound exit from Seattle contains design elements obviously drawn from the Northern formline tradition, whereas the panel on the south side of the exit is of Asian origin, suggesting Seattle's dual cultural orientation. Between the two is a whale-decorated panel with the words "City of Seattle: Portal of the North Pacific."

James Schoppert was a prominent Tlingit artist who lived in the Seattle area until shortly before his untimely death in 1991. His westbound tunnel designs are very much like his paintings, adopting elements from the traditional Northern formline, but using them to create abstractions by breaking them up in nontraditional ways. Between the two sides of his panels are the words "Seattle—Portal to the Pacific."

3.4 Columbia City Branch Library Sculpture, 4721 Rainier Avenue South. Artist Marvin Oliver, who is of Quinault descent, chose traditional western Washington design themes for this whale-fin sculpture, located on a greensward behind the library. Entitled "Spirit of Washington," the sculpture, perhaps 9 feet tall, stands on a 5-foot piece of faux rock. A human figure with a round face (cast in glass), reminiscent of the faces on Salish wood sculptures, stands in the bronze fin. Its clothing bears geometric designs of the sort that are found on baskets and carved bowls. The two sides of the fin are mirror images. The work was installed in 1992 under the sponsorship of the Seattle Arts Commission.

3.5 Youth Service Center Sculpture, East Remington Court, between 13th and 14th avenues. Marvin Oliver was awarded a commission by the King County Arts Commission for a combination sculpture and landscape design, entitled "Spirit of Our Youth," for installation at the King County Youth Service Center. Oliver cast in bronze a 50-foot dorsal whale fin, with a Salish Thunderbird figure on each side of the fin. He chose the image of

the Thunderbird because it symbolizes both transcendent power and the power of the individual, and is thus a visual metaphor for hope and prosperity. The ground surrounding the fin was shaped to suggest the wave pattern that would be created by the passage of the fin through water. The site, used previously as an exercise facility for young people detained at the Center, has been converted to a small public park, and a new exercise facility has been created elsewhere on the Center grounds.

3.6 Pioneer Square, Seattle Totem Pole, First Avenue South, near the intersection of Yesler Way and James Street. The story of the opportunistic larceny of a group of vacationing Seattle businessmen in 1899 that resulted in the city's first publicly sited art work has been told many times. A small book, *The Seattle Totem Pole* (Seattle: University of Washington Press, 1979) by the late anthropologist Viola Garfield, tells the story fully and is available in local shops, so only a brief account is needed here. The businessmen, coming upon the Tlingit village of Tongass in Alaska, found it empty of its inhabitants, so those entrepreneurs helped themselves to a 50-foot totem pole and shipped it home. In fact, the villagers had merely moved temporarily to their summer encampment, as they had done every year since there was a village. Whether the visiting whites really thought the place was abandoned, as they later claimed, or merely took a rather permissive view of Native property rights, is perhaps debatable. In any event, in spite of the fact that a fine was subsequently levied against the souvenir hunters, the pole was never returned to Tongass.

Damaged by fire in 1938, the original was removed and replaced with the present copy, primarily the work of Tlingit carvers Charles Brown and William H. Brown. In 1973 the pole was taken down again and moved to the Seattle Center, where Jack Hudson, a Tsimshian carver now from Metlakatla, Alaska, steam-cleaned the pole and removed the old paint ("The colors were all wrong; they weren't Indian colors," he said), recarved one Raven's wing, cut off the bottom at ground level and carved a groove 16 feet up the back to fit a new steel-beam mount, and repainted the whole before it was returned to its Pioneer Square location.

Its figures tell the story of Raven, who stole the sun and the moon from his miserly grandfather, Raven-at-the-Head-of-the-Nass, and released them, thereby bringing light to the world. Raven, at the pole's top, has a crescent moon in his beak. Then, in descending order, come Woman holding her frog child; Frog, her husband; Mink; Raven again; Whale, holding a seal in its mouth; and finally Grandfather Raven—all characters from the world of Tlingit myth.

3.7 Pioneer Square, Bust of Chief Seattle, near the Seattle Totem Pole. Not Native or Native-style art, this 1909 bust by sculptor James Wehn nevertheless portrays a Native leader who gave more than his name to the city. The Chief's name, in fact, was Sealth, but in the mispronunciation of that Native word by non-Native locals, it has won Seattle.

As a boy, Sealth saw the arrival here in 1792 of Captain George Vancouver, and as the premier chief of the Puget Sound tribes, he gave voice to Native interests in December of 1854 at a Seattle meeting when the federal government conveyed its intent to acquire Native lands and to move their inhabitants to reservations. In the circumstance of overwhelming federal power and of Native vulnerability, it would have been easy for Chief Seattle to become a sycophantic voice. Instead, in his formal response to Governor Isaac Stevens, then newly appointed Commissioner for Indian Affairs for Washington Territory, he provided a classic example of what it means to "speak truth to power." While he could not resist, neither would he pretend to a false camaraderie with the invader. This is the way he concluded his remarks: ". . . when the last red man shall have perished from the earth and his memory among white men shall have become a myth, these shores shall swarm with the invisible dead of my tribe, and when your children's children shall think themselves alone in the field, the store, the shop, upon the highway or in the silence of the woods, they will not be alone. . . . The white man will never be alone. Let him be just and deal kindly with my people, for the dead are not altogether powerless."

The popular forms in which Sealth's speech have been circulated since the 1960s, especially within ecological circles, are clearly distorted and represent the Chief referring to events—mass destruction of the buffalo, blighting of the landscape with telephone wires—that occurred long after his death. But the words attributed to Sealth do give exemplary expression to Native respect for the land. A full account of the controversy and the speech itself are eminently worth reading, especially now that the speech has been reconstructed in a Native Puget Sound language and translated into English by Lushootseed scholar Vi Hilbert in *A Time of Gathering* (see chapter 10), from which the above quotation is taken (pp. 265-66).

3.8 Occidental Park Totem Poles and Figures, Occidental Avenue South, between South Washington and South Main streets. Two 12-foot figures, abstracted from the aboriginal forest setting where they would be at home, now face each other in an alien urban landscape. Tsonoqua (1973) is a mythical forest being, who tries to lure children to her attractively furnished house so that she may eat them. Mothers would tell their miscreant offspring, "If you're not good, Tsonoqua will get you!" Fortunately, the gi-

antess was slow-witted and rarely successful in her quest for tender young flesh. She is traditionally depicted, as here, with a huge head, pendulous breasts, outstretched hands, and pursed lips through which she cries "Hu hu" to attract her would-be victims.

Opposite is a giant figure of a standing Bear (1974), rendered with characteristic Northwest Coast fierceness.

Nearby are two poles. One, 20 feet tall, depicts Man Riding on Tail of Whale (1971). It is difficult to know whether the expression on the man's face is ecstasy or terror, but given the fact that the one sometimes transforms into the other, there may be a suggestion of both. The second pole, Sun and Raven (1973), is yet another sculptural rendering of the myth of Raven stealing the sun and the moon. At the top of this 32-foot pole, carved for the 1974 Spokane World's Fair, is Raven with Moon in his beak, and at the bottom is Raven holding Sun. Immediately beneath is the front of a Northern-style bent-corner box, in which Sun and Moon had been kept until Raven liberated them.

All four of these sculptures were carved by Duane Pasco. Three— Tsonoqua, Bear, and Sun and Raven—were commissioned by Seattle art dealer and entrepreneur Richard White for his restaurant, Kiana Lodge, on Agate Passage (see entry 4.2). White has since donated the sculptures to the Pioneer Square Association, which raised them in their present location in 1987-88, and Kiana Lodge has a new owner.

3.9 Salish-Design Tree Grates, Third Avenue between Yesler and James, in front of the Seattle City Hall, and Ninth Avenue between Olive and Pine, in front of the Convention Place Metro Station. These tree grates—six of them on Third Avenue and one on Ninth, in the space between sidewalk and street—were designed by Salish artist Susan Point in 1988. The circular design in the center of the grate represents a modified spindle whorl, which is classic for Salish art, and the square border of the grate also contains Salish design elements. Two rows of bird shapes face outward, their bodies incorporating the oak leaf and acorn. The trees, whose bases are protected by these metal grates and whose trunks emerge through the hole in the center of the spindle-whorl design, are northern red oaks. Tree grates, here and elsewhere in the downtown area and incorporating a variety of design styles, were a part of the Downtown Seattle Transit Project.

3.10 Alaska Square Totem Pole, Pier 48. The old site of the Alaska Marine Highway System on Seattle's waterfront still has vestiges of its ties with the forty-ninth state. A 32-foot totem pole, carved by Natives from the Port Chilkoot–Haines area, stands facing northward in the tiny Alaska Square

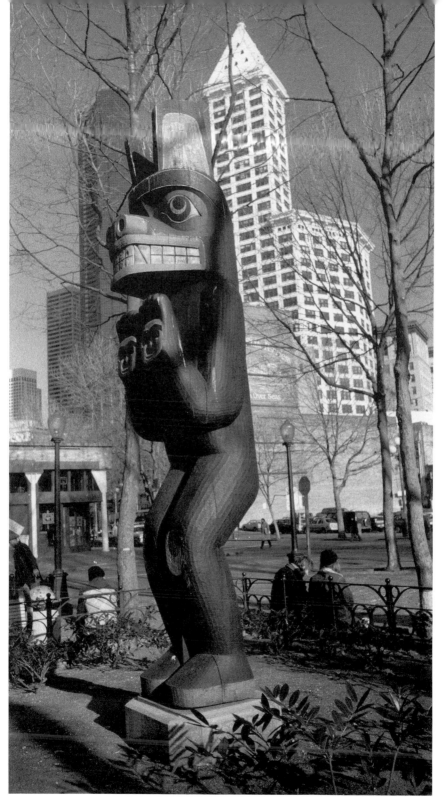

Occidental Park Bear figure by Duane Pasco (3.8)

Park at the pier. The park was built by Ohno Landscape Construction Company in 1975, at a cost of some $68,000. In that year, Native artisans from The Alaska Indian Arts, Inc., were awarded a commission to carve the pole by the Port of Seattle. Alaska Indian Arts was spearheaded by Carl W. Heinmiller, who, with four other World War II veterans, purchased the U.S. Army's old Chilkoot barracks near Haines. There, Natives of Haines, Klukwan, and other Tlingit areas studied indigenous arts that Heinmiller felt were in danger of being lost.

This pole's principal carvers, John Hagan, Ed Kasko, and Cliff Thomas, also carved and painted seven large red-cedar panels, which adorned the exterior of the Alaska Marine Highway System's headquarters before it was moved from Pier 48 to Bellingham. The panels, depicting Beaver, Frog, Raven, Eagle, Killer Whale, and Eagle-Spirit Man, are currently housed in corridors, in a conference room, and in storage at Port of Seattle offices and are accessible to the public only by special arrangement.

The images on the Alaska Square pole represent attributes of Alaska and her Native people. It is topped by Eagle, a major Tlingit crest. Immediately below, indicative of Alaska's great size, is Bear who holds a copper (or *tinah*), indicating Alaska's vast potential wealth. Killer Whale portrays strength; Hawk depicts sharp eyesight and perception

Alaska Square totem pole at Pier 48, carved by Alaska Indian Arts, Inc. (3.10)

of the future; Bear holds Mosquito between its paws, warning people to be gentle. At the bottom of the pole is Strong Boy rending Sea Lion in two, reference to the story of a boy who was ridiculed for being lazy but who secretly strengthened his body until he was able to kill a huge sea lion with his bare hands, thereby avenging his uncle's death and becoming a respected leader of his people. (Compare this latter image with one at entry 3.33.) The pole appears serene and determined in its homage to the Alaska-Seattle connection, despite the noisy elevated viaduct behind it and the occasional homeless snoozer at its base.

3.11 Ye Olde Curiosity Shop Entrance Poles, Pier 54, Alaskan Way (206/ 682-5844). "Curios" is indeed the watchword in this shop, crowded as it is with an enormous array of odds and ends, including the Lord's Prayer engraved on a grain of rice, genuine shrunken human heads, and the mummified body of a 5-foot, 11-inch man. The shop is on every tourist's itinerary. Although it features Native-style souvenirs that range from knick-knacks to the occasional serious piece of art, the best pieces of Native work are on the shelves high above the counter level in the Shop's own private collection, which is not for sale.

Originally opened on Seattle's waterfront in 1899, it has been in its present location for only a few years. The totem poles at its entrance were put in place at an earlier site for the 1962 Seattle World's Fair and recently moved to this new location to give it a familiar identity. Carved by Otis N. Baxter, who was of Makah lineage, the two poles are identical, representing (in descending order) Raven, Bear with Salmon, and Young Bear at the bottom. Across the top is the elongated figure of a sea monster, supported by the poles. Smaller poles are attached to the walls on either side of the entrance, and three additional smaller poles are located on the north wall of the Shop.

3.12 Tillicum Village, Blake Island, from Pier 55 and 56, Seattle Waterfront (206/443-1244). Having passed its 30th anniversary, Tillicum Village qualifies as an established Seattle-area institution. In addition to the name by which it has been known through the years (Tillicum is the Chinook Jargon word for "friendly people"), more recently it has added the designation of Northwest Coast Native American Cultural Center. Its management clearly has a mission to make aspects of the region's Native culture accessible to residents and visitors as a two-hour experience: one that includes a dinner of salmon roasted in the traditional way, in a structure that is reminiscent of the longhouse of the Northwest Coast, with its attendant poles, paintings, and artifacts, in preparation for a dramatic performance that

uses masks, robes, drums, and whistles to tell Native stories.

The tour boat that leaves Seattle's Piers 55 and 56 has Blake Island Marine State Park, eight miles away and the site of the "village," as its destination. Approaching its beachfront location, one can see the large, painted house front, copied from a house in the Kwakiutl village of Newitti; the slim totem pole beside it that is taller than the house itself; the dramatic entry sculpture with twin vertical Lightning Serpents and Thunderbird between them at its top; and other smaller carved objects scattered over the green lawns in front of the main building complex. Entry doors are carved and painted with Eagle and Beaver designs. Inside the foyer area are more freestanding carvings, a Salish-style canoe, and display cases containing masks, baskets, and rattles, with one or more Native artists-in-residence at work on their masks, baskets, or jewelry.

Native people—especially artists, most of them Nuu-chah-nulth from Vancouver Island, and notably the late Hyacinth David and his sons—have been a part of this enterprise from its beginning, and the young actors and dancers in the stage production, produced by Greg Thompson Productions, are from Native families. The Tillicum Village Dancers have appeared in episodes of CBS-TV's "Northern Exposure," which supposedly takes place in Alaska's Tlingit country. A videotape of Edward S. Curtis's classic "In the Land of the War Canoes" is available for viewing following the performance.

Tillicum Village, along with the Lelooska Foundation, is the most comprehensive experience of Native art and culture publicly available in western Washington. See related entries in chapter 9.

3.13 Key Tower, Sculptures of Kwakiutl Coppers, 800 Fifth Avenue. Unfortunately obscured in a narrow space behind the main-floor elevators to the parking garage, these representations of coppers, the most powerful symbols of wealth and prestige on the Northwest Coast, are elegantly sculpted of adze-textured cedar and polished brass by Seattle artist Barry Herem. There are five objects, some perhaps 6 feet tall, in the glass case that is approximately 9 feet by 25 feet. Fortunately, the back walls of the two elevators are made of glass, offering an opportunity to get some distance and perspective on the objects from inside one of the cabs—at least until someone comes along who insists on using the elevator to descend to the garage below.

In addition to the fine aesthetic qualities of the sculptures, this is an excellent educational resource for anyone who wants to understand what coppers were and how they functioned, especially in Kwakiutl society. Shield-shaped and made of sheet copper in traditional times, they had a

raised, horizontal bar across the midsection and a vertical bar from midsection to the bottom. Although there are other plausible explanations, the most likely is that the shape is a human metaphor, the two bars representing the human skeletal structure.

If a chief were to break it up with great show and ceremony, it would have been a demonstration that he had such wealth that he could afford to destroy at least a piece of this, his most valuable possession, and might have been a dare to a rival chief to demonstrate a capacity for similar extravagance. Herem has fashioned his five figures to show the order in which coppers were customarily broken, cutting off one quarter at a time until only the T-shaped "ribs" were left.

A very useful wall-text explains all this and is accompanied by an Edward S. Curtis photograph of a Kwakiutl chief in ceremonial dress, holding a copper.

3.14 Bank of California Collection, 910 Fourth Avenue, 98164 (206/587-6100). Though comparative figures do not exist, we venture the guess that the Bank of California has the largest corporate collection of Northwest Coast Native art in the Seattle area. And the bank's officers are to be congratulated for the new, more accessible arrangements that were made in the spring of 1995 to display it and to share it with a wider public.

The north end of the main banking lobby, just off Fourth Avenue, now brings together objects that earlier were dispersed over a number of locations in the building. It is a collection that includes some quite notable older pieces: a Tlingit globular rattle; a Chilkat blanket; a Kwakiutl button blanket (c. 1929); a mountain sheephorn spoon (c. 1880); argillite poles and platter (c. 1916); a Northern bent-corner box; a Hamatsa mask, a Tlingit dance mask, and a variety of other older masks; jewelry of beads and of sterling; a large number of Curtis prints; and more.

There are also some notable contemporary pieces: prints by Robert Davidson, Joe David, Tony Hunt, and Duane Pasco, and masks by Pasco.

Making all of these things readily available represents admirable corporate stewardship of an important regional cultural resource.

3.15 Victor Steinbrueck Park, Pike Place Market, Totem Poles, Western Avenue at Virginia Street. Two 50-foot poles tower over the small park dedicated to the memory of a distinguished Seattle architect, and over the nearby Pike Place Market. Framed by the panorama of Puget Sound and Olympic Mountains, they make a statement about the connection between this city and a Native heritage that stretches along the northerly waterway from here to southeastern Alaska.

One pole is in classic Haida design, the figures strongly sculptural and organically connected. At the top is Raven, holding a Salish spindle whorl of the sort widely used by Puget Sound Native people; then a humanoid figure holding a copper, which is a kind of shield fashioned of that metal and signifying great wealth; then the head of a smaller humanoid; Killer Whale (sometimes called Blackfish), with a human face in its blowhole; the head of a small Raven; and, finally, Bear holding Hawk. Based on a concept by Marvin Oliver and a tree selected by Oliver, the carving was done by James Bender.

In contrast, the second pole is bare of representation, except at the very top where there are two 8-foot figures representing a man and a woman in farming dress, honoring the Pike Place farmers' market below. Each figure wears a badge with the inscription, "Honored Farmer—1984." James Bender, also the carver of this pole, designed it with the help of architect Victor Steinbrueck.

3.16 Washington State Convention and Trade Center, 800 Convention Place (206/447-5000).

Two locations within the Center are worth the attention of visitors who are interested in the regional Native arts. On Level 1, between the two main escalators, is a classic Kwakiutl entrance pole, an object worthy of the term "monumental" art. It once made an impressive, even fearsome entrance to the Sea Monster House at Seattle's Pacific Science Center. That Center's artifacts have more recently been transferred to the University of Washington, but since the Burke Museum at the University cannot accommodate its height, this pole is on more or less permanent loan in its present location. Here, between the vertically rising escalators, it looks even taller than its 35 feet in space barely high enough to accommodate it without alteration. It was installed in this spot with appropriate ceremony in mid-summer 1994. The house front to which the pole was originally attached is described in the Burke Museum entry under "Museums and Tribal Centers" below.

The pole is in the shape of Whale, head down, mouth open wide to create a 7-foot entrance through which, in traditional times, resident clan members would have gone in and out of the house. Whale has a rather short and narrow dorsal fin, in contrast to the long upward sweep of its pectorals. The shapes of the fins and the white spots painted on the animal's body are all characteristics of a baleen whale (*gwoyim*, in Kwakwala). Riding on Whale's back is the full figure of a whaler holding a harpoon. Above the man's head and emerging out of Whale's flukes is Raven, wings extended, beak open, almost as if in attack. This is Raven with an attitude!

This entrance pole is a detailed reproduction of one originally owned by the Snow family for its hereditary house on Gilford Island, British Columbia. The formline shapes on Whale's mouth, face, and pectorals, on the whaler's tail, and on Raven add the distinctive Kwakiutl green to the red and black that characterize more northerly art. The original pole was carved by the distinguished Kwakiutl artist Mungo Martin; the reproduction by Steve Brown, with the assistance of Martin Stewart, Michael Freeman, and Bill Holm.

Continue on up the escalator to Level 3, and on the far left is a Burke Museum display case, offering an impressive sample of the larger riches to be found in the Thomas Burke Memorial Washington State Museum itself, located on the University of Washington campus. This case, located adjacent to room 303 in the Convention Center, presents a cross-section of the Burke's collection. Perhaps half of the space is devoted to pieces representative of its Northwest Coast Native holdings. Also represented are artifacts from other Pacific Rim cultures, along with samples from its natural history collections (entomology, geology, ornithology, paleontology). The contents of the case are changed from time to time.

3.17 Hatchcovers, northwest corner, Fourth Avenue and Columbia Street; southwest corner, Second Avenue and Virginia Street; northwest corner, Second Avenue and University Street, outside of the Seattle Art Museum entrance; and in twenty-nine other city locations. Seattle Arts Commissioner Jacquetta Blanchett, taken by hatchcover art she saw in Florence in the 1960s, and Paul Schell, director of Seattle's Community Development Department, who thought it practicable to replace some of the city's worn-out hatchcovers, conspired in the commissioning of hatchcover art by three artists. One of them was Nathan Jackson, a distinguished Tlingit artist, who created a circular Whale design of the kind that might have adorned the surface of a Native drum. There is the broad head and snout of Whale, topped by a round blow-hole. The creature's body continues around the circular form, with a pectoral fin wrapped into the design's center, and one of the flukes bringing the circle to completion, almost touching the snout. How many of the other twenty-nine covers can you find?

3.18 Metro Bus Shelter Painted Panels, north side of First Avenue North at North Denny Way. An expression of collaboration between Metro and the King County Arts Commission, the distinctive mural created in this bus shelter by the well-known Salish artist Susan Point is part of a project known as "A Meeting of Cultures." Point says that the location of this shelter is near a site where, in traditional times, local Salish people erected

Cast iron hatchcover, found
at various downtown locations;
designed by Nathan Jackson.
Seattle Arts Commission (3.17)

aerial nets for catching ducks on their habitual flyway over lower Queen
Anne Hill from Lake Union. The spindle whorl–shaped design here shows a
Native person holding a large net, on top of which are two sawbill ducks.
The panels are intended to give the impression of looking through a win-
dow into the past. A surrounding landscape shows how the land once
looked. Traditional Salish weaving motifs are also integrated into the mural.

Born in 1952, Susan Point lives in Vancouver, British Columbia. Known
especially as a prolific producer of limited-edition prints in the Salish style,
she is also an accomplished carver, painter, and engraver.

3.19 Seattle Center Totem Pole (206/684-7200), across from the southwest
corner of Center House. Between 1969 and 1971, Duane Pasco was at 'Ksan
Village near Hazelton, British Columbia, teaching at the Gitanmaax School
of Northwest Coast Native Art. It was during this period that he was associ-
ated with Tsimshian artists Victor Mowatt and Earl Muldoe and enlisted
their assistance in carving this 30-foot pole, raised here in 1970. Reading
from the top, its main figures are Hawk, Bear holding a salmon, Raven, and
Killer Whale.

3.20 Center House Panels, Seattle Center (206/684-7200), north stair-
case, third-floor foyer. A series of five panels, titled "Spirit Dancing in the

Smokehouse," depict a Salish ceremonial in obscure and smoky imagery. Ron Hilbert/Coy carved, burned, and painted these works on a "1% for Art" commission in 1989.

The panels illustrate the moods, costumes, and activities characteristic of supernaturally charged Salish dancers in northwestern Washington and southern British Columbia. The spirit dances depicted were "given back" to tribal members by elders and ancestors in 1910 after years of severe restriction in the United States. Canadian ceremonial prohibitions, imposed in 1884, were not lifted until 1951. Within recent decades the spirit-dance tradition has been resurgent but has also become intensely private. Since nontribal people rarely witness these ceremonies, and photography is not allowed, artist-created depictions such as these panels may be the only glimpse we are permitted of the unique ceremonies.

All of the dance scenes take place in the dim interior of the smokehouse, with its bare floors and flickering fires. The first panel depicts new dancers with staffs and red scarves. In the second panel, a warrior-dance initiate wears a headdress of twined strands of wool, which cascade down around his upper torso from a raised crown, completely covering his face. He also wears wool strands around his ankles. Panel three depicts healing songs, with dancers in red body and face paint and costume. As in other images, drummers beat hand drums. The fourth panel shows a warrior with black face paint, a black tunic decorated in inherited designs, wooden pendant war clubs or paddles, and leggings. A headdress nearly covers his face. The pendants lend visual and aural accents to the dance movements. The dance indicates the physical magnitude of spirit possession and suggests the dancer's vitality and skill, of life within and power to heal and help others. Healing power is also the subject of the final panel. Here Hilbert/Coy illustrates the use of *squed-alich* (power) boards, a unique Salish spiritual rite. Drummers are seen in the dimly lit ceremony.

Spirit dancing among Salish people is powerful today in its resurgent form. It is a religious prerogative, sign of Salish identity and bearer of cultural values, and an affirmation of personal and group worth.

3.21 Seattle Public Schools Administrative and Service Center Totem Pole, 815 Fourth Avenue North. Morrie Alexander's pole, standing at the entrance to Seattle's public education nerve-center, is a tribute to teaching and a memorial to the Lummi artist himself. As a visiting artist for the Washington State Cultural Enrichment Program, Alexander had been an inspirational carver and educator for many students in the public schools. In 1973, on his way to the dedication of this particular pole, he was killed in an automobile accident in Bellingham. Born in 1915, Morrie Alexander

had learned carving from his grandfather, Jack Pierre. His first commission consisted of 3,000 miniature totem poles which were to be sold at the Century of Progress Exposition in Chicago in 1933, for which he was paid twenty-five cents each. Later, the Bureau of Indian Affairs commissioned him to carve poles for Presidents Franklin Roosevelt and John Kennedy.

This 20-foot pole depicts Raven with down-turned beak and Bear holding a fish. The figures are carved in Alexander's typical style, with shallow relief and with haunting, straight-browed faces within the bird's shoulder joints.

3.22 Volunteer Park, "Rivalry of the Winds" Sculpture, behind the Seattle Art Museum building. A battle between wood sculpture and the elements has been waged here for decades. Hail and winds, opportunistic birds, and even well-meaning viewers have left their marks on this 10-foot sculpture carved by Dudley Carter from Western red cedar. Once located in the central Garden Court inside the Museum, presently it stands protected by a formidable wreath of holly behind the Museum's Volunteer Park building. This is the first commissioned piece, and the first major axe-hewn work, that Dudley Carter undertook. It was done in 1929 at the invitation of Museum president Dr. Richard E. Fuller and his mother, Mrs. Eugene Fuller. In 1932 it was borrowed by a chief of the Lummi Tribe during a convention of the Federation of Northwest Indians, held in Everett, and was subsequently given to the people of Seattle by the Fullers.

"Rivalry of the Winds" depicts part of the Duwamish legend "North Wind and Storm Wind." The uppermost figure is that of the warm, gift-bearing South Wind (or Chinook Wind), who wooed the daughter of Mountain Beaver. A beautiful maiden, the middle figure, is shown receiving from South Wind a basket of salal berries. The third and lowest figure is cold, forlorn North Wind, who also desired Mountain Beaver's daughter but as a suitor brought her no gifts. South Wind's thoughtfulness caused the people to give the girl to him, thereby causing North Wind to rage and build an ice fish-weir, which turned to stone, the remnants of which can be seen today in the Duwamish River. (See entry 2.10 for a related but somewhat different version of the myth.)

3.23 NOAA Pacific Marine Center Totem Pole, 1801 Fairview Avenue East (206/553-7656). Predictions of the demise of the North American Native culture have been frequent, especially earlier in this century. Famous photographer Edward S. Curtis pursued his prodigious, multivolume *The North American Indian* project in part because of his belief that it would be the final record of "the vanishing race." So, in the early 1960s, when Tlingit

carver Tom Ukas of Wrangell, Alaska, was commissioned to carve a totem pole for what was then the U.S. Coast and Geodetic Survey (now the National Oceanic and Atmospheric Administration) for installation at its base in Seattle, it was hailed in the press as "perhaps the last authentic totem pole ever to come out of Alaska." All such predictions turned out to be vastly premature. In fact, Native American culture, and especially its art, is thriving (for which this guidebook is itself evidence), and Tlingit poles are being produced at a rate that exceeds anything earlier in the century.

None of that is intended to take anything away from the seventy-two-year-old Tlingit carver, who had made a modest living as Wrangell's harbormaster and as a fisherman and who did his carving on the side. Ukas had an explicit sense of mission, namely to perpetuate the Tlingit culture that was his precious inheritance. He gave expression to that mission in the 26-foot pole that was originally installed here in 1961 and, after being taken down for restoration and repainting by Steve Brown, has now been reinstalled at NOAA's base on Lake Union.

The pole, intended to symbolize the goodwill that existed between the old Coast and Geodetic Survey and the Alaskan Territory, is topped by Thunderbird, with a wingspread of nearly six feet, who represents

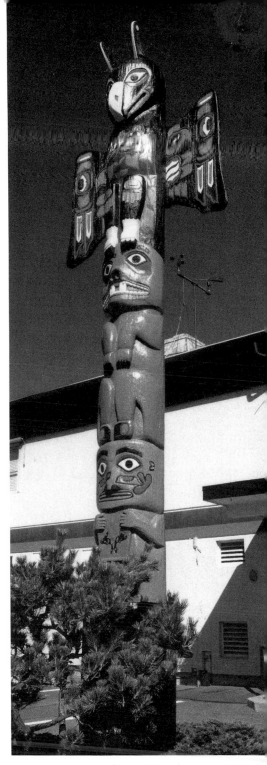

Totem pole, National Oceanic and Atmospheric Administration's Pacific Marine Center; carved by Tom Ukas and restored by Steve Brown (3.23)

friendship and brotherhood. Caught in Thunderbird's claws is Wolf. The bottom figure is that of a man, reportedly the hunter who, in Native lore, first saw Thunderbird.

3.24 Carved Cedar Panel, 3125 Eastlake Avenue East. The new building at this location is turned away from the busyness and noise of Eastlake Avenue and Interstate 5 above it, but the owners of the building wanted "to give something back to the street." So they commissioned Salish artist Ron Hilbert/Coy to carve and paint a cedar panel, some 30 feet long and 18 inches wide, for installation above the wide garage doors that open onto the building's street side.

Inspection from a vantage point a bit closer than the sidewalk shows the panel to be a complex narrative—two narratives, actually. One centers in the revival of the First Salmon ceremony by the nearby Tulalip Tribes. Read from the left where Mount Rainier is depicted, the panel tells the Salish story of Salmon Boy, who, falling from his canoe, was in danger of drowning until the supernatural Changer saved the boy's life by changing him into First Salmon, progenitor of subsequent generations of that food so central and special to Northwest Coast Native people. In the Tulalip ceremony, the first king salmon captured in the season is brought into the smokehouse on a bower of cedar boughs and treated as royalty. Its flesh is given to the fire, and its bones are taken out and solemnly returned to Puget Sound so that it can be regenerated and the species continually renewed. When Salmon returns to his own people, he tells them that he has been treated honorably and urges them to continue to give their bodies to sustain the people of the land.

At the left near the image of Mount Rainier, the panel shows the Changer with his arm extended, the boy falling into the water, and the transformation itself occurring—the figure is half boy, half salmon—and resulting in a great host of fish.

The center of the panel depicts the First Salmon ceremony in the smokehouse, with the fresh-caught fish being carried into the house. At the far right, near the image of Mount Baker, is Salmon Boy and above him the Tulalip canoe that will return the salmon's skeleton to the Sound, thus completing the cycle. Nearby is the Changer, arm extended as a symbol of his transformative power.

On the bottom edge of the panel, visible only on close inspection, is an allusion to a second story, in which a humpback salmon swims from salt water to fresh to spawn, discovers that changes occurring in his body make him less attractive to the females, decides to turn around and go back to salt water in quest of his lost beauty, but meets death instead.

Along the length of the panel are words painted in gold and in Lushootseed, the language of this region's Salish people. They are a sentence from the famous 1854 speech attributed to Chief Seattle, in a translation by Lushootseed scholar and storyteller Vi Hilbert, who is the artist's mother. "At night when the streets of your cities and villages will be silent and you think them deserted, they will throng with returning hosts that once filled and still love this beautiful land."

Appropriately, the building at this address houses some of the archives of the local Lushootseed Research project. Carving and building were blessed by Snoqualmie doctor Kenny Moses in June 1992, and the building was given the name "elevated house" after a structure once located in Upper Skagit country. One of its owners is a non-Native member of the board of Lushootseed Research.

3.25 Totem Pole, 2707 Boyer Avenue East. Strolling through this quiet and attractive residential neighborhood south of Portage Bay, one comes upon an unexpected treat: a very substantial Haida-style totem pole on a small terrace just below the entrance to the house at this address. Eunice and Dan Porte, Jr., are acquainted at first hand with many Native cultures, and none seems to have intrigued them more than that of the Northwest Coast. Some years ago, they decided to purchase a totem pole and found this one at the Vancouver Museum, in whose rotunda it had been carved by Coast Salish artist Francis Horne, with assistance from Len Paquette, as a public demonstration at the time of the Vancouver Exposition. Fourteen feet tall, the pole has the watchmen, typical of Haida totems, at its top, followed in descending order by Wolf, Frog, Bear, a human, and two bear cubs. It replicates a pole at Koona (now Skedans) in the Queen Charlotte Islands.

On Valentine's Day, 1986, the Portes validated their new treasure with a kind of "potlatch" at which the artist was present. Coast Salish elder Vi Hilbert blessed the pole, sang, and told traditional stories to the 150 or so guests.

Artist Horne, born in 1955 of Lummi ancestry, was raised in Duncan, British Columbia, on Vancouver Island, a city noted for its avenue of totem poles.

The Portes welcome viewers. Since the pole is on private property, we urge special care and respect on the part of those who may visit it.

3.26 Continental Plaza Motel, 2500 Aurora Avenue North, 98109 (206/ 284-1900). No Seattle thoroughfare is busier than Aurora Avenue (U.S. Route 99), and it is easy to miss its Native designs when speeding past this Best Western motel, located just south of the celebrated Canlis restaurant.

The eight large, painted figures, some 7 feet tall, are on the motel's recessed walls that face the busy highway, and are rendered in classic red and black, befitting the Northern formline tradition that inspired them. Reading from south to north, the figures represent a pair of salmon, Raven, a mythical Sea Wolf, a hummingbird, a seal on its back with a seal pup on its chest, Whale, and a mythical Sea Eagle or Sea Raven. The front unit of this multi-unit motel complex is called the Haida building, and under a previous owner its rooms were decorated with Native designs. Anyone wanting to stop and inspect the painted figures would do well to turn onto Halladay Street, just beyond the motel, from the northbound lane of Aurora Avenue, and enter its parking area from the back.

3.27 Girl Scout Administrative Offices, Carved Figure, 3611 Woodland Park Avenue North. The 7-foot Bear, carved and unpainted, on the second-storey wall of this building, virtually stands on the word "Totem" in the large letters beneath it that identify this place as the offices of the "Totem Girl Scout Council." Bear holds a copper—Northwest Coast symbol of wealth and prosperity and power—in its mouth. The carving was done by artist and former Seattle art dealer Michael Johnson, who now lives and works in Santa Fe, New Mexico.

3.28 Ivar's Salmon House, 401 Northeast Northlake Way (206/632-0767). The late Ivar Haglund wanted his Salmon House restaurant, on the north shore of Lake Union under the Interstate 5 bridge, to resemble a Northern-style longhouse. And so it does, with its cedar-sided, post-and-beam construction and its roof that slopes in both directions from a ridgepole that runs the length of the building. The center of the roof is raised, as it would have been in earlier times to accommodate a smokehole over a central fire pit, though Ivar's kitchens below are less primitive.

A painted house front, done in 1969 from a design by Tom Speer, with painting primarily by Speer and Steve Brown and consultation by Bill Holm, fills the entrance face of the building with Northern formline shapes, somewhat obscured now by trees and shrubs. The main figure is the mythical Thunderbird; its head and body occupy the center over the entrance doors and its wings extend to the sides, with a Killer Whale under each wing. Beside the entrance walk, set back from the doors, is a painted totem pole, perhaps 25-feet tall, topped with Eagle, followed by Bear, Frog, and Raven, and with the head of a bird (Jay?) facing upward on Raven's body. Nearby are three slender companion poles of similar height, each topped with a single unpainted figure: Raven, Killer Whale, and Salmon. These poles were carved by now-retired carver Bill Neidinger.

Inside the building, Native-style objects and painted and carved designs are everywhere, but their quality varies widely. Throughout the structure there are vertical panels on the posts that support the beams, carved in shallow relief and painted. Although by now much the worse for wear, they are finely fashioned Northern-style designs that, in their several readings, represent Wolf, Killer Whale, Dogfish, Raven, Jay, Beaver, Woodworm, and other totemic creatures. The panels were carved by Duane Pasco in 1969.

A long corridor extends from the reception area to the banquet rooms at the rear of the restaurant. Above the corridor are two notable objects: a long cannibal bird mask, called a HokHok, used by the Kwakiutl in their high-ranking Hamatsa dance, and a crest hat or helmet carved in the shape of Killer Whale. Along the entire length of the corridor, on both sides, are copies of vintage photographs of Native people by such distinguished, turn-of-the-century photographers as Asahel Curtis, Edward S. Curtis, and Samuel G. Morse.

The Whale Maker cocktail lounge, to the left of the reception area, contains some of Ivar Haglund's collection of Taiwanese art, which should not be confused with the predominant Northwest Coast theme of the building.

In the central public dining room, one does well to ignore everything on the walls, with the exception of two sculptures, perhaps 30 inches tall, over two serving-pantry doors. They are Eagle and Raven, the work of Bill Neidinger. Canoes suspended from the ceiling are interesting examples of authentic Native art that is both utilitarian and aesthetically pleasing. All are of the styles that would have been used by western Washington tribes: a 26-foot sealing canoe from Quillayute (1916); a 27-foot fishing and traveling canoe from Neah Bay (1923); a 52-foot racing canoe, the *Skagit II*, from the Nooksak River, carved by Howie Tom (1929); and an undocumented Salish dugout canoe, perhaps 30 feet in length.

The art work in the private banquet rooms is of distinctly mixed quality. The Pasco vertical panels on the support beams are worth examining; and in the Makah Dining Room, several of those better-preserved carved and painted designs have been put together to form an attractive wall mural. But the back wall of the Potlatch Dining Room is filled with a formline design that is a decidedly unsatisfactory combination of fine, original work by Tom Speer and Steve Brown (in the center) with more recent, decidedly inferior attempts at imitation (on each side).

3.29 Montlake Cut Totem Pole, north of the Museum of History and Industry, 2700 24th Avenue East. Chief John Wallace (1861-1951), a Kaigani Haida from Hydaburg, Alaska, was a noted carver of totem poles and canoes. In addition to this pole, which he originally carved in 1937 for a site

Montlake Cut totem pole by
John Wallace (3.29)

near a cannery on Prince of Wales
Island in Southeast Alaska, two
others stand at the entrance to the
Department of the Interior in Wash-
ington, D.C., and another at Seward
and Sixth in Juneau.

The pole on the Montlake Cut
was brought to Seattle and stored
after the cannery closed; restoration
began in 1981. The pole was in-
stalled in its present location as a
gift to the City of Seattle in 1983.

The pole depicts the "Story of
North Island" in British Columbia
at a stormy time when the island's
Haida residents were without food.
An old woman, who was abandoned
when the villagers moved to a new
fishing site, was provided with food
by Eagle. When Bear stole the food,
the spirits gave the woman a son to
help her. The boy, aided by a man in
a dream, killed the bear, and Eagle
conferred upon the boy the eagle's
own special power as a hunter. One
night the old woman and the boy
awoke to find themselves no longer
in their shack but in a big house,
with carvings inside and three to-
tems in front.

According to the story, these were
the first carvings and totems that
were ever seen among the Haida.
The man who made the house and
did the carving gave the woman and
the boy medicine for them and their
descendants to use when a good art-
ist or carver was wanted.

Figures on the pole are Eagle at
the top, with a fish at its feet; the
old woman; Bear with the boy be-

tween its legs; another Eagle holding a seal, one of the animals provided as food to the woman; a birdlike figure, probably Raven; and the figure of a man at the bottom, probably the man who made the big house and its carvings.

3.30 University of Washington, Burke Museum Outdoor Sculptures,
Northeast 45th Street and 17th Avenue Northeast. In 1985, in preparation for celebrating the 100th anniversary of the Thomas Burke Memorial Washington State Museum, curator-emeritus Bill Holm completed the large whale sculpture that sits at the Museum's entrance (see figure, page xxvii). Begun by Holm in 1970 or 1971, it lay unfinished and without a fin until shortly before the 1985 celebration. It has since become the Burke's official logo. The sculpture is a faithful replica of a nineteenth-century grave monument in the Haida community of Howkan, Alaska. Called "Single Fin," the monument was commissioned by Moses Kool-Keet as a memorial to his uncle. The body of the whale is still in place at the grave site in Howkan, but the old fin is inside the Burke Museum, at some time in the past shortened by half from its original 12-foot height perhaps because of wood rot. Beside the fin is a copy of an 1897 picture by Juneau photographers Lloyd Winter and Percy Pond, showing the monument in place at Howkan. The sculpture was even then betraying signs of age.

The two totem poles standing nearby, just off the circle drive at the museum's entrance, are virtual textbook instances of classic Northern Coast monumental art—classic because of the intrinsic fineness of their design and execution, and because they are superb representatives of two different cultural styles, the Tsimshian on the left, the Haida on the right. Both are replicas of distinguished old poles, carved for Burke Museum display some years ago by Bill Holm.

What typifies the Tsimshian pole is the discreteness of the fully sculpted figures that sit one on top of another. A human figure, grasping the dorsal fin of a supernatural Sea Bear, sits at the pole's top; then the Sea Bear itself; next Raven, or a mountain hawk; next Bear, with somewhat human characteristics, sitting on the head of yet another Bear at the bottom. The original, dating from 1880, was a memorial to a deceased chief, raised on the occasion of the public announcement of his successor. It stood until 1918 in the Niska village of Gitlakhdamks on the Nass River in northern British Columbia, and may have been destroyed under missionary influence.

What typifies the taller Haida pole is the somewhat flatter surface of the carving and the complex interconnections of the figures up and down its length. That complexity is easily seen in a careful "reading" of the pole. At its apex are two watchmen, wearing hats with tall potlatch rings, who are

raised to their elevated position so as to be able to warn the pole's owner of any approaching threat. The legs of the watchmen on either side pass through the ears of Heron immediately below. A man wearing a whale's skin sits on Heron's head. On the body of Heron is a human figure holding onto the bird's tail, which bears the image of a bird's head. Next, a woman wearing a labret sits on Whale's back, holding onto its dorsal fin. She and the smaller human figures on either side wear hats with potlatch rings, similar to those on the two watchmen. Around her hat is the representation of Tsamaos, the river snag, enemy of the careless canoe paddler. The bottom figure is that of a large Killer Whale, with the figure of a bird on its flukes.

The original, probably dating from 1870, was the frontal pole for a chief's house in the village of Haina (New Gold Harbor on Maude Island) in the Queen Charlotte Islands. The pole's images most likely represent crests belonging to the families of the chief and his wife.

3.31 University of Washington, Ethnic Cultural Center Wall Mural, 3931 Brooklyn Avenue Northeast. (206/543-4635). A large, classic, Northern formline–style painted mural completely fills the wall of a high-ceilinged conference room in this University facility. It depicts Eagle with a crested-head; another smaller eagle head, wing,

Tsimshian totem pole replica by Bill Holm, Thomas Burke Memorial Washington State Museum (3.30)

and talons within the larger bird's body; extended wings; and talons. The sheer size of the image makes a dramatic statement. The mural was designed and painted by Tlingit artist Mick Beasley when he and his twin brother and fellow artist, Rick, were students at the University of Washington. It is a fitting feature for the Ethnic Cultural Center, which is devoted to the University's celebration of cultural diversity.

3.32 Sand Point Naval Air Station Pole, 7500 Sand Point Way Northeast. This pole is unique among the monumental objects included in this guidebook. Unlike most totem poles, which are carved with the pole in a horizontal position on the ground, this 52-foot, red-cedar log was carved in a vertical posture, with the artist, Dudley Carter, working from an extendable scaffold. The actual carving was completed in twenty-seven days, from August 11 to September 2, 1962, in full view of the public at Westlake Mall in downtown Seattle; it was then moved to the Sand Point site.

The pole was commissioned by a group of Naval Air Reservists known as the "Thunderbirds," a name derived from the original Naval Air Station emblem. Appropriately, the pole is topped with a traditional Indian Thunderbird, and other figures represent aspects of the mission of Naval aviation. A human face on the bird's breast indicates that it possesses the attributes of a man, and on the bird's wings is the Naval Air Service insignia. The bird is positioned to show supremacy over the Killer Whale, symbolizing the submarine menace. A frogman interlocked in the whale's tail plays a part in combatting the undersea predator, as does the figure of a spaceman. A face on the whale's dorsal fin indicates its human intelligence, and the dorsal fin also suggests a periscope. At the bottom of the pole is a Bear-man, signifying the strength of the Naval Air Reserve. Near the center of the pole are a shield and anchor, traditional symbols of the sea service.

3.33 Tlingit House Post, 6507 20th Avenue Northeast. Tucked back a bit from the street and attached to an apartment building wall at the second-floor level, this 6-foot house post is easily missed, but it rewards a careful look. While its origins are unclear—it was already on the building when then-new owners acquired it more than forty years ago—it appears to be an authentic Native work, judged both by the character of its design and execution and by the Tlingit story it represents. It tells of a young man who, having been derided as a weakling, strengthened himself until he was able to redeem his reputation by splitting a sea lion in two with his bare hands. The main figure on this post is the young man in the act of pulling the animal apart, and on his head is a headdress made of sea lion intestines. The animal's flippers are under the young man's arms and over his shoulders,

and its protruding tongue is a symbol of death. The head on which the young man stands represents the island on which his defiant act was performed. (See a similar depiction in entry 3.10.)

The original, of which this is a copy, is the Duk'toohl house post in the Whale House of Klukwan, Alaska. It is one of the classics of Tlingit sculpture.

3.34 Seattle Pacific University Totem Pole, near Seventh Avenue West and West Cremona. When Seattle Pacific commissioned Tlingit carver Abner Johnson (Goocheesh, meaning "Father Wolf") to fashion a totem pole for the campus, Johnson was determined that, like the traditional poles he carved in his native Alaska, this one should represent the history, the ways, the accomplishments of those for whom the pole was to be made. Although some of the pole's images are not traditional, they do reflect Seattle Pacific's identity and heritage. At the top, a falcon—the school's athletic symbol— denotes the pole's owner. Other figures are a family, representing the school as a community of students, faculty, and staff; a whale, identifying the school's location in a seaport city; and the heads of an eagle and a raven on either side of the whale's flukes, signifying ties with Alaskan Native culture. Near the center of the pole is a circle that affirms the unity of scientific and biblical truth within this Christian university. Raised in the fall of 1979, the 25-foot pole is located on a plaza near the University's library.

3.35 Daybreak Star Indian Center, Discovery Park, entrance at 3901 West Government Street (206/285-4425). This is the first building in a planned Native cultural and educational complex. It is located on land leased in 1970 to the United Indians of All Tribes Foundation, after a peaceful demonstration by Native people seeking rights to their traditional grounds at the time the Defense Department vacated Fort Lawton Military Reservation at this site. The glass-fronted structure, designed by Lawney Reyes of the Colville Federated Tribes, is reminiscent of the traditional longhouse and houses some social services and a collection of both historic and contemporary Native art.

Twelve Native artists were commissioned to provide works, reflecting a variety of Native American styles, through the City of Seattle "1% for Art" program. Tlingit Nathan Jackson's carved and painted cedar panel, "Man and Killer Whale," shows a man astride two killer whales, a hapless seal between them. It is carved in shallow relief and demonstrates Tlingit formline design principles. A black primary formline grid entirely encompasses each whale; the man and seal exemplify formline color variation, with red and black used interchangeably as primary colors.

Another carved and painted cedar panel, "Origin of the Sun," is by Tsimshian Roy Vickers. It illustrates the legend in which Wi-Gyt, the avian "light-bringer," steals the sun from a box jealously guarded by the Chief at the Head of the Nass and, placing it in the sky, brings daylight to the world. On this 8-by-11-foot panel, the sun is represented by a boxed red circle at the center bottom. Inside the outlined structure of the Chief's house, Wi-Gyt's head and body surround the box protectively. Above the house is Daybreak Star in the form of an arch containing the abstracted face of a frog. Vickers's Tsimshian style features geometric shapes and angular lines drawn out to points.

Ron Hilbert/Coy, a Tulalip/Upper Skagit Native, chose to leave his piece unpainted, hoping passers-by would feel free to touch the fire-polished figures on the carved cedar panel. His work, entitled "Longhouse," depicts Salish winter ceremonial dancing in a mysteriously indistinct manner, as it might appear in a smokehouse. The 5-by-12-foot scene is peopled with dancers, drummers, and observers of the ceremonies.

On the lower level of the Center, two painted fir panels by Marvin Oliver represent Raven/Eagle and Bear in traditional formline circle motifs. The 8-foot panels, originally designed as exterior doors, were installed in their present location to keep their design integrity when it was learned that doors must bear metal push-bars. The panel under the south end of the balcony depicts Bear's face, with a characteristic protruding tongue and paws drawn up under his chin. The Raven/Eagle panel at the base of the opposite staircase contains the head of Raven within the body of Eagle.

The Center maintains a collection that includes eight contemporary Northwest Coast masks by Alex Williams, a 16-foot Kwakwaka'wakw totem pole, and a model longhouse. Because of space limitations, these pieces are not always on view.

Outside the building, a weathered, 10-foot figure stands nearly hidden in the trees. The old carving, donated by Anne Gerber, may well have been a Kwakwaka'wakw speaker's figure. Such carved images were incorporated into welcoming ceremonies in Kwakwaka'wakw potlatches. Shallowly hollowed out in back, such figures had their mouths carved through so that a chief might stand concealed behind the figure while he called out guests' names or made announcements. The body of this one has suffered from the elements and from vandalism, but the face, with a few traces of paint still visible, gazes stoically out over Shilshole Bay.

3.36 Totem House Fish and Chips Totem Pole, 3058 Northwest 54th Street. The late Jimmy John, to whom this 1938 Haida-style pole is attributed, was a well-known WestCoast (Nuu-chah-nulth) carver, whose poles

Totem House Fish and Chips pole, Ballard, carved by Jimmy John (3.36)

can also be seen in Nanaimo and Ladysmith, British Columbia. During the 1940s, John could be found carving small totem replicas for tourists at the Hudson's Bay Company store in Vancouver. The building at this site in Ballard, of post-and-beam construction in the Haida longhouse style, was originally built as a gift shop, located directly across the street from what was then the main entrance to the Chittenden Locks. We are told that the carver camped out at the construction site while he carved the pole. Unfortunately for the gift shop business, the Locks were closed to the public as a security measure when World War II began, and the gift shop closed as well. The building was reopened in 1944 as the fast-food restaurant it still is today.

The pole, in the Haida style, bears the marks of an accomplished carver. There is clear photographic evidence that the images on this pole were directly influenced by a model Haida totem pole that had been carved in argillite around the turn of the century. The model was included in "The Box of Daylight" exhibition curated by Bill Holm at the Seattle Art Museum in 1983. In fact, so clear is the derivation that this pole must have been carved with the argillite model immediately at hand.

Based on a comparison of the argillite model with this pole, the figure at the top appears to be Raven, with a human face at its feet. The next figure, having a large head and prominent teeth, is probably one of the manifestations of Raven, with long wings at his sides. A small, pointed-beaked bird's head, probably a young raven, appears on that creature's body. The next figure is a long-snouted Wolf, with a human, face up, at its feet. The lowest image is Killer Whale, with dorsal and pectoral fins and flukes in elongated form at its sides.

Except for the stretching out of the figures when they were translated from the small argillite model to the tall pole, the work was done with remarkable understanding of the Haida style. How the Nuu-chah-nulth Jimmy John happened to have access both to the model and to Haida aesthetic sensibilities is an unsolved puzzle, and therefore the attribution to him is in doubt.

Jimmy John, where are you now, when we need you?

3.37 Ormbrek House, 2615 Northwest 73rd Street. Unique among these entries is this north Ballard house, two sides of which were painted in 1975 in Northern formline style. The house belongs to Mr. Richard Ormbrek. Mrs. Ormbrek, who has since died, was of mixed Haida and Tlingit heritage, related to the famous Haida artist Charles Edenshaw. According to Richard Ormbrek, the smaller painting on the front of the house was adapted from a design by the Haida artist himself. The larger design on the side of

Ormbreck House, Ballard (3.37)

the house was projected at night from the slide photograph of a classic Haida housefront, traced with carpenter's pencil, and later painted by Ormbrek family friend Steve Priestly.

3.38 Metro Bus Shelter Painted Panel, College Place North, corner of North 97th Street. This is one of three murals commissioned in 1993, in collaboration with the King County Arts Commission, as a part of Metro's "1% for Art" program. Each mural is located near a historic Native American site within King County. Seattle artist Roger Fernandes, an enrolled member of the Lower Elwha S'Klallam Tribe, has painted six upper panels here, based on Puget Salish house post figures. Representing human, animal, and supernatural beings, these figures were traditionally carved into support beams in cedar plankhouses.

According to the artist, the lower panels depict a Duwamish/Snoqualmie Spirit Canoe ceremony, conducted by a shaman who would create a spirit canoe for travel to the spirit world in order to recover the soul of a sick person.

Small paintings on the shelter's sides have been selected by the artist from ancient Puget Salish petroglyphs. They also show the Spirit Canoe ceremony, salmon, and spirits that were said to influence the ancient artists.

On the back of the shelter, Fernandes has painted a series of basket designs of male and female figures, and a common salmon-gill basketry design represented by geometric S-shaped patterns.

3.39 Northgate Mall Totem Pole, Northeast Northgate Way at Third Avenue Northeast. The western red cedar tree that became this 59-foot pole was felled by carver Dudley Carter himself, at a site near King Creek, twenty miles southeast of Orting. The upper 35-foot portion of the pole was carved as the log lay horizontally, and the rest was carved, with a double-bit axe and an adze, as Carter stood on a scaffold. The images, characteristically idiosyncratic, are Carter's combination of Northwest Coast designs, South Pacific motifs, and his own fanciful inventions. The pole, topped by a 4-foot, 6-inch, maned Thunderbird, rises out of the back of a three-dimensional "canoe-bird" figure.

This pole displays a Carter hallmark. Native carvers and artists working in two dimensions use crosshatching in certain areas to represent a contrast in color or weight in the design element. In carved pieces, crosshatching is most often represented by evenly spaced, straight, intersecting incised lines; in two-dimensional works, the lines are drawn or painted. In Carter pieces, the crosshatching is emphasized by a third dimension: the lines are not incised but are deeply grooved, resulting in a bumpy surface. Sometimes, in his earlier works, the lines are curvilinear rather than straight, emphasizing a diamond pattern in the hatched area. At the base of this pole, Carter's crosshatching has been painted in such a manner that the alternating "diamonds" are in contrasting colors, with a result appearing more like a woven design than a traditional carved design. At other times, Carter's crosshatched areas are more like scales or feathers (see the feathered throat area on the lowest bird image on this pole).

In 1954 Carter added the stylized "Northgate" lettering, noteworthy atop the pedestrian and bus-stop shelter on Northgate Way directly in front of the pole.

3.40 Northwest Hospital Sculpture, 1550 North 115th Street. "Adventure on Western Waters" was carved by Dudley Carter in 1987, and is said to represent an experience in the carver's life as he was growing up in British Columbia. Located on a traffic circle in front of a medical office building in the hospital complex, the image is of a 12-foot canoe, which is being driven forcefully over wind-whipped waves by a lone paddler—or might the waters be stirred by a sea monster? The enigmatic swirl is typical of the mystery with which Carter endowed many of his later works. The design of the canoe is reminiscent of traditional Native craft, even though it too is

touched with fancy, especially in the winged Mountain Goat figure on its prow.

3.41 Evergreen Washelli Cemetery Totem Pole, 11111 Aurora Avenue North. Three intriguing human visages stare out at visitors from a totem pole near the parking area south of Evergreen Washelli's Cemetery and Funeral Home Office. The pole depicts a Haida version of Nanasimgat's voyage to the undersea abode of Killer Whale in search of his lost wife. In the legend, Nanasimgat's wife disappeared while she was cleaning blood stains from a white otter pelt at the water's edge. When Nanasimgat learned that she had been carried off on the back of Killer Whale, he undertook a journey to Whale's nether world, where a series of heroic deeds ensued.

On the Evergreen Washelli pole, the bottom figure is Killer Whale, with what may be the white sea otter, or a seal, in his mouth. The creature holding the whale's flukes in its mouth is unidentifiable. Nanasimgat's wife can be seen riding the whale's back and clutching its dorsal fin. Above her, Nanasimgat himself crouches in apparent apprehension as he journeys. The early photograph of the pole shows that he originally held a club, suggesting that he was ready for battle, and a 1994 repainting and restoration of the pole by Seattle artist Jay Haavik has added it. Above

Evergreen Washelli Cemetery totem pole, carved by George Smith and Luke Watson at its original site in the Queen Charlotte Islands. *Royal British Columbia Museum Photographic Collections* (3.41)

Nanasimgat is another figure, perhaps a shaman helping to guide Nanasimgat in his journey, or perhaps another image of Nanasimgat himself. The man holds a bundle of tobacco roots in his right hand; a small animal, perhaps Marten, his guardian spirit, is between his knees. His figure is flanked by Canada geese. The bird at his head is most likely Crane, whom Nanasimgat allegedly consulted before his journey, and the bird is hiding the man's head with its breast feathers.

This pole was brought to the Seattle area in the early 1940s as a gift to Evergreen Washelli's president, Clinton Harley, from his friend Tom Kelly, who had logging interests in the Queen Charlotte Islands, home of the Haidas. Choosing among divergent accounts of its origin, it appears most likely that Kelly purchased the pole in Skidegate, and that it had been carved there around 1930 by George Smith and his nephew Luke Watson.

The cemetery's name was proposed by James Gilchrist Swan, who was living with the Makah in Neah Bay in the 1880s. Mary B. Leary, wife of Seattle's mayor at the time, had asked Swan for an appropriate name for the new city cemetery, and he suggested "Washelli," the Makah word for "west wind," noting an association between the west and "the region of the hereafter."

3.42 Broadview Branch Library, Greenwood Avenue North and North 130th Street (206/684-7519). When the Broadview branch of the Seattle Public Library was built in 1975, Seattle's "1% for Art" program paid for three large wall panels by Marvin Oliver, then becoming well known for his fine Northern Northwest Coast designs. One panel is located in a 12-by-14-foot space on the outer wall over the inside entrance doors. It is an abstract design, painted in primary red and black, compact and balanced without being symmetrical, in the best Northern style. The design was used for a brief time as a logo on some printed library materials, and it was also reproduced in red as a decal and affixed to the entry doors, to warn visitors who might otherwise mistake the glass for open space. The decals, now some years later, are still in place. On a recent visit to the branch, it was interesting to discover that one of the regular staff members behind the circulation desk, quite well acquainted with the decals, was unaware that the original design was directly over his head every time he entered the place. That is a common problem with "overhead art" (see related comment on the Port Angeles Post Office mural, entry 4.13).

On the opposite side of that same high entry wall Oliver painted a Northern-style Eagle in full body profile, again in black and red. At the far side of the circulation desk, this time at a good level for full viewing, is a Northern formline–style carved cedar panel, perhaps 6 by 8 feet. The wall

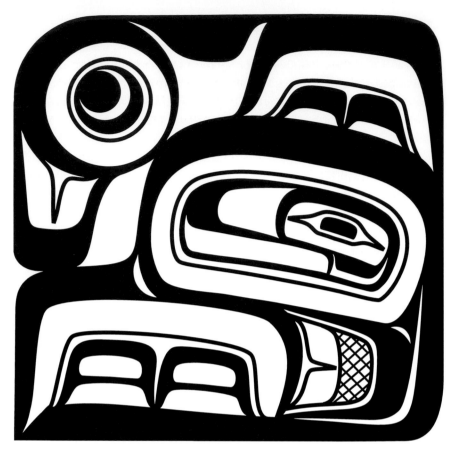

Interior abstract graphic by Marvin Oliver, Broadview Branch, Seattle Public Library. *Reproduced courtesy of the artist* (3.42)

text says it was "untitled," but in his own résumé Oliver calls it Bear—and, on close viewing, the formline animal emerges. The panel is painted in traditional black and red (primary and secondary formlines) and in turquoise (tertiary spaces).

Museums and Tribal Centers

Seattle Art Museum, 100 University Street, 98101 (206/654-3100). The Northwest Coast collection in this museum is relatively small—some 250 objects—but two things about it are remarkable: the objects themselves are among the most superb instances of Northwest Coast genius to be found anywhere, and some 90 percent of them are actively on view. Its core is the John H. Hauberg Collection, handsomely detailed in illuminating text and superb photographs in *The Spirit Within,* an indispensable resource for anyone with a serious interest not just in this collection but in Northwest Coast art generally (see chapter 10 for more information). Third-floor galleries display objects that range from rattles to monumental house posts. Kwakwaka'wakw masks of great dramatic power are concentrated in the center of one room. In another, ceremonial regalia—headdresses, frontlets, a magnificent Chilkat tunic, and much more—make for rich and rewarding viewing.

In addition to its permanent collection, the museum hosts major traveling exhibits of Native arts. Tours are conducted for school children, grades three through five, and a curriculum resource-unit, "Shared Treasures, Gifts of Our Ancestors, Northwest Coast Native Art," is available for purchase. The Katherine White Collection, exhibited in galleries immediately adja-

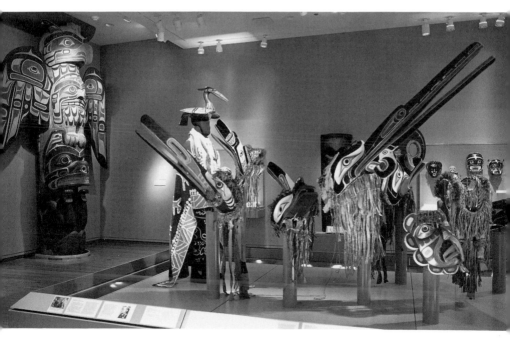

Portion of the Hauberg Collection, Seattle Art Museum. *Photograph by Susan Dirk*

cent to those of the Northwest Coast, is one of the premier collections of African tribal art in the country. For other museum services, see "Galleries and Shops" below and chapters 8 and 9.

Museum of History and Industry, 2700 24th Avenue East, 98112 (206/324-1126). This museum, known locally as MOHAI, is an important regional resource, but its significance for the Native art and culture of western Washington is largely in its Sophie Frye Bass Library. The library houses the state's most extensive collection of Pacific Northwest photography, plus books and other printed materials, accumulating some 700,000 items that are available to the public by appointment. Many of those materials cast important light on the Native presence in the Puget Sound area.

Occasionally MOHAI engages in activities more actively related to the Native culture. In 1991 it was sponsor for the Seattle visit of "Crossroads of Continents," a major exhibition of Siberian and Alaskan arts and artifacts put together by teams of both Soviet and American ethnographers from collections in both countries. The exhibit brought to this country for the first time items previously seen only by visitors to the Soviet Union. Coincident with that exhibition, MOHAI engaged Tsimshian artist David Boxley to carve a totem pole in a public space adjacent to the exhibition site at the Seattle Center. MOHAI subsequently sold the pole to the City of Kent, where it is displayed at the Old Fishing Hole (see entry 2.5).

The only Northwest Coast object permanently displayed at MOHAI is a speaker's staff, or "talking stick," carved by David Boxley for the 1990 Goodwill Games that were held in Seattle. The stick, traditionally raised when a chief or his designated speaker is making a statement, calls for attention and respect. Boxley's stick has the figures of Eagle and Bear at its top, symbols of the United States and of the Soviet Union. On the shaft of the stick are some thirty rings, or sleeves, each made by a Native craftsman representing some group of Native people from the Pacific Northwest, Alaska, and the Soviet Far East. Some rings are adorned by carving, some by painting, some by beadwork, and some by basketry.

The "talking stick" was carried on an eight-day "goodwill trek" through Oregon and Washington that culminated in the opening ceremonies of the Goodwill Games at the University of Washington's Husky Stadium. A duplicate copy of the stick was presented to the Mayor of St. Petersburg and is displayed in that Russian city.

Burke Museum (Thomas Burke Memorial Washington State Museum), University of Washington campus, entrance at Northeast 45th Street and 17th Avenue Northeast, 98195 (206/543-5590). The Burke Museum contains one

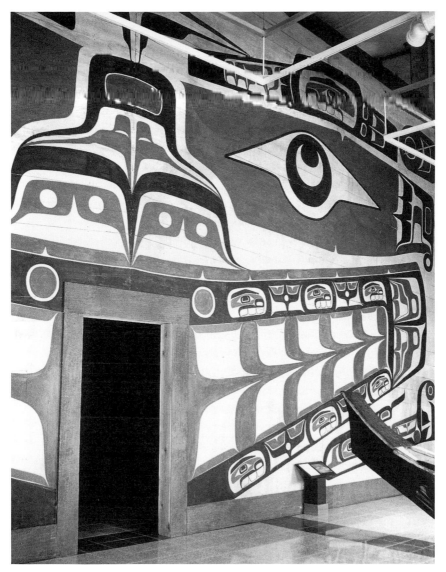

Detail of front of Sea Monster House replica, Thomas Burke Memorial Washington State Museum; painted by Steve Brown and Jack Hudson. *Photograph by John A. Putnam*

of the largest and most notable collections of Northwest Coast Native art and artifacts in the United States, numbering some 7,000 objects, with an additional 6,500 objects from Alaskan and Arctic Native cultures. Included are masks, hunting and cooking paraphernalia, clothing, sculpture, baskets, weapons, and canoes. *Spirit and Ancestor,* by Bill Holm (see chapter 10), catalogues 100 of the most distinguished Northwest Coast pieces in the collection. An interactive videodisk monitor, located near the upper-level Mu-

seum Shop, provides access to over 13,000 objects in the Pacific Northwest collection, with easy indexing (according to type of object, tribal area, major donor, etc.) to match viewer interest. Similar monitors are also installed in the University's Art Library and in the American Indian Studies Center.

Towering over the Burke's main-floor entrance hall are two totem poles. On the left is Dzoonokwa, a cannibal giantess with pursed lips and pendulant breasts (see the Introduction for more on this mythical figure). This is a copy, carved by Bill Holm, of an early twentieth-century pole in the Kwakwaka'wakw village of Gwayusdums on Gilford Island, British Columbia, which was raised originally as a form of public shaming for an unpaid marriage debt. The three coppers, held by the giantess, were probably added to the original a few years later when the debt was repaid.

The pole on the right is topped with the likeness of a deceased Tlingit chief sitting on the replica of a bent-corner box. On the original pole, carved at Old Wrangell, Alaska, before 1850, the box was actually the mortuary container in which the chief's remains were interred. This copy was also carved by Bill Holm.

The entrance hall itself contains a continuing exhibit of Native canoes, remarkable for their combination of aesthetic grace and utility.

Beyond the two poles, and serving as the entrance to a main exhibit area, is a monumental Kwakwaka'wakw house front. Once a part of the Sea Monster House at Seattle's Pacific Science Center, it was removed a few years ago to make room for more science-related exhibits and has recently come into the possession of the Burke. The house front, bearing an identifying sea monster painted in grand formline design, is a detailed reproduction from a house traditionally owned by the Scow family on Gilford Island.

Interior dance screens, similarly removed from the Sea Monster House, are installed on the rear wall of the exhibit area enclosed by the house front. Reading from the left, they represent Bear, Raven with Sisiutl, and Copper. The dance screens are the work of Steve Brown, Russell Smith, and Jerry Smith; the house front is by Brown, Jack Hudson, and Tom Speer.

The exhibit area enclosed between house front and dance screens contains cases displaying Kwakwaka'wakw feast dishes and button blankets. Permanent Northwest Coast exhibits in adjacent main-floor areas include a traditional, full-size cedar plank house, furnished with household artifacts of the sort found among the western Washington Salish at the turn of the century, and a miniature display showing such a house in a typical beachfront setting, with a canoe in the process of being carved on the beach; a set of carved masks that demonstrate the differences in carving styles among the several coastal tribes; and three cases containing representative

artifacts—masks, boxes, baskets, clothing—from three distinct geographic areas on the Northwest Coast: Southern (Salish, Makah), Central (Northern Wakashan, Nuxalk, and Kwakwa̲ka̲'wakw), and Northern (Haida, Tsimshian, and Tlingit). Special theme exhibits created by Burke Museum curators and traveling exhibits are frequent.

Outside of the main entrance, along the museum's front wall, is a garden of native flora, featuring food and medicinal plants that have been in traditional use by Native peoples of the area. Each group of plants has identifying information.

A lower-level museum cafe, the Boiserie, offers variety coffees and snacks (entrance is from the museum's upper level, or directly from the adjacent parking area). Cafe hours extend beyond museum hours.

Galleries and Shops

Bailey Nelson Gallery, 2001 Western Avenue, 98121 (206/448-7340). Much of Ken Bailey and Diane Nelson's inventory pushes at the boundaries of tradition. Masks and prints of brilliant and surprising hues and designs line the walls. Yet, in a corner of the gallery one might also find a studied and detailed replica of an old Bella Coola bent-corner chest, or a giant Kwakwa̲ka̲'wakw-style feast dish. The proprietors select pieces from relatively unknown craftspeople, as well as from eminent artists working in the Northwest Coast Native tradition. Artists whose work is frequently displayed here include Barry Herem, Jay Haavik, James Bender, and Davey Stephens. Items from the Southwest's Native traditions are also found here. The gallery works with artists and customers in arranging commissions.

Bruce Boyd/Curioseri, 316 Occidental Avenue South, #100, Box 20242, 98102 (223-0717). Despite the limited hours during which this gallery is open (call for current days and times), collectors do well to make the connection occasionally, because it is often possible to find unusual pieces in various ethnic styles that Bruce Boyd has picked up from his diverse sources. An interested buyer or seller may make an appointment, and buyers can be advised about Boyd's recent acquisitions through his recorded answering service. In addition to Northwest Coast items, expect to find a selection of baskets, Eskimo pieces, and carved Oceanic relics, as well as Native pieces from the Plains, the Plateau, and the eastern United States. The Curioseri is a relatively small gallery, and therefore the proprietor is selective in both purchase and display. He will, however, search for specific items for his customers.

Burke Museum Gift Shop, just inside the main entrance of the University of Washington campus, Northeast 45th Street and 17th Avenue Northeast, 98195 (206/685-0909). While this shop is by no means limited to Northwest Coast Native arts—its inventory reflects the Burke Museum's larger commitment to the natural and cultural history of the Pacific Rim—more than half of its display space is occupied by contemporary masks, drums, prints, argillite carvings, bowls, boxes, and jewelry produced by artists working in the Northwest Native style. There is also a wide selection of fine jewelry by Navajo and Hopi artists from the American Southwest.

Audio and video tapes and books on Native American arts broadly are available here, as are popular sweatshirts, T-shirts, and note cards imprinted with Native designs. Museum members receive a 10 percent discount year-around and 20 percent during the annual Christmas sale. Visitors are free to browse without interruption, or the staff will provide friendly personalized attention when it is desired. Although there is a charge for admission to Burke Museum exhibits, there is no charge to Gift Shop visitors.

Flury & Company, 322 First Avenue South, 98104 (206/587-0260). This spacious gallery handsomely displays Native American art and artifacts and vintage photographs and photogravures from *The North American Indian,* by Edward S. Curtis and Adam Clark Vroman. Owner Lois Flury and manager James Flury are experts on the life and works of Curtis, and the gallery sells books and other items related to the famous photographer. In addition to buying and selling Northwest Coast Native baskets, masks, and wood carvings, the Flurys research and appraise both individual items and complete collections.

Jackson Street Gallery, Ltd., 108 South Jackson Street, 98104 (206/447-0102). Located in an area of the city filled with galleries, this one specializes in nineteenth- and early twentieth-century paintings and Native American artifacts. Owners James Flury, Lois Flury, and Steve Watson offer verbal appraisals of individual pieces without fee and written appraisals for insurance or estate evaluation for a fee. Their Native American collections include the Northwest, Southwest, Plains, and Plateau, with an occasional Eskimo piece as well.

La Tienda Folk Arts Gallery, 4138 University Way Northeast, 98105 (206/632-1796). "The Ave," as University Way is popularly known, is a busy thoroughfare adjacent to the University of Washington campus and is probably more multi-ethnic (at least when determined by the variety of its restaurants) than any other section of Seattle. La Tienda has an established

place in that milieu, and its owner, Leslie Grace, makes frequent trips, especially south of the border, to find quality folk arts and artifacts. Although the shop's Northwest Coast offerings are limited, they are regularly worth examining, and Ms. Grace is a reliable guide to its inventory.

The Legacy, Ltd, 1003 First Avenue, 98104 (206/624-6350, 800/729-1562) This upscale and well-stocked gallery attracts visitors from European cities as well as from Chimacum, Washington. Its location in the city's center and its retailing record of more than fifty years make it one of the area's premier businesses. The gallery inventory consists of contemporary and historic Northwest Coast Indian and Alaskan Eskimo art and artifacts—masks, poles, prints, jewelry, drums, pottery, and books and magazines on Native art. Individual pieces are well-documented and many are of museum quality.

The newest medium to appropriate Northwest Coast designs is clothing. Unlike the images that appear on T-shirts and sweats in great (and often tacky) profusion, the latest trend is in jackets, shawls, dresses, sweaters, kimonos, and neckties, some appropriately considered haute couture. The trend was begun in elegant wearables by Haida artist Dorothy Grant, utilizing designs by Robert Davidson, and now other highly regarded Native artists—Susan Point, Art Thompson, John Goodwin, and Don Yeomans, among them—have caught on. This gallery has been ahead of the trend and offers its own distinctive private label called "Legacy Designs."

From time to time the gallery mounts special shows featuring a noted individual artist, a distinctive tribal tradition, or a distinguished artistic family. Owner Mardonna Austin-McKillop offers services for appraisals, for locating an extant work to fill out a collection, and for the commissioning of new work to a collector's specifications.

Northwest Craft Center, Seattle Center, west of the fountain, 98109 (206/728-1555). Although this gallery is primarily a place to find really fine quality ceramic art by leading Northwest potters, it also has a consistent inventory of Northwest Coast Native-style, limited-edition prints. Work by Duane Pasco, Barry Herem, and Jay Haavik is regularly found here.

Marvin Oliver Gallery, 3501 Fremont Avenue North, 98104 (206/633-2468). Marvin Oliver, of mixed Quinault and Isleta Pueblo heritage and a faculty member in the University of Washington's American Indian Studies Program, is one of the most prominent and highly regarded artists working in the Northwest Coast Native style in western Washington. He opened this gallery in 1994 as an outlet for his own work—prints, sculptures, fabrics,

and cards. Days and hours are limited, and a call before a planned visit is wise. More information about the artist is provided in chapter 6.

Sacred Circle Gallery of American Indian Art, Daybreak Star Center, Discovery Park, entrance at 3901 West Government Way, Box 99100, 98199 (206/285-4425). The retail sales division of this gallery features contemporary prints, painted works, carvings, cards, and current books on Native arts. Director Steve Charles regularly schedules works from the Plateau and Plains and occasionally carries works from other Native American areas. An exhibit gallery, only a door away from the retail area, displays a variety of media, ranging from photography and collages to paintings, with styles from modern and abstract to assiduously traditional. The gallery shows retrospectives as well as artists' newer works. The subject matter is frequently confrontational, reflecting the artists' convictions on social and political issues. Daybreak Star Center's notable permanent art is located throughout the building and surrounding grounds (see entry 3.35).

Seattle Art Museum, The Museum Store, 100 University Street, 98101 (206/654-3120). Masks, boxes, panels, jewelry, books, cards, and posters are among the Native art-related items available for sale in the generously stocked but cramped quarters of the shop. A wide range of other items reflects the cosmopolitan collection—Asian and African, contemporary American and European, as well as Northwest Coast—within the museum itself. Museum members receive a 15 percent discount on purchases in the Museum Store, which is accessible directly from First Avenue and does not require the payment of the museum's admission fee. The store is open during regular museum hours.

Snow Goose Associates, 8806 Roosevelt Way Northeast, 98115 (206/523-6223). Special shows at the Snow Goose rival carefully curated museum exhibits, and demonstrations by prominent Native artists are popular. Its normal inventory includes Canadian Inuit prints, sculpture, and wall hangings; Alaskan Eskimo ivory carvings, baskets, dolls, prints, drawings, masks, and jewelry; Northwest Coast Native masks, baskets (contemporary and old), jewelry, prints, boxes, paddles, and drums. Here a collector can find out-of-print books, Chilkat and Raven's Tail robes, button blankets, and woven Salish blankets, or enlist the assistance of gallery owners Lisa Steinbrueck and Susan Helmke in commissioning works to individual specifications.

Stonington Gallery, 2030 First Avenue, 98121 (206/443-1108). Handsome

displays of hand-crafted works from the Arctic Circle to California draw Seattle collectors and visitors alike to this gallery. The inventory includes prints, paintings, jewelry, baskets, books, carved wood, and stone items in a wide variety of styles, including but by no means limited to the Northwest Coast Native arts. Art works are displayed in a space pleasant for browsing, with a helpful but unobtrusive staff available. Prominent among the inventory are water colors and prints by gallery owner Nancy Taylor Stonington.

The gallery frequently presents one- or two-person shows as well as juried invitational exhibits. Each year a "theme" show enlivens the art scene, with contributions by as many as seventy artists. The Stonington has a strong commitment to public education, especially in Northwest Coast Native arts. "Artists-in-action" programs have featured dancing, storytelling, informative lectures, puppetry, and carving by experts in art, archaeology, and performance. These programs provide informal opportunities to meet and visit with experts and collectors. In-house framing is available.

Traditions and Beyond, 113 Cherry Street, 98104 (206/621-0655). A paraphrase of this shop's name might well be "a gallery and more." In addition to marketing original Native art works and reproductions, it provides a variety of services for the Native American community. Run by the Seattle Indian Services Commission, a nonprofit agency created in 1972, its aims are to provide a showcase for Indian art, to heighten awareness of Native cultures, and to generate funds for the education of Native people. The shop features original beadwork, pottery, woven baskets, dolls, rattles, and wood and soapstone carvings. Pendleton blankets, prints, greetings cards, and T-shirts round out its inventory.

Tribes Nature and Native American Art and Tea Company, 704 North 34th Street, 98103 (206/632-8842). The funky Fremont District in Seattle houses this retail sales gallery, which features Native American art, including but not limited to the Northwest Coast, as well as instruction in the Native skills of drum-making and storytelling. Masks, model totem poles, prints, and drawings are included in its inventory, along with audio and video tapes and spiritually oriented craft items. The "Tea" in the name of the shop refers to packaged Native teas from a Chippewa retail source. "Tribes" can also be booked to provide storytelling presentations outside of the gallery.

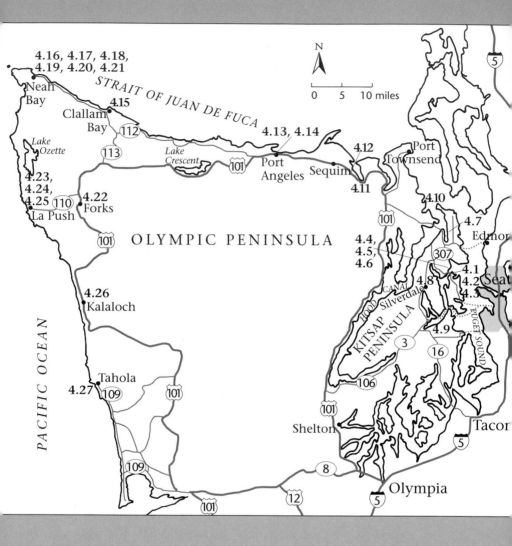

4.16, 4.17, 4.18,
4.19, 4.20, 4.21

Neah
Bay

STRAIT OF JUAN DE FUCA

N

0 5 10 miles

Clallam
Bay

4.15

112

*Lake
Ozette*

113

*Lake
Crescent*

101

4.13, 4.14

Port
Angeles

Sequim

4.12

Port
Townsend

4.11

Port
Townsend

4.10

4.23,
4.24,
4.25

La Push

110

4.22
Forks

101

OLYMPIC PENINSULA

4.4,
4.5,
4.6

101

4.7

Edmor

307

4.1
4.2 Seat
4.3

4.8

HOOD CANAL

Silverdale

4.26
Kalaloch

KITSAP
PENINSULA

3

4.9

16

PUGET SOUND

PACIFIC OCEAN

Tahola

4.27

109

101

106

101

Shelton

Tacor

5

109

8

12

101

5

Olympia

4. West

Kitsap and Olympic Peninsulas

Sites

All locations are in an arc around the Olympic National Park, from Agate Passage, between Bainbridge Island and the Kitsap Peninsula, north to Suquamish and Little Boston, then west skirting the Strait of Juan de Fuca along S.R. 104, U.S. 101, and S.R. 112, and south on U.S. 101 and S.R. 109 along the Pacific Ocean to Taholah, north of Grays Harbor.

4.1 Agate Passage Totem Pole

4.2 Kiana Lodge, Multiple Objects

4.3 Suquamish Tribal Center Totem Pole

4.4 Suquamish Village Totem Pole

4.5 Suquamish Village, Grave of Chief Sealth

4.6 Suquamish Village, "Old Man House" Historic Site

4.7 Little Boston, Port Gamble S'Klallam Tribal Center, Multiple Objects

4.8 Silverdale, Kitsap Place Totem Pole

4.9 Port Orchard, Marina Totem Pole

4.10 Port Ludlow Totem Pole

4.11 Blyn, Jamestown S'Klallam Tribal Center, Multiple Objects

4.12 Blyn, Jamestown S'Klallam 7 Cedars Casino

4.13 Port Angeles, U.S. Post Office Mural

4.14 Hurricane Ridge Visitor's Center, Multiple Objects

4.15 Clallam Bay, Smuggler's Inn Totem Pole

4.16 Neah Bay, Indian Health Service Building Totem Pole

4.17 Neah Bay, Dakwas Park Totem Pole

4.18 Neah Bay Schools, Multiple Objects

4.19 Neah Bay, Youth Center Mural

4.20 Neah Bay, Cape Motel Totem Pole

4.21 Neah Bay, Makah Forestry Enterprises Wall Post

4.22 Forks, Forks Motel Totem Pole

4.23 La Push, Ocean Park Resort Motel Sculptures

4.24 La Push, Welcome Figures

4.25 La Push, Coast Guard Station Totem Pole

4.26 Kalaloch, Olympic National Park Amphitheater Mural

4.27 Taholah, Quinault Tribal Center Totem Pole

Agate Passage

4.1 Agate Passage Totem Pole, north side of the Agate Pass Bridge, between Bainbridge Island and the Kitsap Peninsula, Highway 302 near Suquamish. This pole is one of several carved in connection with the 1962 Seattle World's Fair. Today it gives visitors arriving on the Kitsap Peninsula a totemic message about Native history and industry. Profiles representing Chiefs Kitsap (d. 1856) and Sealth (d. 1857) are carved just below images of an anchor and a handclasp, symbolizing the first meeting of Native people with European mariners and the subsequent treaty signings. Native transportation is represented by a carved paddle, and food gathering by a clam and a salmon. Text on a nearby interpretive marker suggests that the large "blackfish" denotes whaling for oil, which was both a staple and a trade item.

The Native people themselves are depicted in images of the industrious Beaver and of Thunderbird, with its ambitiously outstretched wings. Encircling the base of the pole are carved flames, denoting camping, feasting, and potlatching. The marker also refers to the image of a deer, which has

apparently been removed since the marker was installed. The pole was erected by the Kitsap County Historical Society, and the marker was installed by that Society, the Historical Sites and Markers Commission, and the State Highway Commission.

4.2 **Kiana Lodge,** 14976 Sandy Hook Road Northeast, Box 1395, Poulsbo 98370 (360/598-4311; for Seattle callers, 206/282-4633). Located on the shore of Agate Passage, Kiana Lodge is a stunning place, made so both by the natural beauty of expansive lawns and towering cedars and by the cedar-sided buildings, whose character is a fitting complement to their setting. In earlier years, the charter boat "Virginia V" brought dinner visitors here from the Seattle waterfront. Currently, Kiana Lodge is a banquet and catering facility to be engaged for all kinds of meetings and especially for celebratory events.

A building called the Lodge contains a small dining room, a bar, and a lounge. A much larger structure, the Greenhouse-Longhouse, can accommodate large numbers of diners. The lawns are a popular venue for weddings. The setting is embellished by a rich variety of Native arts and artifacts. The Lodge contains one of the area's largest collections of fine Northwest Coast baskets, recently catalogued by consultants from the Smithsonian Institution, and additionally displays masks, paddles, drums, and feast dishes. Large, Northwest Coast–style wall murals—the split image of Dogfish on one wall, images of Eagle and Raven on the other—designed and painted by Duane Pasco, add drama to the spacious lounge area. In the larger banquet structure, a large Killer Whale wall panel, also by Pasco, dominates the room, and a Northern-style canoe is sometimes used as a kind of gigantic feast dish on banquet occasions. Near the entrance to the grounds, but secluded in a stand of trees and shrubs, is a gift shop in the form of a small, Northern-style longhouse, with an entrance pole—Raven above, Whale below, with access to the shop through the body of the whale; two slender corner poles each topped by Raven; and a house front painted in Northern formline style. All of these are early works by Duane Pasco. Other Pasco pieces, originally commissioned for Kiana by a previous owner, were removed by him and given to the City of Seattle; they may now be seen in Occidental Square in the older part of the city (see entry 3.8).

Beside the path leading to the gift shop, almost obscured by encroaching shrubbery, is the "Princess Chair," a large chair-shaped sculpture by Dudley Carter, depicting an Indian woman embracing a small deer under each arm.

Along the Agate Passage waterfront, near the end of the path leading to Kiana's landing wharf, stands a structure that resembles a Northwest Coast

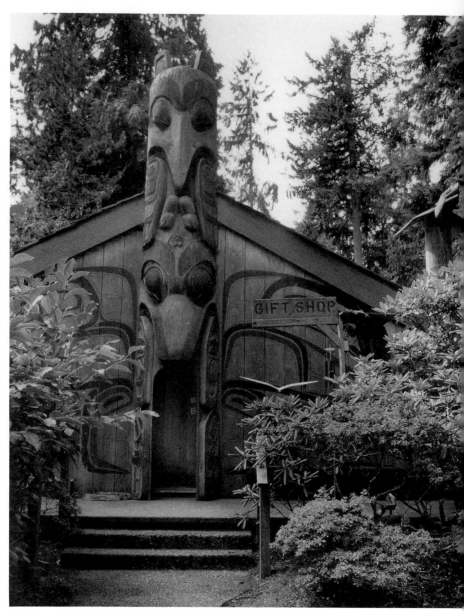

Gift shop entrance pole by Duane Pasco, Kiana Lodge (4.2)

mortuary monument: a large wooden panel that contains the three-dimensional head of Eagle with a solar corona around its head, its body carved in shallow relief on either side. The panel is supported by two posts, perhaps 8 feet in height.

Since Kiana Lodge is frequently reserved for private events, casual drop-ins to see the grounds and the art collection cannot be accommodated. Call to arrange an appropriate time for a visit.

4.3 Suquamish Tribal Center Totem Pole, just north of Agate Passage on Highway 305. This pole, carved by Bill Neidinger (see his other work at entry 3.28), was commissioned for nearly Kiana Lodge by Thurmont Richard White, an active patron of Native and Native-style arts, and later donated to the Suquamish Tribal Center at the time of its opening in 1981.

There is a small humanoid crouched at its top; and below him is a bird that has the appearance of Raven, except that its extended wings are those more often associated with Thunderbird. On the body of the bird is a somewhat elongated humanoid figure, holding onto the legs of Frog beneath. Next is Bear, followed by Killer Whale, and then a long-beaked bird that may be Kingfisher, given the two fish shapes carved on either side of its head. The bottom figure is the head of another Frog.

4.4 Suquamish Village "Lands in the Sky" Pole, near the village center. This 35-foot pole, which now gazes stolidly toward the Seattle skyline from a grassy knoll overlooking Suquamish village on the Puget Sound shore, traveled more than seven thousand miles before it finally came to rest here. An ambassador for Seattle's 1962 Century 21 World's Fair, the pole's creator, Joe Hillaire, spun yarns and carved legends as he and the 13,000-pound pole visited twenty-five states in thirty days to promote the Fair and to demonstrate the art of totem-pole carving. Hillaire and the pole were to return to an Indian village exhibit, to be completed at the Fair in the meantime; but on returning, Hillaire found that the funds for the village had been looted and its construction had stopped. The project was eventually rescued by the Kitsap County Historical Association, the Washington State Pioneer's Association, and American Legion Post #60.

Hillaire met the challenge of carving images from an ancient legend on a somewhat traditional work, while at the same time honoring the Fair's space-age theme. The two Indians at the base of the pole are shooting arrows to a web in the sky. According to legend, they climbed the web and met the spirit of Mother Earth, who provided them with stone weapons. The vicious animals, cast at them by the Moon, they managed to kill with the help of four exceptional weapons: a war club, a lance, a harpoon, and an arrowhead. Hillaire topped the pole with Thunderbird, symbol of power, wisdom, and vision.

Some of the images appear to represent incidents from this and perhaps other legends that were not identified when the pole was commissioned. On the back of the pole, for example, are two human figures flying earthward and a human figure offering berries to an animal. On the front are a

pair of two-headed Lizards whose invincibility was legendary. In this way, the pole illustrates the conglomerate nature of some Salish story poles. Since totem carving was not native to the Salish culture, there was no standard, historic iconography from which to draw the imagery. Consequently, images on poles are often a combination of significant animals, personal spirit guides, actions or incidents in legends or in family histories, and material objects drawn from Native cosmology. The images are mnemonic, designed to trigger associations that will be meaningful to the initiated, however opaque they may be to the casual viewer.

4.5 Grave of Chief Sealth (Seattle), in the cemetery adjacent to St. Peter's Roman Catholic Church, South Street. It seems appropriate that the final resting place of the distinguished Native leader who gave the City of Seattle its name should be located with a view to the skyline of his city namesake. The stone marker, surmounted by a modified Celtic cross, says simply: "Seattle. Chief of the Suquamish and Allied Tribes. Died June 7, 1866. The firm friend of whites, and for him the City of Seattle was named by its Founders. Sealth."

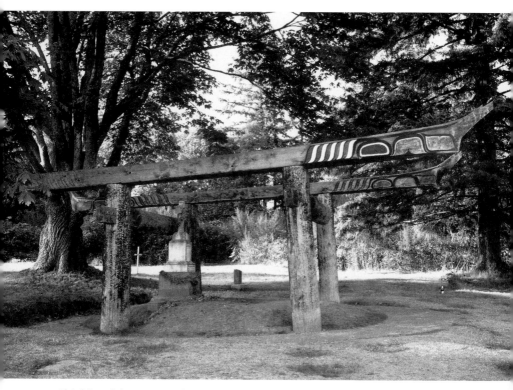

Chief Seattle's grave on the Port Madison (Suquamish) Reservation; canoes carved by George David (4.5)

Over the grave site are two Salish racing canoes, carved by George David, each some 35 feet long, decorated fore and aft with formline-style designs, each supported by two 8-foot posts and the pair connected at their ends by two cross-beams. Various offerings are placed on the grave from time to time by visitors. Among the two dozen or so items that we noticed on a recent visit were an American flag, a toy frog, and two large pine cones—each with a significance known only to the person who placed it there.

4.6 Site of Historic "Old Man House," foot of Northeast McKinstry Street. The structure originally located at this site, and used both as a residence and as a festival hall, was enormous: 500 feet long, with a width that varied from 40 to 60 feet. Built in 1800, it burned in 1870; in the intervening seventy years, it was home to Chief Sealth and hundreds if not thousands of others. It literally brought diverse Puget Sound tribes together under one roof. Its Indian name was Tsu-suc-cub; in Chinook Jargon, the trade language used up and down the Coast, it was O-Le-Man (meaning "strong man"); and so to white settlers it became "Old Man." The historical marker at the site gives drawings and information about Puget Sound plank houses and their construction, and about this particular house and its uses. To reach the site, take Suquamish Way to Division, just west of the village center, turn on McKinstry and follow it to the end.

Little Boston

4.7 Port Gamble S'Klallam Tribal Center, reservation entrance on Little Boston Road, off the Hansville Road, northwest of Kingston. When the Port Gamble S'Klallam wanted a totem pole to stand sentinel over the tribal cemetery, they turned to Tsimshian David Boxley, an experienced totem carver with more than forty poles to his credit. Even though they knew the pole would be done in the northern British Columbia style rather than in their own indigenous Coast Salish fashion, by choosing Boxley they were assured of a high-quality carving, befitting the pole's solemn purpose. Boxley was assisted by Carl Cook, Jake Jones, and Skip George. The pole is topped by Thunderbird, its wings extended; then come a S'Klallam figure, Killer Whale, Bear, Raven, and a chief holding a speaker's staff. The pole was raised in August 1988. A carving shed used by Boxley still stands behind the pole as a shelter for cemetery visitors.

Six-tenths of a mile beyond the cemetery is Salmon Berries Lane Northeast, the entrance to a tribal community of newer two-storey homes, which have been painted by artist Ron Hilbert/Coy with images characteristic of the Pacific Northwest. One depicts black bears in a mountainous setting,

others display eagles and killer whales, and still another shows two Salish canoes filled with whalers in pursuit of their cetacean prey.

Across the road from the cemetery, near the buildings of tribal administration, are two poles carved by Jake Jones, an elder in the tribal community. One in front of the assembly hall/gymnasium has Thunderbird at its top, three human figures wearing tall hats (perhaps traditional watchmen), Killer Whale, a crouching human figure with a black mask across its eyes, and Raven holding a copper (symbol of wealth) in its beak. The dates, 1855 and 1940, appear on the pole. The former is the date of the Treaty of Point-No-Point, in which Native tribes ceded most of their ancestral lands to the United States and received designated reserves in return; the latter is the date on which the Port Gamble S'Klallam village moved from the beach on Port Gamble Bay to its present location on higher ground.

Another pole, perhaps 7 feet tall, also carved by Jake Jones, is located in front of the nearby Tribal Clinic. It has two main figures: the one on top cannot be identified, the one farther down appears to be Bear. The two are separated by smaller seated human figures wearing hats topped by potlatch rings.

At the intersection of the Hansville Road and Little Boston Road is the Klallam Smoke Shop, marked by yet another pole. In descending order, the figures are Thunderbird, Bear with a fish or otter in its paws, Eagle, and the bottom figure, most interesting of all, Whale swallowing a canoe with its whaler-passenger.

Silverdale

4.8 Kitsap Place Story Pole. The Chief Kitsap Memorial Pole stolidly overlooks shopping and traffic activities at Winmar's Kitsap Place, across Silverdale Way from Kitsap Mall. The pole, a tribute to the early nineteenth-century Suquamish chief for whom the county and the peninsula are named, is the result of a joint project between Kitsap Place/Winmar Company, Inc., and the Suquamish Tribe of Port Madison Reservation.

The memorial pole reflects the conventional Salish carving style: it is not a totem pole, but like a totem pole it identifies people, events, and legends of the local Native community. Carved in June of 1989 by Salish carvers Joseph Waterhouse and Frank Corpuz, its figure of Kitsap Tyee (the latter word meaning "chief," or "big man") wears a hat bearing images of his spirit guides, Wolf and Lightning. His face is marked by three drops of blood on one side, indicating the loss of an eye, and a symbolic wolf claw on the other. The upper portion of his face is painted black, indicating warrior status. Chief Kitsap holds a salmon with a young man's body within it.

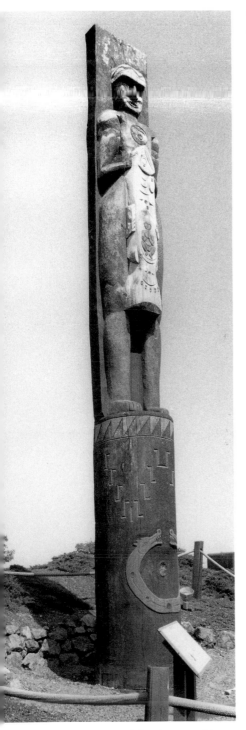

Chief Kitsap memorial pole, carved by Joseph Waterhouse and Frank Corpuz (4.8)

Tradition says that his infant son was lost during a fishing expedition. After many years of searching, Chief Kitsap was led by Raven (depicted in the tattoo on his chest) to a fishing spot where the Chief caught a large salmon. When it was cut open, the son, by then a young man, sprang from the salmon's belly. He had been cared for by the Salmon People until reunion with his father.

Chief Kitsap's great stature is indicated by his stance between symbols of heaven and earth and by his lightning tattoos. The Salmon People are represented by traditional basketry motifs. Symbolic images of a two-headed serpent, guardian of the world of the ancestors, and of the abalone, a seed of knowledge, are at the base of the pole. The back of the pole depicts Lightning Snake, signifying the power of the Suquamish Tribe. In its monumental form, this "modern" pole, laden with historical icons, captures the style, the spirit, and the tradition of the people for whom it stands.

Port Orchard

4.9 Port Orchard Marina Totem Pole, foot of Sidney Avenue. This pole ties Port Orchard on the eastern edge of the Kitsap Peninsula with Neah Bay on the extreme western tip of the Olympic Peninsula. The tie has a thread winding back to Pullman in eastern Washington. The pole, carved in 1989 by Makah

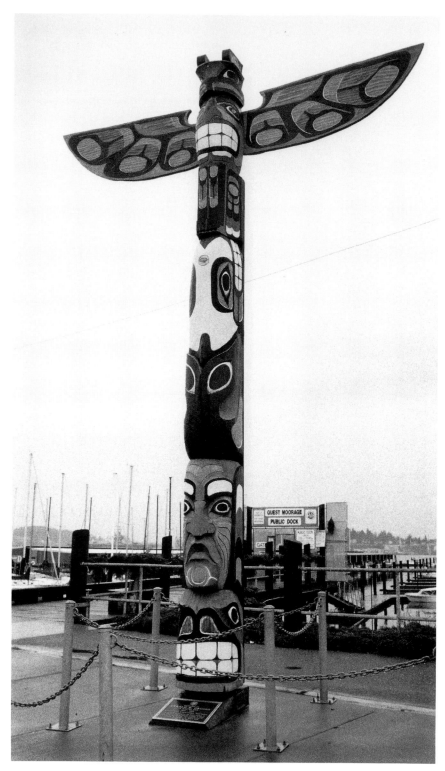

Port Orchard Marina totem pole, carved by Frank Smith (4.9)

artist Frank Smith for the Port Orchard Centennial celebration, is dedicated to Gerald H. Grosso, a former Port Orchard councilman and journalist and a friend of the artist. In the 1980s, Grosso had worked as a volunteer on various archaeological sites in western Washington, under the supervision of Dr. Richard Daugherty of Washington State University in Pullman. When Daugherty undertook the excavation of the ancient Ozette Indian site near Neah Bay, he asked Grosso to be the project's on-site manager. Because of Grosso's years of enthusiasm and dedication to the project, and because of his close relationship with the Makah people of Neah Bay, he was honored with the dedication of this pole.

Prominently located on the shore of the town's marina, the pole typifies the consistent and somewhat flamboyant style that has marked Frank Smith's work over fifty years. Atop the pole is Thunderbird, with boldly painted outstretched wings. Below are Killer Whale, a human face with chin or lip decoration (possibly a labret), and what may be a sea mammal.

Port Ludlow

4.10 Totem pole, Port Ludlow resort community, Oak Bay Road east of State Route 19. The Pope & Talbot lumber interests have been a presence in the north Kitsap Peninsula–west Olympic Peninsula area since the middle of the nineteenth century. In more recent years, Pope Resources has developed a destination resort and residential community at Port Ludlow on Ludlow Bay. In recognition of its long involvement here, Pope Resources commissioned Tsimshian artist David Boxley, whose studio is near Hansville across the Hood Canal from Port Ludlow, to carve a 40-foot totem pole for a point of land near The Inn at Ludlow Bay and across from the marina at the Port Ludlow resort. In carving the pole, David Boxley had the assistance of Robert Leask and Wayne Hewson.

The pole, raised in June of 1995, was carved from a 720-year-old red cedar log taken from the Nolan Creek area south of the Hoh rain forest. It is topped by Eagle, representing the natural habitat prior to logging and subsequent development. Below Eagle is Bear, totem of the S'Klallam people whose traditional lands these were. Then two human figures, their arms linked, are lumber company founders Andrew J. Pope and Captain William C. Talbot. Below them a woodsman holds an axe, standing in for the men who worked the Pope & Talbot sawmill that was located, from 1852 to 1935, on the spot where the pole now stands. Next is Beaver, symbolizing the building and development phase of the Pope enterprise. Finally come three pairs of human figures, representing the human community that is now Port Ludlow.

4.11 Jamestown S'Klallam Tribal Center, 305 Old Blyn Highway (Post Office: Sequim 98382) (360/683-1109). The Jamestown S'Klallam have an impressive achievement in this new Tribal Center, adjacent to the main highway along the northern end of the Peninsula, giving substance to their translation of S'Klallam as "Strong People." They have enhanced the natural beauty of their Sequim Bay location with cedar-hued structures and handsome landscaping, and they have given aesthetic expression to their identity with a variety of art forms. Most prominent is the totem pole that towers over the two-storey main Tribal Center, clearly one of the classiest on the Peninsula. Begun by Harold "Brick" Johnson and now dedicated to him, it was completed by artist Dale Faulstich. Reading down the pole, the figures represent Thunderbird, Wolf, Killer Whale, Frog, Raven, and Bear; between Bear's legs is a small man wearing a hat with three potlatch rings. Over the Tribal Center entrance is a carved circular panel. Eagle almost completely fills the space, with a Bella Coola–style face in its body and a small salmon beneath its talons. In the reception area inside the Tribal Center is a large wall panel of formline design, resembling the back of a chief's seat, and occasionally other art objects are temporarily displayed there.

Over the entrance to an adjacent building that houses tribal social services is a large panel depicting Sisiutl, a two-headed sea monster of enormous potency for good and for ill, and on the entrance door is an elaborate formline Whale painted in traditional red, black, and blue. The S'Klallam Native Art Gallery, Northwest Native Expressions, occupies the front portion of this same building and is described in the section "Galleries and Shops" below. The S'Klallam understand art both as an assertion of their identity as a people and as an aspect of their economic development. To those ends, for example, they have commissioned a suite of four limited-edition prints by Dale Faulstich for sale to the general public, and they have created the gallery both as cultural disseminator and as commercial resource.

4.12 7 Cedars Casino, U.S. 101, .3 miles west of Jamestown S'Klallam Tribal Center, between Blyn and Sequim (Post Office: Sequim 98382) (360/ 683-7777). Newly opened in 1995, this is aesthetically the most ambitious and impressive tribe-sponsored project in western Washington. The Jamestown S'Klallam people have invited artists experienced in Northwest Coast Native styles to collaborate with them in the production of a total of ten totem poles, along with numerous carved or painted panels. Seven of the

poles (three of them in place as this is written) will make a dramatic statement along the much-traveled highway between Hood Canal and Port Angeles; three others, perhaps more, will be raised inside the casino.

The central exterior pole, "Whale and Whale Hunter," is 50 feet tall and was carved from an 800-year old Western red cedar log that was 7½ inches in diameter when the carving began. The pole calls attention to the fact that the S'Klallam were the only Puget Sound Salish people who actively hunted whales and fur seals. The main figure is Whale, head down, pectoral fins on either side, with a small human face emerging from its blowhole. Above are the dorsal fin and the tail flukes. Looking out between the flukes is the face of the human hunter, with arms and legs wrapped around Whale's body. Above the hunter is Sun, which, in conjunction with Earth, is held in S'Klallam mythology to be the source of all living things. Raven, cultural hero in Northwest Coast legend, is seen grasping Sun's corona in his beak. The topmost figure represents the contemporary rekindling of the Jamestown tribe's cultural awareness.

One flanking pole depicts Lord James Balch, founder and head chief of the people whose land, in traditional times, stretched from Clallam Bay to Port Townsend, and in whose honor the tribe is named. With him on the pole are Salmon and Eagle. The other flanking pole represents T'Chits-a-ma-hun, S'Klallam head chief, who, in the 1850s, saved Port Townsend from massacre by other Native groups. T'Chits-a-ma-hun holds up his hand in friendly welcome, and the pole signifies the tradition of amity between the Native and non-Native communities. Above is Thunderbird, the most powerful of all spirit figures and an important S'Klallam crest. Both flanking poles are 28 feet tall. The one on the left is embellished with gold leaf, the one on the right with silver.

Because there is no longstanding tradition of totem poles among the Coast Salish tribes, for these poles the artists, with the full support of tribal authorities, have chosen to include distinctively Salish design elements within a kind of generic Northwest Coast totem pole style.

Under each of the four gables flanking the entrance to the extensive casino building is a large figure representing an animal important in tribal life and myth: Thunderbird, Wolf, Killer Whale, and Loon; and beneath the porte-cochere, and above the main building entrance, is Bear.

Inside the building, two monumental poles reach from floor to high ceiling: on the left, Raven and his Box of Daylight; on the right, Eagle and Salmon. Directly ahead is an impressive longhouse structure of traditional post-and-beam design, which houses the casino's branch of Northwest Native Expressions, the S'Klallam's own art gallery. Inside the casino itself, Native-style prints adorn the walls everywhere. The plan, as time goes on, is

for more elaboration of soffits, glass partitions, and pillars with Native-style designs than can be detailed here. Those interested in Northwest Coast arts will do well to visit this showplace.

Dale Faulstich, a Sequim artist long associated with the S'Klallam arts, and his Creative Art Enterprises were retained by the tribe for the design and production of poles, panels, and related arts for the casino. Faulstich enlisted James Bender and Loren White, both widely known for their Native-style carvings, to assist in this multi-year project. More information about these three artists is provided in chapter 6.

Port Angeles

4.13 United States Post Office Mural, 424 East First Street, corner of Peabody. The rare person among the scores entering the Port Angeles Post Office six days a week is aware that over the building's inside entrance is a handsome example of contemporary Nuu-chah-nulth art by Art Thompson, one of its master practitioners. The space between the outer and inner doors is so narrow, and the mural so high on the wall above the inner door, that it is almost impossible to get a proper perspective on the classic Thunderbird and Whale motif, painted in traditional red, black, and blue. Apparently the architect thought to make the work more visible, at least from outside of the building, by placing a semicircular window in the outer wall that corresponds to the semicircular space on the inner wall occupied by the painting. Unfortunately for that intent, the window has several ribs that separate individual vertical panes, which tend to obscure the unlighted image inside. Thompson's work deserves a better presentation.

4.14 Hurricane Ridge Visitor's Center, Olympic National Park, south of downtown Port Angeles (360/452-0329). Although probably not worth a side trip by itself, the Visitor's Center has a couple of items of interest to those who are driving to spectacular Hurricane Ridge anyway. At the entrance to the long drive to the top, beside one of the parking areas, there is a totem pole created by S'Klallam carvers Richard Mike and Floyd Cooke. The broad wings of Thunderbird, at the top, bear incised images that are probably intended to be Sun and Moon. Below Thunderbird are Whale, its flukes turned up over its back, and Bear. At the bottom there are carved designs that appear to be nonrepresentational. Alongside the pole is an ancient log, which was at one time being hollowed into a canoe but was never finished. Inside the Visitor's Center are a thirty-foot sealing canoe, with its related gear, and interpretive plaques providing brief information about totem poles and canoes. We reproduce a "harpooner's prayer," part

of the display, for those who never get to Hurricane Ridge. As the plaque says, the prayer "suggests the spiritual relationship between the hunter and his prey," something that is characteristic of Native hunters of all kinds of prey:

> Whale, I have given you what you wish to get—my good harpoon. And now you have it. Whale, turn toward the fine beach of my village of Yahksis. And the young men will say to one another, "What a great whale he is." . . . We will cover your great body with bluebill duck feathers. And with the down of the great eagle, the chief of all birds. For this is what you are wishing and this is what you are trying to find, from one end of the world to the other. Every day you are traveling and spouting.

Clallam Bay

4.15 Smuggler's Inn Totem Pole, on State Route 112. When Arlen and Donna Lynn Olson commissioned this pole from Neah Bay carver Frank Smith in the 1960s, they had a suitable setting in mind for a Makah-style pole. As time passed, it seemed more appropriate to place it outside of Arlen's brother's restaurant, the Smuggler's Inn at Clallam Bay. Since then, the pole has remained at that site through various ownership changes of the restaurant. Its figures are drawn from Makah history and legend. Thunderbird atop the pole is supported by Whale, with its tail flukes wrapped over its back. Frank Smith says that while he carves images of legendary characters, his poles do not tell a story. Although carefully maintained, the pole has one strikingly nontraditional feature: a floodlight fixture attached to Thunderbird's head, added to illuminate the parking area in front of the restaurant.

Neah Bay

4.16 Indian Health Service Building Totem Pole, west end of the village. Frank Smith, tribal elder and veteran carver, is the source of several pieces of monumental art in this Makah village (see also his entrance arch at the Makah Cultural and Research Center, described in "Museums and Tribal Centers" below). Like other work he did in the 1960s, the totem pole in front of the Indian Health Service Building bears his characteristic Thunderbird, its widely outstretched wings painted with black and red formline feathers on a blue-green background. A grimacing face is centered on the bird's chest. Below is a flippered sea creature balanced on the snout

of Whale. The remarkable "eyes" below the whale's head are actually painted motifs within the mammal's flippers. At the bottom of the pole is a humanoid face.

4.17 Dakwas Park Totem Pole, Bayview Avenue, west of the village center. When we first visited Neah Bay, there was a totem pole standing in this grassy, fenced-in area on Bayview Avenue, mere yards away from the Strait of Juan de Fuca; but on our second visit the pole was missing. Carved years earlier by Frank Smith, the pole had been unprotected against the ravages of weather that swept in upon it from the Strait. In a state of deterioration, its images were unclear and difficult to identify, with the exception of the standard Thunderbird at the top, so it was taken down for renovation under the sponsorship of the Neah Bay Senior Center. Now it has been returned, but with a difference. When Frank Smith originally carved it, he deliberately left it unpainted. Now it bears colors applied by a different hand, something Smith says would never have been done in traditional times.

We were told by one local townsperson that the fenced-in area where the pole stands was, in fact, a mass grave for smallpox epidemic victims, perhaps from the "mortality" of 1853 that claimed one-third of the Makah population. After repeated inquiry, we were unable to confirm that report.

4.18 Neah Bay Schools. This building complex is generously decorated with Frank Smith's somewhat more recent work. He was chosen to carve figures representing the Makah Circle of Life, which were to surround the roof of the new gymnasium. In an ironic reversal of roles, two of his Whale panels were hoisted up to lofty perches on the roof by equipment that was on site for building construction; but two mountain-dwelling Thunderbirds, completed after the hoisting equipment left, now stand at eye level on the ground. The whales are painted on planks and attached to the wooden ornamental roof structure. The Thunderbirds, standing against the wall on either side of the building's entrance, have the same signature-style wings as described in the Indian Health Service entry above.

Four poles carved by Smith in the 1970s flank the main entrance to the gymnasium. Two support the replica of a WestCoast canoe, forming a post-and-lintel structure that spans the entrance. Painted uniformly black and identically carved in shallow relief, they are indistinct and difficult to read, but each appears to represent the elongated figure of a sea monster supporting the canoe. An additional black, freestanding pole is on either side.

4.19 Youth Center Wall Mural, Bayview Avenue near the village center. The east wall of the village's Youth Center presents three figures that are

among the most important images of the Makah: Thunderbird, Killer Whale, and Wolf. While weather coming in off the nearby Strait has taken its toll over the years on the sharpness of these images, they still retain some of their traditional power. The painted designs were done by Steve Brown and Lance Wilke.

4.20 Cape Motel Totem Pole, south side of Bayview Avenue, east of the village center. This is one of the most intriguing and mysterious poles we found in our search of western Washington. It probably did not originate here, and ordinarily knowledgeable Neah Bay people know little about it. One experienced carver said he thought it had been brought from Canada; another said he thought it looked like a Puget Sound Salish piece. Given the images on the pole, the latter seems the more likely, though the purpose for raising it among the Makah is something of a mystery.

Three things about it are distinctive: (1) it combines shallow carving with images painted on the rounded surface of the pole; (2) the carved figures appear to be wearing ceremonial garb—one figure wears what resembles a Salish warrior's headdress—and other painted images present figures in ceremonial postures—dancing, drumming, and seated in cross-legged style; and (3), although the painting is in poor condition, background surfaces are

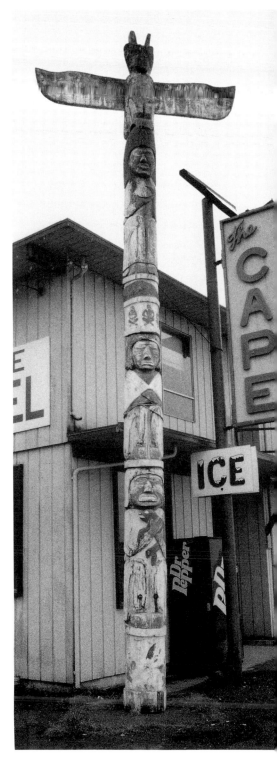

Cape Motel totem pole (4.20)

Neah Bay 111

white, some features are outlined in black, and faces, hands, bodies are predominantly painted in brown, an unusual color for Northwest Coast poles.

4.21 Carved Wall Post, Makah Forestry Enterprises, near the entrance to Neah Bay village (enter at the sign for the Makah Agency, Bureau of Indian Affairs). High up on the side of the Makah Forestry Enterprises building is a totemic carving that bears the marks of Frank Smith's work. Although the figures on the pole are a bit difficult to unscramble, they are almost certainly Thunderbird and Whale, with what appears to be another birdlike image between them.

Forks

4.22 Forks Motel Totem Pole, 432 Forks Avenue. Marcus Westby lived for several years among the Quileute in nearby La Push, and some time around 1960 he was commissioned by the then-owner of this motel, Jane Smiley, to carve a totem pole to grace its grounds. Westby did so, in what he identifies as Haida style, but not to his own total satisfaction. The carver held that, to be truly Haida, the pole should have at its top the traditional figures of three watchmen wearing hats with potlatch rings; the pole's patron insisted, on the contrary, that the top figure must be an American bald eagle, and in realistic rather than in

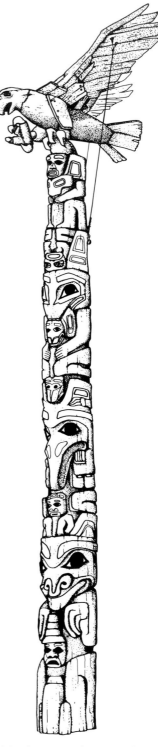

Forks Motel totem pole, carved by Marcus Westby (4.22)

stylized Haida fashion. Westby yielded, and the result is a stylistically anomalous eagle that appears just to have landed, with wings that must be steadied by guy wires to keep them from blowing away in the wind.

The interlocking figures create ambiguity, even appearing to carry transformation to the extreme. The whale's blowhole has only contour a human face, but the figure that emerges has arms and legs. Major images, reading down, are Whale, with a human head between its flukes; an unidentified kneeling creature; Raven; and Bear, holding a small human figure wearing a hat with potlatch rings (if Westby was prevented from putting the traditional three of these at the top, he at least determined to put one of them at the bottom).

La Push

4.23 Ocean Park Resort Motel Sculptures. Three sculptures are associated with this modest resort on First Beach. One is a pole that stands under the west gable of the resort office. It was carved some years ago by Dick Beardsley, an employee of the resort, and depicts a large bird (probably an eagle), with a whale beneath. The face of a man, wearing a hat with two potlatch rings, appears between the whale's flukes, his hands holding onto the flukes and his legs wrapped around the whale's body. A human face looks out from the whale's blowhole.

When we first saw this pole, it was unpainted and had a pleasant aspect in its semitraditional Northern style. On a later visit, we were startled to discover that the pole had been painted in bright enamels—blue, black, red, white, and yellow—in an arbitrary manner representing no traditional color conventions whatever. The result has been to transform a dignified carving into a garish object, perhaps more appealing to tourist photography.

To the west of the motel office is the figure of a whale, perhaps 8 feet long, also recently painted but with a bit more restraint. It is a replica of an earlier carving by Leven Coe, which, in the 1940s, stood beside the Tuttel Trading Store. The whale was then shown being captured by a large Thunderbird. The bird was also replicated, but has long been removed because of deterioration and presently sits, undisplayed, in the Makah Cultural and Research Center in Neah Bay.

To the east of the office is a detached pole, more Salish in style, carved by Jack Ward, reportedly following a "serpent vision" at Cape Rock. It shows the head and upper body of a gull. The irregular lower line of the body suggests that perhaps it is being eaten by the black serpentlike figure beneath it. A caricatured human face, eyes bugging out, toothed-mouth a bit agape, follows, and the bottom figure is a bird of indeterminate species.

4.24 Male and Female Welcome Figures. When last seen, two freestanding figures, some 7 feet in height, were placed against the wall of a building adjacent to the Tribal School. They appeared to have been carved with mobility in mind, and it seemed clear that they were merely being stored at the site where they were seen. They can be moved, for ceremonial or other purposes, and set up wherever their presence is desired. The arms of the male are hinged and can be raised in a variety of gestures. The male wears a bright yellow, belted tunic; the female wears a blue top and a yellow skirt, and her arms are permanently fixed in front of her breasts. Both figures are adorned with face paint. The similarity of the male to the welcome figure on the Coast Guard pole (entry 4.25) suggests the possibility that this pair was also carved by David Forlines.

4.25 Coast Guard Station Totem Pole, Quillayute River, across from the Marina in La Push. In 1989, as part of the Washington State Centennial activities, tribes from Puget Sound and the Olympic Peninsula participated in an event that involved many tribal groups in canoe carving for the first time in generations. The "Paddle to Seattle" enlisted tribal members on what was, for some, an arduous canoe journey from the reservations to Seattle's Golden Gardens Park. On the trip back to the reservation, the U.S. Coast Guard provided escort service for the Quileute crew. In gratitude for that service, and for other services provided over the years by the local complement of the Station, the tribe commissioned David Forlines to carve this pole, which stands in front of the building. At the pole's top is the Coast Guard insignia; below that, a Native male welcome figure stands on the shore, with arms raised in greeting and wearing a feathered headband. Below are three canoes in blue water, representing the "Paddle to Seattle" and the return escort.

The artist, David Forlines, a non-Native, was a kind of carver-in-residence for the Quileute. A measure of the tribe's respect for him was shown at his death, when he was buried on reservation land.

Kalaloch

4.26 Olympic National Park Amphitheater Mural, Highway 101. The image of Thunderbird and Whale is one of the most impressive found among coastal people, variously rendered in distinctive tribal styles, especially along the southern coast. This one, painted on doors at the back of the amphitheater stage, which open to reveal space for audiovisual projection, is in the style of the Makah or the Nuu-chah-nulth. The supernatural Thunderbird was said to live at the tops of the highest mountains and, with

114　**Kitsap and Olympic Peninsulas**

lightning serpents on its wings, was responsible for some of the most spec-
tacular and powerful of nature's displays. Because of Thunderbird's enor-
mity, no ordinary provender could satisfy, so it was said to cast lightning
serpents to harpoon whales, after which it would swoop down and carry
one off for food. On this mural, there are no lightning serpents, but there
is a harpoon in the body of the whale and a whaler's sealskin float above its
flukes. Artist Davey Stephens painted this mural (see page xxxi) in 1986
during a summer as a Kalaloch park ranger.

Taholah

4.27 Quinault Tribal Cultural Center Totem Pole. During 1969-70, non-
Native carver Jim Ploegman lived in Taholah, the headquarters of the
Quinault Nation, and commuted to his classes at Highline Community
College in the Seattle suburb. With the assistance of Bennie Charlie and
other local Quinaults, Ploegman supervised the carving of this pole, which
subsequently lay on the ground for twenty years before being raised in
front of the new Cultural Center. The unevenness of the images on the two
sides of the pole attests to the damage done to one side over those twenty
years. Reading from top to bottom, figures on the pole are Eagle, Salmon,
Whale, and Bear. Ploegman also carved or supervised poles at Highline
Community College, as a member of its staff (see entry 2.4).

Museums and Tribal Centers

Shelton

Skokomish Tribal Center, North 80 Tribal Center Road (360/426-4232).
Not quite a museum, this Tribal Center has a large and varied display area
that deserves a visit by anyone interested in Puget Sound Native art and
culture. Two large welcome figures—a 10-foot woman and a 12-foot man,
carved by Skokomish artist Andy Wilbur—greet visitors to the Center's re-
ception hall, standing on either side of a Salish canoe carved in 1938.
Unique among its objects are two spirit posts (*shuyilas*) of traditional size
and design, carved by Bruce Miller. In Salish longhouses, these posts had
both a structural and a spiritual purpose: they served as supports for roof
beams, as a small, nearby model of such a house shows; and they repre-
sented the spirit guides of the families resident in the houses.
 Display cases contain examples of contemporary work—baskets, jewelry,
wood carvings—done by such tribal artists as Emily Miller, Louisa Pulsifer,

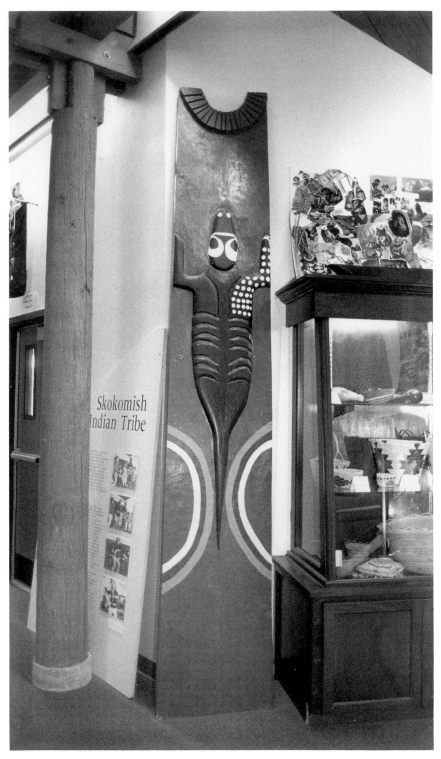

Spirit post at Skokomish Tribal Center, carved by Bruce Miller

116 **Kitsap and Olympic Peninsulas**

Bruce Miller, Ron Johnson, Paul Peterson, Pete Peterson, and Richard Cultie—along with older objects, including projectile points, perhaps as much as 5,000-7,000 years old, that were removed in 1989 from an archaeological site at nearby Lake Cushman. Extensive interpretive wall text and historic photographs tell the story of the Twana (Skokomish) and the Puget Sound Salish and describe the process of basket weaving in some detail.

The adjacent Senior Room contains a large Killer Whale carving, the joint work of Bert Wilbur and Andy Wilbur, and a stylized Eagle wall panel, flanked by canoe paddles painted with distinctive designs.

Silverdale

Kitsap County Historical Museum, 3343 Northwest Byron Street, 98383 (360/692-1949). This museum is adjacent to the Waterfront Park in Old Town Silverdale. It has a small collection of Native artifacts—canoe models, tools, baskets, woven mats—and photographs of local Native life that are relevant to the history of Kitsap County, which is the museum's primary interest. One of its more unusual objects is a structural element that was excavated from Old Man House, one of the largest nineteenth-century Native residential structures in the Puget Sound area, located in Suquamish (see entry 4.6).

Suquamish

Suquamish Museum, just north of Agate Passage on Highway 305, Box 498, 98392 (360/598-3311). The Port Madison Indian Reservation, along the shores of Agate Passage between Bainbridge Island and the Kitsap Peninsula, is the home of Puget Sound's First People, and the Suquamish Museum is its cultural centerpiece. A permanent exhibit, "The Eyes of Chief Seattle," portrays through photographs and artifacts the life of Puget Sound Indians before and after white settlement. The hands-on nature of the exhibit helps to convey the touch and texture of that life. An accompanying catalogue contains much of the information in the exhibit. A fifteen-minute oral history slide-tape program, "Come Forth Laughing: Voices of the Suquamish People," weaves interviews with tribal elders together with historical images to depict both tradition and change over the past century of Native experience. The museum and an associated Cultural Center serve as the focus of community life, and feature a two-day Native American Art Fair each spring and a "Chief Seattle Days" weekend each August.

Port Townsend

Jefferson County Historical Society Museum, 210 Madison Street, 98368 (360/385-1003). James Gilchrist Swan (1818-1900) has been described, with justification, as "the Pacific Northwest's first and foremost ethnologist." After coming to Washington Territory in 1852, he lived for three years in close association with Native tribes near the mouth of the Columbia River; then for four years, with later intermittent return visits, with the Makah on the tip of the Olympic Peninsula; and, finally, for the better part of a year with the Haida in the Queen Charlotte Islands. Swan wrote a number of ethnographic treatises on the Native cultures and was a procurer of Native artifacts for eastern museums. For our purposes, the most interesting feature of this museum is some twenty-five items of Swan memorabilia, along with a small collection of baskets and other objects from the nearby S'Klallam and Makah and from British Columbia and Alaska tribes. Elsewhere in the museum is an extensive display of historical photographs recording the nineteenth-century life of Native people on the Olympic Peninsula.

Sequim

Museum and Arts Center, 175 West Cedar Street, 98382 (360/683-8110). As a part of its commitment to local history, this small museum displays historical photographs of the early Native community, including the history of the "Dungeness Massacre," which pitted the local Jamestown S'Klallam against a Tsimshian raiding party from northern British Columbia. Cases contain baskets and woven hats, a paddle and model canoe, tools, beaded objects, and fishing gear. A special feature is the Native longhouse "retaining plank" replicated by artist David Forlines. Retaining planks faced the walls of the central pit in the longhouse and depicted important scenes from tribal lore. This one tells the story of Great Spirit Cla-Tum.

Neah Bay

Makah Cultural and Research Center, Bayview Avenue, east end of the village (360/645-2711). In traditional times there were five villages, now there is one; but the flag of the Makah Indian Nation names all five: Di'ah, Wa'atch, Osett, Tsoo-Yess, and Ba'adah. Later Di'ah came to be known as Neah Bay, which today is the headquarters of the Makah Indian Nation. And the chief physical symbol of its pride as a nation is the Makah Cultural and Research Center, the most elaborate and impressive cultural resource of

any Native group in western Washington. The 1979 building, by Seattle architect Fred Bassetti, would be noteworthy in itself, but the care with which displays and dioramas have been created, and the mood of dignity and of reverence for a tradition that is evoked throughout—the work of Victoria designer Jean André—impress even more.

The centerpiece is the reconstruction of a traditional plank house, with its dirt floor, its several living compartments, its outlook on the beach and on a canoe being carved there, and the realistic sea view beyond the shore. On its outside one can see evidence of the midden on which such houses were constructed. Nearby is another reconstruction of a plank house exterior, showing the effective drainage system that surrounded such houses in rain country.

Thematic display cases flank these reconstructions, offering illustrations of the full range of Makah life: weaving, spinning, clothing, bedding, and basketry; plant gathering and hunting, food preparation and serving; trade; technologies of stone, bone, and wood; toys and games; design and symbolism. Classic canoes exhibit the marriage of art and utility.

A special exhibit preserves and honors the work of an influential Makah artist known as Young Doctor, whose career (1851-1934) spanned a period of enormous change for the Makah Nation.

In fact, extensive as all of this is, it is only a small part of what this Center possesses. It was initially built to house the archaeological riches unearthed at Ozette, one of the five traditional villages of the Makah. In 1970 the movement of the tides finally exposed the village that had been covered by a mudslide five hundred years before. The dig was closed after eleven years of continuous work. Some 50,000 objects are currently being processed, identified, and catalogued in the Center's adjacent research facility, designed by Seattle architect Eric Anderson to match the main museum structure. What is unique about the Ozette site is that, unlike a trash midden that has to be sifted for clues to an earlier culture, the mudslide preserved a cross-section of life in the process of being lived. Artifacts, protected from deterioration by the wet-site the slide created, were found whole.

The importance of this massive collection can also be seen in the fact, reported by the Center's director, that the Ozette material comprises roughly 95 percent of all Northwest Coast precontact materials (that is, from before the era of European exploration) that are available anywhere.

A new arch near the entrance identifies the Center. Two identically carved and painted poles—bird figures perhaps 15 feet tall, by veteran Neah Bay artist Frank Smith—support a welcome message of similar length between them.

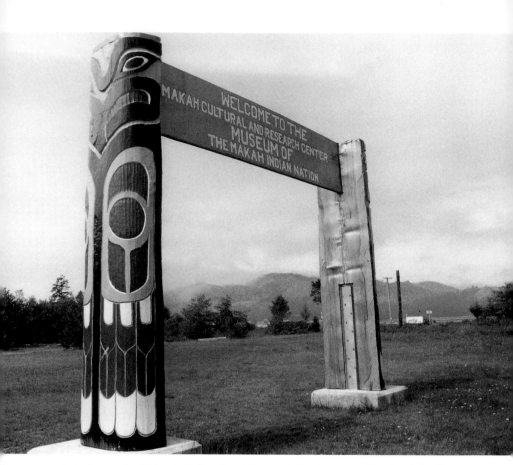

Entrance arch at Makah Cultural and Research Center, carved by Frank Smith

Forks

Forks Timber Museum, Highway 101 south of the city center (360/374-9663). In the midst of history and memorabilia that celebrate logging, the colorful if sometimes-threatened source of livelihood in this Olympic Peninsula outpost, there are two reasons for at least a momentary stop at the Timber Museum for those interested in Northwest Coast Native culture. One is a Salish totem pole, rather ungrandly tucked into a stairwell leading to the second-floor display area. The pole, commissioned by Oscar Kuppler for $50 in 1928, was completed by Native carver Joe Kallappa on the beach in front of his Port Angeles home. Initially raised at Kuppler's Lake Crescent home, it was later sold to a Mr. DeWilde, who donated it to the Olympic National Park. It is on loan to the museum from the National Park Service. Figures on the pole represent Thunderbird, Whale, Frog, and Fox.

The other reason for visiting the museum is an unfinished Native whaling canoe, about 28 feet long, that hangs from the second-floor rafters.

Found by loggers near the Sooes River south of the Makah Reservation, the canoe may be as much as 200 years old.

Galleries and Shops

Port Townsend

Ancestral Spirits Gallery, 921 Washington Street, 98368 (360/385-0078). Located on Port Townsend's "other" downtown street near the Haller Fountain, this quaint space has a sophisticated agenda. Owner-managers Annette Huenke and Alexander Vinniski specialize in Native arts from Inuit country and from the Northwest Coast. The owners tackle troublesome customs procedures in order to present some of British Columbia's best-known artists, including Bill Reid, Robert Davidson, Reg Davidson, Patrick Amos, Joe David, and Don Yeomans, among others. The gallery's collection includes contemporary sculpture, jewelry, carvings, drums, prints, and original paintings. Special events and educational programs are offered periodically throughout the year. Ask to be placed on the mailing list to receive notices.

North by Northwest, 918 Water Street, 98368 (360/385-0955). Port Townsend is more than just a place to visit in the summer tourist season. Boaters, bibliophiles, and arts and crafts enthusiasts can be found poking around colorful Water Street and its environs year-around. North by Northwest is a regular stop for many of those browsers. Since its inception in 1974, owner Liz Smith has carried a variety of Native-related items. In addition to popular sweatshirts and T-shirts with Native designs, the shop carries a variety of Indian and Eskimo masks, drums, and limited-edition prints. Jewelry, old and new baskets, soapstone carvings, Cowichan sweaters, and books related to Native art are found among its inventory, which also includes some Native items from the Southwest. Liz Smith offers to appraise baskets and accepts new and old items for sale on consignment.

Northwest Native Expressions, 637 Water Street, 98368 (360/385-4770). Masks, serigraphs, and lithographs adorn the brick walls of the lobby and stairwell of the historic Water Street Hotel. The stairs lead to a loft filled with carvings, weavings, and more prints. This gallery is a branch of Northwest Native Expressions operated by the Jamestown S'Klallam Tribal Center in Blyn. Works here are of the same fine quality, featuring such artists as Bill and Fran James, Andy Wilbur, Greg Colfax, Dale Faulstich, Oliver Ward,

James Bender, and Marvin Oliver. Most of the items are contemporary, but there are a few older collectibles from various Native populations in the United States and Canada. The gallery staff is attentive to the browser even while managing the hotel's desk duties.

Blyn

Northwest Native Expressions, Jamestown S'Klallam Tribal Center, 305 Old Blyn Highway, Sequim 98382 (360/681-4640). This very attractive, newer gallery is located just off the highway east of Sequim, as part of the Jamestown S'Klallam Tribal Center complex on the shore of Sequim Bay. The gallery sells masks, frontlets, headdresses, feast bowls, bentwood boxes, drums, prints, lithographs, jewelry, cards, and cassette tapes. During the summer the Jamestown S'Klallam Band frequently hosts programs designed to support the continuation of the tribe's indigenous art forms. Here there may be an opportunity to watch the amazing process of box-bending and the exacting art of drum-making. Basketry and weaving classes and children's cultural programs are held throughout the year. Call for a schedule of events. The Tribal Center has a number of permanent works, described under "Jamestown S'Klallam Tribal Center" in entry 4.11.

Northwest Native Expressions, 7 Cedars Casino, 1033 Old Blyn Highway (Post Office: Sequim 98382) (360/681-6755). This is a much larger branch of the gallery originally located at the Tribal Center, with a similar though more extensive inventory of art objects.

Port Angeles

Northwest Native Art Gallery, 1320 Marie View Street, 98362 (360/452-5839). If you want to see contemporary Makah art without driving all the way to Neah Bay, this bed-and-breakfast is a good place to do it. Owner Bonita Melville was born and raised in Neah Bay, and she has a great deal of information about Makah arts to share with guests. In fact, much of what is displayed in the shop reflects her own family's legends and history. The inventory, which is strictly contemporary, changes from time to time, and newer artists frequently find their first market here. Expect to see woven cedar-bark "baseball" caps, prints, baskets, jewelry, masks, drums, and delicately engraved silver earrings, pins, pendants, and bracelets.

Neah Bay

Dee-Ah Screen Prints and **Orca Drums,** Bayview Avenue, 98357 (360/645-2765). These family-owned shops are located adjacent to each other on the north side of Neah Bay's main street. **Dee-Ah Screen Prints** features original Makah designs created by John Goodwin, whose ceremonial name Ny-Tom appears on his work. Inspired by tribal history, Goodwin's designs—Thunderbird transforming, as well as themes depicting the canoe races during the annual Makah days—are worked into silver jewelry, reproduced as limited-edition prints, and applied to T-shirts, sweatshirts, aprons, and hats. Goodwin also works in wood, produces button blankets, and creates custom designs and logos in the Northwest Coast style.

 Orca Drums is a joint enterprise of Steve Pendleton and John Goodwin, who are brothers. Pendleton crafts the drums in the traditional way, using yellow cedar and elk and split deer hides; Goodwin supplies the painted design on the drum's face. Drums are available in 10-inch, 13-inch, 15-inch, and 17-inch diameters.

Makah Museum Craftshop, Makah Cultural and Research Center, Bayview Avenue, east end of the village (360/645-2711). The work of some of the talented artists who call Neah Bay home frequently finds its way into this shop, whose inventory is selected to support an educational and artistic appreciation of the Makah culture. Masks, model totem poles, drums, paintings, baskets, bentwood boxes, and jewelry are among the items regularly available here, along with books, maps, posters, and cards. Carving and weaving demonstrations are arranged from time to time as a means of furthering the educational mission of the shop.

Washburn's General Store, Bayview Avenue, 98357 (360/645-2211). A truly "general" store, Washburn's is a purveyor of fishing tackle, groceries, rental videos, hardware, and an array of fine works created by Neah Bay's Makah artists. Greg and Steve Lovik, Washburn's manager and assistant manager, stock masks, rattles, drums, jewelry, model totem poles, prints, beadwork, baskets, and woolen items. The art selection is small at any one time, but because of high quality and reasonable prices the inventory changes frequently. Makah artists, master carvers and apprentices, are participants in a cultural renaissance, producing works of beauty and significance after more than 150 years in which Western dominance denied the Makah their rich cultural heritage.

5. North

Everett to Blaine

Sites

With the exception of Lynden, all locations are on, or within twenty miles to the west of, Interstate 5.

5.1 Everett, Chief Shelton Totem Pole

5.2 Everett Community College Totem Pole

5.3 Marysville, City Park Totem Pole

5.4 Tulalip Tribal Center, Totem Poles and Canoe Shed

5.5 Tulalip, Elementary School Totem Poles

5.6 Tulalip, Marina Welcome Figure

5.7 Fidalgo Island, Swinomish Totem Pole

5.8 Fidalgo Island, Swinomish Community Smokehouse

5.9 Fidalgo Island, Swinomish Casino Multiple Objects

5.10 Fidalgo Island, Rosario Beach, "Maiden of Deception Pass" Story Pole

5.11 Fidalgo Island, Shell Refinery Totem Pole

5.12 Friday Harbor, San Juan Island, University of Washington Laboratories Carving

5.13 Bellingham, Whatcom County Museum of History and Art Totem Poles

5.14 Bellingham, County Jail Totem Pole

5.15 Lummi, Northwest Indian College Totem Pole

5.16 Lummi, Indian Business Council Totem Pole

5.17 Lummi Island, Totem Pole

5.18 Ferndale, Old National Bank, Campfire Totem Pole

5.19 Ferndale Library Totem Pole

5.20 Ferndale, Intalco Aluminum Corporation Totem Pole

5.21 Ferndale, Tosco Northwest Refinery Totem Pole

5.22 Blaine, Peace Arch Heritage Park Totem Pole

Everett

5.1 Chief Shelton Totem Pole, corner of 44th Street and Rucker Avenue. In 1922, the Everett Chapter of the Improved Order of Red Men, a fraternal organization, commissioned Snohomish Chief William Shelton to carve this lofty pole. By then Chief Shelton had been carving poles for eleven years; and for the sum of $3,500, he fashioned this 80-foot story pole to illustrate Lushootseed legends. Dedicated to the memory of Chief Patkanim, who had signed the Mukilteo Treaty in 1852, the pole was given to the City of Everett in 1929. After a good deal of discussion about whether it should be put in a park or have an outlook toward the Tulalip Reservation, it was eventually placed in its present busy urban location.

The iconography of the pole may seem obscure to visitors who are not acquainted with Native legends, but explanatory texts surround the base of the pole. A great deal of additional information is contained in Chief Shelton's book, *The Story of the Totem Pole: Early Indian Legends as Handed Down from Generation to Generation* (1923). He encouraged tribal members to share their private and personal spiritual stories openly, so that these ancient and powerful tales might instruct a younger generation.

Stories from sixteen of Chief Shelton's friends are depicted in part on the Everett pole. Since all are documented at the site, the summaries that follow are merely illustrations. On the bottom of the pole's north face is the legend of Hoh-Kevi, Little Diver. Hoh-Kevi was a diving duck, whose impetuous and irresponsible escapades brought misfortune to many creatures,

including one, depicted here, who was transformed into a snake while attempting to rescue Hoh-Kevi from a tree.

On the same side of the pole is the intriguing, gaping grin of Sway-Uoch, a tall, ugly, child-eating woman who lost two teeth when she forgot to remove the bones from her victims. The enigmatic form of a hammer, or maul, represents the story of Fox attempting to steal from Sckaat-Cheed's son-in-law, Mountain Sheep. Grizzly Bear is perched at the top of the pole, as if still chasing two black bear boys in a cedar tree.

Near the top on the pole's south side a gambling game, called *sawg-uts,* is in progress. Here the wolves are about to outsmart a deer by attacking before the end of the game. These and other illustrated stories are complex, but the reward of careful investigation is discovery of fantastic images, clever humor, and a timely moral.

5.2 Everett Community College Totem Pole, 801 Wetmore. Located in the campus courtyard adjacent to the student center, this pole was raised in 1992, shortly after the 500th anniversary of Columbus's arrival, as a symbol of new beginnings for the next 500 years. It was a gift of the United Native American Council and was carved by the Alex Paul family. Figures on the old-growth cedar pole are Thunderbird (representing welcome, vision, and

Chief Shelton totem pole, carved by William Shelton (5.1)

unity), Wolf (teachers and strength), Baby Frog (students and curiosity), Baby Bear (students and strength), Butterfly (education and graduation), and Baby Wolf (student leaders). Four colored circles at the top of Thunderbird are the four directions of universal learning and healing for all people. The style of the pole is intended to represent the variety of tribes present in the College's Native American population.

Marysville

5.3 Marysville Park Totem Pole, corner of Fifth Street and State Avenue. This small pole is probably a copy of an original by Chief William Shelton and, like most copies, is less distinguished than the original. According to one account by a Tulalip elder, for which we have been unable to find verification in the press or in local memory, that original pole had a violent history. It was reportedly burned by white residents of Marysville, in angry retaliation for the 1974 decision by Federal Judge George Boldt that upheld Native treaty fishing rights. According to this report, the local Boy Scout organization arranged for the present replacement and its erection in this attractive park in the center of town.

The pole is topped by Eagle, sitting on a strange, masklike, sharp-toothed head, painted red. Killer Whale with a seal in its mouth completes the configuration. An accompanying cement plate at its base does not admit to the reported substitution, saying that the pole was Chief Shelton's gift to the park in May of 1937.

Tulalip

5.4 Totem Poles and Canoe Shed, Tulalip Tribal Center, 6700 Totem Beach Road. This site on Tulalip Bay was designated by the Treaty of Point Elliott in 1855 as the reserve for three bands of Native people—the Snohomish, the Skykomish, and the Snoqualmie—who became known as the Tulalip Tribes.

Two poles stand before the Tribal Center. The smaller, near the canoe shed, was carved by two brothers, Herman Williams, Sr., and Clyde Williams, Sr. Eagle tops the pole, followed by a two-headed land animal with a frog on its back and a fish in its lower mouth. Then the two-headed one and a Whale are tooth to tooth, almost as if in competition for the fish. Finally, there is an enigmatic creature (perhaps Bear) that seems to be holding the bones of a fish, possibly a salmon, against its body. Its uncertain identity is partly the result of missing eyes, nose, and paws or hands.

Near the smaller pole is a fenced and roofed enclosure containing two

old racing canoes, one new racing canoe, and one classic Salish-style canoe carved in 1988 for the 1989 "Paddle to Seattle," one of the western Washington tribal events related to the State's Centennial.

The taller pole is accompanied by a plaque that reads "Donated by Delbert and Norman Buse, October 6, 1972, with sincere appreciation and special acknowledgement for the efforts of Charles R. Sheldon. Carved by Clyde Williams, Dennis Jerry Jones, and their helpers." The Buses owned a nearby timber company, where Sheldon, a long-time tribal council member, worked. It was Sheldon who had persuaded the Buses to contribute the log for the pole. Later, Jerry Jones was to head the Tulalip canoe-carving project for the "Paddle to Seattle."

Reading from the top, the figures on this pole are: Eagle; a very dark figure that may be Brown Bear; Man holding a fish by the tail; Killer Whale; Beaver; another unidentified creature, holding a frog by its hind legs; and finally a bird, probably Raven, with a missing beak.

5.5 **Totem Poles**, Tulalip Elementary School, Marine Drive and 36th Avenue Northwest. Old photographs show that these two poles were originally one pole. That accounts for the rather abrupt square top on the pole to the left. The reason for dividing the original pole, whether done by the artist or his successors, is not in the available record. Like other poles by Chief Shelton, these may represent "great guiding spirits" that have appeared to specific individuals known to the artist. While there is no available coherent account of the original, we can suggest likely associations of some of the images on these poles with an account of Indian totem legends written by Chief Shelton in 1913.

The pole on the right, which was the upper portion of the original, is carved on both sides. Eagle, at its customary top spot on the front, is easily identified. Both poles show the figures of men standing on disembodied heads, perhaps sea creatures (clearly so in one case, where a pair of feet protrude from the mouth) or a personified rock. On the taller pole, the head and part of the body of a serpent may be reference to the story of Szue-Szue, whose totem was Snake, who had the power to regenerate when its body was severed. Or the snake may be associated with the white bird—an owl—below it. Snake and Owl were Priest Point Joe's totem partners in healing, and the power of Owl is demonstrated in its grabbing the large black animal in its claws.

On the back of the taller pole, below Eagle, a man wears a blanket, has two feathers in his headband (one is missing), and holds a totem stick in each hand (again, one is missing). This figure is probably the great totem spirit of the mountain, who taught Charlie Bah-lolh songs and dances. The

figures at the bottom may be related to the experience of Chehalis Andrew, who met three spirit men in a canoe and was given by one of them a magic gambling bone for luck in playing the Indian game *slah-halub*. The bone, once held in the boy's hand, is missing.

At the top of the smaller pole are two *squed-aliches* (power talismans), given to Billy Edwards, which could find any lost thing or any missing person. Three similar objects at the bottom may be John Farrensby's lucky power talismans, representing three totem brothers who were of different sizes. Two girls in braids and pink dresses may be Billkadub's spirit guides, who promised to be with him and give him luck in gambling. (Billkadub was George Williams, a member of the Tulalip Tribes.) A gambling stick is probably missing from the image. The Bear-and-Man image may be the totem of George Swinomish, given to him in his days of brooding after the death of his wife. The spirit guide, both man and bear, assured George that he would live to a very old age, thus helping George overcome his preoccupation with death.

If these descriptions hardly exhaust the poles' significance, they at least suggest something of the spiritual richness the poles possess for the Native community that surrounds them.

5.6 Welcome Figure, Tulalip Marina, Totem Beach Road. Located on the porch of the building that houses the Marina Cafe, this small carving of a Native man wearing a blanket diagonally across his body is intended to greet visitors to the Marina. The word "Kla-How-Ya" that appears on its base is the Chinook Jargon word for "welcome." But it has two other more poignant purposes. It is a memorial to all of those members of the Tulalip Tribes who have been lost at sea, the latest having occurred in 1990 in an apparent boating accident. And it is also a memorial to "our brothers at Clam Village across the water." Sometime in the first half of the nineteenth century, a natural disaster occurred across the water beyond Tulalip Bay. A large section of Camano Head collapsed and fell on a Native village located at its base. It may have occurred in connection with an earthquake recorded on June 29, 1833, perhaps as a result of a tidal wave generated by the earth tremor. The memorial was carved by Kelly Moses.

On the walk leading from the marina to the cafe is an archway, topped with the silhouette of a Salish canoe and two paddlers and decorated on its two vertical supports with carvings: two killer whales on each post on the front; human figures on one post, and a killer whale and a shark on the other post, on the back. Old photographs suggest that the original of this arch, in much larger form, was located at Mission Beach Resort nearby on Tulalip Bay.

5.7 Swinomish Village Totem Pole, corner of Sneeoosh Road in the center of the village (located on the main road across Swinomish Channel from La Conner). The 61 foot pole was carved in the mid-1930s as a monument to Swinomish, Skagit, Upper Skagit, and Samish tribes, whose remaining members were then living on the Swinomish Reservation. Its images replicate images previously carved on interior posts in tribal council halls. They were meant to record knowledge that traditionally had been passed from generation to generation in the telling of stories. The legends that lie behind the Swinomish pole have been recounted by Martin J. Sampson, son of Mrs. William Peter, tribal doctor of the Upper Skagit people, with the permission of those whose stories the pole illustrates. Without such permission, the identity of its images would have remained hidden to the uninitiated viewer.

At the bottom of the pole is the Maiden of Deception Pass, whose story is told by its own pole at Rosario Beach (see entry 5.10). On the opposite side, the bottom figure is Twu-yalets-sa, the boy who was punished for his excessive killing of animals. A robe made of animal pelts rests on his right forearm. Three easily recognized images are Sun, Moon, and Star, representing the story of two sisters who married stars but later, disillusioned with their marriages, escaped back to their homes through a hole in the sky (the same legend is the theme of Dudley Carter's Marymoor sculpture; see entry 2.14). Further up the pole is Mink, who figures prominently in legends because of his overconfident and cunning ways. Other images depict Grizzly Bear and Rattlesnake, spirit guides who were instrumental in the recovery of a Duwamish chief's daughter from a strange illness. The Blackfish is on the pole because it was the spirit guide of Sam Dan, an Indian doctor who cured a child whom a government doctor had been unable to help. Other images—Mountain Goat, Black Bear in combat with a giant Lizard, two Wildcats, two smaller Lizards, Cougar, Hail, and Toad—are there because they served as spirit guides for prominent tribal members.

Man Swallowing Shark shows the superiority of humans over other living things, and the Makah-style canoe is there because of its importance in providing safe travel for families. Tokens represented on the pole—two small figures made to look like ducks (*tchaz-u*), round cedar disks (*squed-alich*), and cedar poles (*tust-ed*)—were familiar objects associated with traditional Native songs, dances, and games.

At the top of the pole are male and female American eagles. Perhaps the pole's most unusual feature is the figure, beneath the eagles, of President Franklin D. Roosevelt, known to the Native people as the Great White Fa-

ther, or the Chief of Chiefs. It was during the Roosevelt administration that Native people were given self-government, and Roosevelt's presence here commemorates that important event.

5.8 Community Smokehouse, north end of the village. This massive structure—210 feet long, 70 feet wide, and 45 feet high—is designed to be the center of Swinomish tribal life, a place for the most solemn of ceremonies—the tribe's ancestral religion, Seowyn, is practiced here—and the most joyous of community celebrations. The four-sided main room can accommodate nearly one thousand persons on its rising tiers. Vertical-beam supports, carved by the Alex Paul family, bear images important to the history of the Swinomish as a people: Salmon, Eagle, the Maiden of Deception Pass, and Bear on one side of the house, and Medicine Man with magic boards, Boy with magic robe and dog, Whale, and Medicine Woman holding a *tust-ed* cedar stick on the other. The inner panels of the doors have carved images of Man and Woman in poses that resemble welcome figures.

In addition to this assembly area, other sections of the building are designed to provide smaller meeting rooms, a small museum, kitchen and dining facilities, and restrooms.

Two tall, slender poles, each with the carved figure of Eagle holding Salmon, flank the main entrance to the structure and are also the work of the Paul family.

An earlier community house collapsed in 1945. Replacement was begun, but was interrupted when a workman was killed. New plans were drawn up in 1981, and a grant from Seattle City Light—compensation for the flooding of traditional lands when Seattle City Light reservoirs were built, put in trust for the Swinomish—provided funding. The tribe sought architectural designers with special sensitivities to the nature of the project, and found Cedar Tree Associates of Seattle, whose team was comprised of Folke Nyberg, University of Washington professor of architecture and urban design, and designers Will Glover and Art Peterson. Peterson, who had researched Native American architecture, said, "It was a life-changing experience to be working with people who blessed the building site and offered prayers to the cedar and other building materials that they would incorporate into their new life in the structure of the smokehouse." Construction work was done almost entirely by Native Americans, mostly from the Swinomish and Lummi tribes. The building was dedicated in the fall of 1992.

Three smokehouse events are open annually to the general public: the Swinomish Spiritual Encampment in April, a candlelight service in December, and Treaty Day in January.

Swinomish Community Smokehouse (5.8)

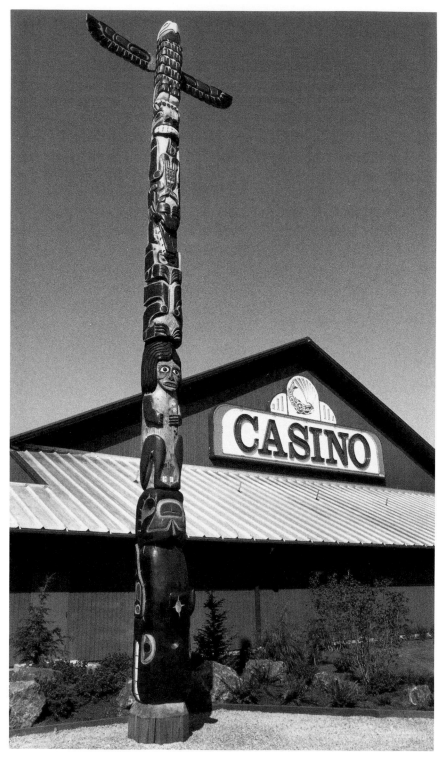

Swinomish Casino totem pole, carved by Alex Paul Family (5.9)

5.9 Swinomish Casino, 837 Casino Drive, Anacortes 98221 (360/293-2691). This new, large, impressive structure is north of Swinomish village, on a frontage road beside State Route 20, the main road between Mount Vernon and Anacortes. It is one of several casinos on western Washington tribal lands (Lummi, Puyallup, Tulalip, Jamestown S'Klallam), and it is distinctive in the way it features Native arts. The building design itself evokes the Native longhouse, both inside and out, with its post-and-beam construction.

Outside the entrance is a totem pole, some 37 feet tall, carved by Swinomish artists Alex Paul, Sr., Alex Paul, Jr., and Kevin Paul. It represents, from the top, Thunderbird, Bear (with a fish held against its body), Wolf holding a copper, a Native man with a pair of dice and gambling sticks, and Killer Whale.

Inside the main entrance, we see the circular casino logo in glazed ceramic, embedded in the floor, consisting of a female salmon (Swinomish means "people of the salmon"), her salmon eggs representing regeneration; a stylized clam shell above the fish; and Salish basket designs surrounding it.

The ceiling of the huge lobby is supported by massive cedar posts that have been carved with Native images by the Paul family. High up on the walls between the posts are masks and plaques carved by Bill Bailey; lower on the walls, framed prints in the Native styles are displayed, along with photographs depicting tribal history; and glass cases contain baskets and other artifacts characteristic of the Salish tradition.

5.10 Rosario Beach, "Maiden of Deception Pass" Story Pole, on Reservation Bay, south shore of Fidalgo Island. It was hardly surprising that, in raising their first story pole in this century, the Samish of Fidalgo Island chose a legend that explains their long persistence as a people, or that they chose to locate it at the legendary site of Rosario Beach. Ko-kwal-alwoot, the "Maiden" of legend, was fascinated by the swirling waters of nearby Deception Pass and swam frequently into them, her long hair floating behind her. She thus drew the romantic attention of the water spirit who lived in them and moved them. He proposed to marry her, but her father, fearing the girl would drown, refused permission. In angry reprisal, the water spirit withheld the seafood on which her people depended for survival. To save them, she joined the water spirit; she did not drown but was miraculously transformed, and the bounty of the sea was restored. The Samish believe that the Maiden has been their protecting spirit through the centuries since.

The 25-foot pole represents the Maiden in both her human and transformed presence. Above her head, she holds a large salmon, and on her dress are carved smaller evidences of the sea's bounty: mussels, crabs, her-

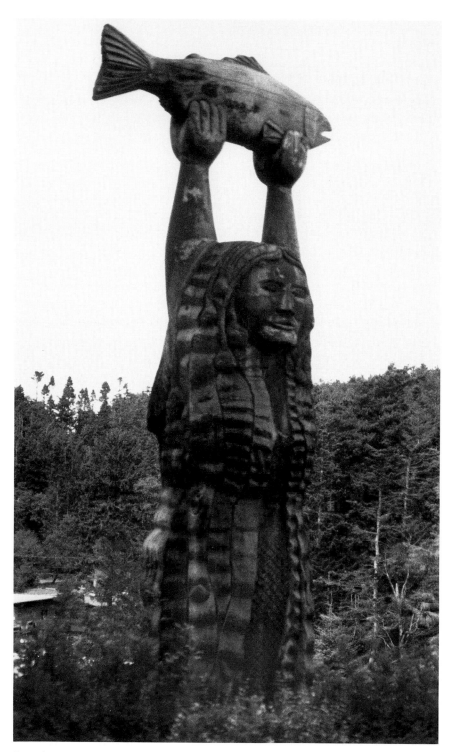

"Maiden of Deception Pass," designed by Bill Mitchell and carved by Tracy Powell and Samish tribal assistants (5.10)

ring. An official project of the
Samish Band, the pole was designed
by non-Native graphic artist Bill
Mitchell and carved by non-Native
Tracy Powell, with the assistance of
young tribal apprentices, all under
the careful supervision of Samish
elders. It was raised in 1983. The
5-foot working model of the
Maiden is on display at Potlatch
Gifts, the Anacortes shop operated
by the Samish Band (see entry in
"Galleries and Shops" below).

5.11 Shell Refinery Pole, March's
Point Road off Highway 20, east of
Anacortes. This pole by Dudley
Carter is a puzzle. It tells a story
about Mink that was part of the my-
thology of Swinomish, Snohomish,
and Upper and Lower Skagit people.
According to the version reportedly
used by the carver, Mink, in human
form, killed Wolf for stealing from
his salmon trap. Mink then deliber-
ately "sings his power" to let every-
one know why Wolf was killed.
Seeing Wolf's pelt hanging from
Mink's ceiling, Wolf's relatives plan
vengeance, but Mink escapes
through a secret exit under the wall
of his house. Later Mink is tricked
by Devilfish and becomes her cap-
tive at the bottom of the river.
When Mink tells her that his uncle,
the Sun, will dry up all of the devil-
fish unless she releases him, Mink is
able to return home safely.

The back of this pole, uncharac-
teristically (for a totem) incised in
shallow relief with figures that re-

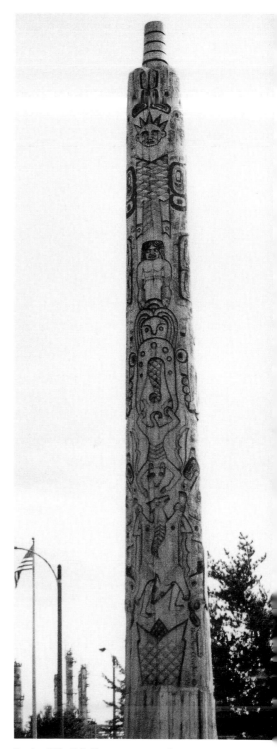

Back of Shell Refinery totem pole,
carved by Dudley Carter (5.11)

semble line drawings more than anything in the coastal tradition, is clearly related to the myth about Mink. Uncle Sun is at the top; the Devilfish has Mink by his hind legs; and, there, farther down, is Mink wearing the skin of Wolf. On either side of this pictorial narrative are a series of small elements, painted rather than incised, drawn from the formline tradition. Added by Bill Holm, who was assisting Carter, they may also relate to the myth in depicting Wolf and Devilfish.

So far so good. But what is one to make of the front of the pole, which Carter carved in bold, sculptural totemic style, and where one might ordinarily expect to find the primary statement of the text? At its top are a series of potlatch rings that sit on the head of a quadruped, which may indeed be Mink, with a small fish in its mouth. Next comes a figure that might be Eagle or Hawk, then a large quadruped that resembles a land otter, with what appears to be a serpent (but not Devilfish) in its mouth and Carter's mysterious "pineapple" crosshatch on its back. At the bottom, there is an androgynous humanoid of uncertain origin or purpose. With the possible exception of the first figure, the rest appear to bear no relation whatever to the pole's announced mythological text. This is Dudley Carter at his idiosyncratic best—or worst, depending on your point of view.

The pole is publicly accessible, standing in the refinery's unrestricted area, and its setting is handsome against the backdrop of Padilla Bay and Mount Baker beyond.

Friday Harbor, San Juan Island

5.12 University of Washington Friday Harbor Laboratories, 620 University Road (360/378-2165). Visitors to the town of Friday Harbor will find reward in a brisk twenty-minute walk from the commercial district at the harbor to the University of Washington's marine biology facility, on the harbor's north shore. The walk along University Road is pleasant in itself, and at its end the reward is a small gem of Northwest Coast Native-style art: a plaque, carved in shallow relief by Duane Pasco, representing a shrimp. It is located on the outside wall of the assembly hall, part of the Laboratories' conference-center complex.

Bellingham

5.13 Whatcom County Museum of History and Art Totem Poles, behind the Museum at 121 Prospect Street. These two poles are the work of Lummi carvers Morrie Alexander and Dale James. The 11-foot pole, the shorter of the two, was entirely Alexander's work from 1971, and it represents a Tyee

(head man, or chief) wearing a hat with three potlatch rings. Below that figure is a small power symbol, intended to show the head man's influence or prestige

The taller, 16-foot pole was begun by Alexander and completed by James after Alexander's death in 1973. The top figure, whose posture resembles that of a bear, Dale James has identified as a "Sasquatch," and the lower as Raven. There are small faces in the tops of the bird's wings. The pole is derived from a story about how Raven became the tribal crest for one group of Native people.

Morrie Alexander learned the carving craft in the 1940s from his grandfather, Jack Pierre. His work embodied themes and techniques derived both from the local Lummi and from their Cowichan kin in British Columbia. Dale James apprenticed to Alexander in a program sponsored by the Whatcom Museum and the Ford Foundation, designed to create a new generation of Lummi carvers.

5.14 Whatcom County Jail Totem Pole, 311 Grand Avenue. Few totem poles have the distinction of being "jailed." This commemorative pole is located, obscurely, on the grounds of the Whatcom County Public Safety Building and jail, on a one-way street which not many Bellingham residents and even fewer visitors are likely to use. Images are carved in the Salish story-

Whatcom County Museum of History and Art totem pole, carved by Morrie Alexander and Dale James (5.13)

Bellingham 139

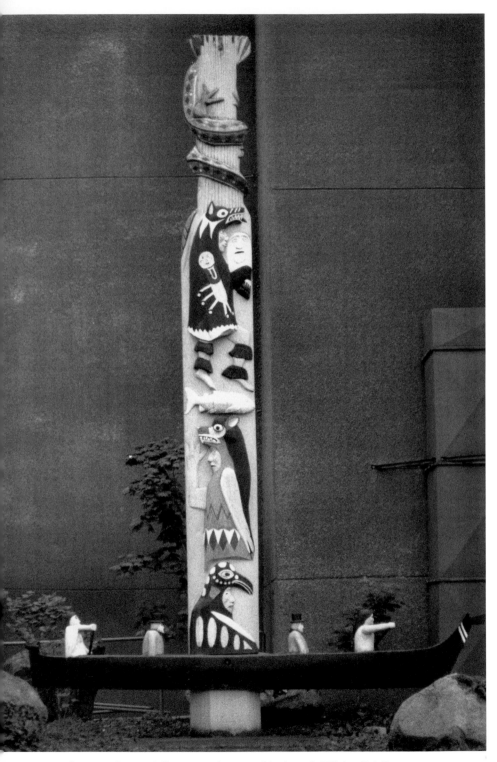

Whatcom County jail totem pole, carved by Joseph Hillaire (5.14)

pole style. They are carefully delineated, but their identities and meaning are elusive. What is clear is that the pole memorializes the event in 1852 when Captain Henry Roeder and Russell V. Peabody, the first permanent white settlers in the area, were met by local chief Chow-its-Hoot as they came ashore at the mouth of Whatcom Creek. At the base of the pole is a realistically carved canoe, paddled by two robust Lummi Indians, with two distinguished-looking, top-hatted gentlemen—Roeder and Peabody—as their passengers. Images on the pole itself—from detailed, carefully painted headdresses and ceremonial costumes to a diamond-backed reptile at the top—depict Native ceremonies and legends that are not shared publicly today. The pole was carved in 1951 by Lummi Joseph Hillaire, and erected and dedicated near the original landing site; it was subsequently restored and moved to its present location.

Lummi

5.15 Northwest Indian College Totem Poles, 2522 Kwina Road. Two tall poles at the corner of the College campus were carved in 1962 under the direction of Al Charles, who also carved poles at the bank in Ferndale (entry 5.18) and at Intalco Refinery (entry 5.20). For these at Lummi, he was assisted with one pole by his son Gordon and by Solomon Schultz, and with the other, by his son-in-law Morrie Alexander and by Ben Hillaire. A 60-foot racing canoe rests at the base of the two poles.

At the dedication, Al Charles told ancestral stories in the Lummi language related to the poles' imagery, which were reported in the press in translated and edited form. A brief account here will be a mere shadow of the rich oral tradition of legend and its carved representation as Charles recounted them on that occasion.

At the top of the pole on the left is Eagle, symbol of Lummi wealth and power. Next is the legendary figure of a young man, Sku-loxt, who lived with his tribe in the San Juan Islands and who sought the power to avenge his brother's killing during a skirmish with a mainland tribe. Sku-loxt is seen holding Quo-qui-stun, the weapon received in his power quest. He met the mainland enemy near what is now Gooseberry Point and killed nearly all of the villagers. The last surviving family head in the village promised Sku-loxt the land along the Nooksak and Red rivers in exchange for his life. The third figure on the pole is that hapless villager, pointing to the promised land that became the Lummi's mainland home. At the base of the pole are two replicas of masks that had belonged to Al Charles's family since before the arrival of Europeans.

The pole on the right is topped by Heron (or Crane), representing alert-

ness. Below is Bear, the emblem of the Charles family. The next two images illustrate the legend of Cha-cha-kin, who was devoured by a whale while paddling his canoe. Eventually the man was able to cut his way out of the whale's stomach with his hunting knife and was deposited on a beach now identified as Birch Bay. Because of Cha-cha-kin's carelessness, he was transformed into a mink, which may (or may not) be the identity of the otherwise unidentifiable green figure with white spots at the low end of the pole.

Inside the campus and in front of the College Learning Assistance Center is a unique pole that should not be missed, though information about it from tribal members is minimal. Originally carved by Joe Hillaire for a site elsewhere, it was returned to Lummi some years later and restored by Dale James after a tribal decision to raise it here. The only clearly identifiable figure is Eagle on its top. The major figure, obviously of legendary significance, wears a fantastic plumed headdress, holds three unidentified black strands in each hand, wears black leggings, and has talons on its feet. It stands on the head of a small black monster, with canines in a menacing mouth and claws at the ends of its forearms. Perhaps casual viewers were not meant to be privy to its meaning.

5.16 Totem Pole, Lummi Indian Business Council, 2616 Kwina Road. Lummi artist Morrie Alexander's distinctive style is evident in this two-figure pole, which greets visitors to the Council offices. Like his poles at the Whatcom County Museum (entry 5.13) and the Seattle School District Administrative Offices (entry 3.21), it is shorter than most Northern-style poles and is carved in a deep and bold design of Raven atop Wolf. Alexander's depiction of these animals is relatively realistic in their body proportions and features, making identification easy. This sculpture is the size of traditional Salish posts, but unlike those posts, which were carved on planks, this one has retained the pole-shape of the tree from which it was taken.

5.17 Lummi Island Totem Pole. Although there are many instances of Salish monumental art in the area between Everett and Blaine, this totem pole is, to our knowledge, the only major piece of Northern-style art in all of Area 5. It is located on private land with access by ferry from Gooseberry Point, and may be viewed only by prearrangement through Bellingham artist Scott Jensen, who fulfilled a commission from its owner to create it.

A complex pole, its imagery is drawn from three separate Native stories as recorded by ethnologist Marius Barbeau. The upper figures are Wasco, a supernatural sea wolf, with a young man between its ears; and, between its knees, the small seated figure of a woman, the young man's mother-in-law,

wearing a labret in her lower lip and a shaman's headdress on her head. The story tells how the mother-in-law falsely claimed to be providing food for her village at a time of famine, when in fact it was being provided by the son-in-law, who, wearing the monster's skin every night, gathered por pois, or whole from the seas and deposited it on the shore for the villagers to find each morning. Truth wins out in the end.

The middle figure is Raven with a broken beak, the result of a trick he tried to play on a halibut fisherman. When Raven dived into the sea, stripped the man's line of its bait, and tugged on the hook, the fisherman jerked the line so hard that it broke the bird's beak. Pulling up the broken beak, the fisherman placed it on the roof of his lodge so that Raven could reclaim it. When Raven tried to reattach it, it merely dangled from his chin—as it does on this image. Raven's up-turned tail feathers bear a bird-like face.

The bottom figure is Grizzly Bear, who caught sight of the beautiful daughter of a chief while she was out berry picking and lured her into marriage. The girl sits between Bear's legs, clasping her berry basket against her knees. This fated love affair does not have a happy ending.

But the three stories, taken together, make an elegant pole. Those interested in seeing it may call artist Scott Jensen (360/734-2158) to make the necessary arrangements. It will be wise to call several days in advance of a prospective visit.

Ferndale

5.18 Camp Fire Totem Pole, Old National Bank. Refurbished in 1985, the Camp Fire totem pole was originally raised in October 1965, and was dedicated by the Camp Fire Organization to the Ferndale community. It was designed by Carol Batdorf and carved by Al Charles, a Lummi Indian who had worked as a janitor at Ferndale's Central School. Charles found the 16-foot log on the beach and salvaged it for the carving. Topping the pole is Eagle, coinhabitant with the Lummi of the river banks and bays of the area and adopted by them as a symbol of their supremacy. Below the bird, and between its wings, is the representation of a Lummi mask, central to their ceremonial life.

Essential to their sustenance is Salmon, headed downward in the middle of the pole, and along each side of Salmon are small faces, signs of the year-around abundance in the area of fish, berries, roots, ferns, and cedar. At the bottom of the pole is Beaver, who is trapped by the Indians for fur and meat and who symbolizes as well the industriousness of the early white settlers in the area. Carved faces on the sides of Beaver are today's citizens of

Ferndale, looking toward the future. On Beaver's crosshatched tail is the log-and-flame logo of the Camp Fire organization, sponsors of the pole.

5.19 Ferndale Library Totem Pole, 2222 Main Street (360/384-3647). Originally carved in 1954 by Lummi Joseph Hillaire for a Mobil refinery in the countryside near Ferndale, this pole was to symbolize the spirit of cooperation between the corporate entity and the Lummi people. Title to the pole was transferred to a group of Mobil retirees in 1992, when ownership of the refinery changed, by which time the pole was in need of extensive repair. With historical guidance from George Thomas, and with funding from the Mobil Foundation, the refurbishing was accomplished in 1994 by Dan Thomas and Sean Siner, and the pole was presented by the retiree group to the City of Ferndale for display at the library.

The pole is an unusual combination of traditional imagery and contemporary appeal. On one side of the lower half of the pole, at its base, is the Lummi crest: a mythical serpent, protector of the people, coiled about a clump of bulrushes symbolizing productivity. On the other side is the crest of Hat-lick, carver Hillaire's father and a late Lummi spiritual leader. The figure of a man wears the traditional Hillaire family costume—war clubs and deer hooves decorating the tunic, with a headdress of split eagle feathers, symbols of humility. The man stands on a two-headed wolf.

The carver called the theme of the pole's upper half "Call of the American Indian for equality in industry." Four human figures surround the pole: on the west is Swie-whee, the mythical mask; on the south, Chee-san, the mighty wind; on the east, War-bonnet; and on the north, Humility. The four are described as "in a dancing mood, calling to Pagsis (Pegasus), the Flying Horse, who is standing on the pinnacle, looking down in a listening mood to the call of the Indians for equality in industry." If it seems strange to find a figure from Greek mythology topping a Lummi totem pole, it must be recalled that Pegasus, the Flying Horse, was Mobil's widely recognized corporate logo.

5.20 Intalco Aluminum Corporation Totem Pole, west of Ferndale to the end of Mountain View Road. This is yet another pole by Lummi Al Charles, who, with a seventh-grade education, supported his family as a fisherman, a cutter of shingle bolts, and a public-school janitor in Ferndale, as well as by his carving. Devoted to his Native culture, he taught the local Native language on the Lummi Reservation.

This pole was commissioned by the owners of the refinery, and their ownership is represented by a kind of heraldic crest near the top of the pole. Thunderbird is, not surprisingly, the top figure, and just below is a

complex non-Native design that bears the initials "P" and "H," standing for Intalco's two corporate owners, Pechiney and Howmet Realty. Below the crest is Raven, holding a disk (probably Sun) in his mouth; then a figure of somewhat uncertain identity, perhaps Sea Wolf; then Beaver; and finally Killer Whale.

5.21 Totem Pole, Tosco Northwest Refinery, 3901 Umick Road (360/384-1011). Like the Intalco pole in the entry just above, this one incorporates the symbol of its (former) corporate ownership, British Petroleum. Eagle is the topmost figure, below which is a green and gold shield bearing the initials "BP." Below is Killer Whale; then a bird, probably Raven; and finally Bear. The connection with the Intalco pole is no mere coincidence, since this one was carved by Intalco employee George Swanset, a Native from the nearby town of Nooksak.

A cautionary note: When the refinery was owned by BP, its security guards were less than enthusiastic about any photographs of this pole that might include, however incidentally, the refinery structures in its background. Even though the refinery is under new ownership, those who want to view or to photograph the pole from inside the grounds, rather than from a nearby public road, are advised to check initially with the administrative office.

Blaine

5.22 Peace Arch Heritage Park Pole. This 20-foot carved column, located at the eastern end of Heritage Park at the Blaine international crossing, is a sample of Dudley Carter's creative imagery. The figures on the column, carved in 1965, suggest international peace, Northwest Coast Native heritage, and Northwest Coast wildlife. A curious and beguiling semi-human figure crouches at the top of the pole, clutching a small bird, possibly a dove. Immediately below is a great curl-horned bird (Eagle?) atop a wolflike animal. Floral and human motifs are carved on the animal's back. The rear of the pole is a complex of typical Carter crosshatched elements, leading downward to a fanciful animal holding a winged insect in its claws. Other swirling and curling appendages wrap around portions of the pole in what we have come to recognize as Carteresque style. Here, especially in his inventive tableau on the back of the pole, as in others of his carvings, the artist both drew on and deviated from a Northern Northwest Coast artistic style.

The pole was carved for the Washington State Parks and Recreation Commission, with the assistance of Phil Claymore. Peace Arch Heritage

Park is accessible from State Route 5, taking exit 275 and following the signs.

Museums and Tribal Centers

La Conner

Skagit County Museum, 501 South Fourth, 98257 (360/466-3365). The most interesting—and by far the strangest—object in this small museum is a black headdress or mask. When worn, its front would come down to the level of the brow and its back would cover the back of the head and neck. From the top of the piece seven serpent heads protrude. Museum officials have been unable to determine the provenance of the piece. The best guess is that it may have come from one of the local Salish groups, perhaps representing a spirit guide and possibly used in an initiation ceremony.

A display case on "Indians of Skagit County" contains a *tust-ed* ceremonial pole, mauls, knives and scrapers, game pieces, hooks, a spindle whorl replica, and a variety of baskets. A second case on "Northwest Indian Design" includes baskets, a woven hat, and the headdress or mask described above. A third display on "Early Skagit County Transportation" offers Native and non-Native canoe models.

Bellingham

Whatcom County Museum of History and Art, 121 Prospect, 98227 (360/ 676-6981). A new annex, beside the main building, houses this museum's Northwest Coast collection in three glass cases. One is devoted entirely to woven objects—baskets, hats, bowls, bags, and other containers—representing Salish, Tlingit, Makah, Nootka, Cowlitz, Yakima, Pomo, and Ojibwa traditions. Most are from the collection of the late Melville Jacobs, professor of anthropology at the University of Washington. As this is written, the basket collection is being reorganized by Anna Jefferson, a member of the nearby Lummi Tribe.

Two other cases, numbering 108 objects, are partially in a diorama setting and contain masks (one by Kwakwaka'wakw master Mungo Martin), clothing, stone implements, fishing equipment, rattles, boxes, canoe models, a Chilkat blanket, and a racing canoe. Materials illustrative of the Native culture, prepared by Bellingham artist Scott Jensen and including a striking Northwest Coast–style transformation mask, are available for educational outreach in Whatcom County. Two totem poles by Lummi carvers

stand at the rear of the main building (see related entry 5.13).

Lynden

Pioneer Museum, 217 Front Street, 98264 (360/354-3675). This is clearly the most impressive collection of any small museum in western Washington. Until recently, the collection has been indifferently displayed and inadequately documented, but as this is written, the museum is seeking resources that will permit the cataloguing of the objects, redesigning of the display, and rewriting of the wall text. The objects were originally identified as from the Queen Charlotte Islands, home of the Haida people, but, in fact, the provenance of some of the items is still being determined. Much of the collection appears to be Tlingit in origin; some items are Kwakwaka'wakw; a few pieces may have originated among the Haida, the Bella Bella, and the Nootka.

We can hardly provide a complete inventory, preferring to urge readers to view for themselves, but here are some pieces that particularly interested us: a classic oyster-catcher rattle; a shaman's goat-horn crown and amulet; seal bowls once used as grease dishes; spoons carved of mountain goat horn; a classic frontlet for wear with a ceremonial headdress; and a classic Salish canoe prow, probably collected from Chief Henry Kwina of Lummi and carved in his grandfather's time, making it some 150 years old. A dramatic carved miniature made for sale by an unknown Native artist depicts a small, unclothed, kneeling figure, female, perhaps an alleged witch—head drawn back; hands tied behind her back with her own hair, which is perhaps being twisted as a form of torture; cloth cord around her neck; her face painted white, her body red.

Other items in this rather large collection include stone tools, baskets and other woven objects, maskettes, bowls and ladles, canoe models, clubs, and more. The larger part of the museum chronicles the pioneer origins and more recent history of Lynden and the surrounding area.

Galleries and Shops

Anacortes

Samish Potlatch Gifts, 803 31st Street, Box 217, 98221 (360/293-6404). The Samish Indian Tribe, whose traditional home is on Fidalgo Island where Anacortes is located, operates this shop. Its customary inventory includes carvings, jewelry, baskets, masks, prints, woolens, carved panels and

totem figures, cups, and cards, many of them reflecting the distinctive art and life of the Salish people, the larger culture of which the Samish are a part. Ceremonial items are available on order. The staff of the shop are glad to help meet customers' interests by making referrals to other shops and to Native craftspeople. This shop keeps irregular hours, so a call in advance of a visit is advised.

La Conner

Legends, 708 First Street, 98257 (360/466-5240). Given the location of this shop in the middle of the main thoroughfare in one of the most popular tourist destinations north of Seattle, it is understandable that a substantial portion of its inventory is "tourist art." But it is worth an occasional visit by those with a more serious interest, particularly in silk screen prints by Northwest Coast artists. On a recent visit, there was work by Art Thompson, Marvin Oliver, Susan Point, Richard Hunt, Patrick Amos, and Roger Fernandes, among others. Also there are handsome jackets by John Goodwin (Ny-Tom) and an occasional drum or canoe paddle, along with standard books and a wide variety of note cards. The shop is owned by a member of the nearby Swinomish Tribe.

Lopez Island

Kestrel Tool, Route 1, Box 1762, 98261 (360/468-2103). This retail source is unique among the shops listed here. Instead of offering the products of artistic activity, it sells the tools needed by some artists to produce their art. Greg Blomberg has developed a reputation for making fine carving tools— knives, adzes—of the sort traditionally employed by Northwest Native artists in carving everything from ivory and argillite miniatures to the most monumental shapes. In earlier times, each artist took pride in making his own tools, in addition to which there were no specialized suppliers like Blomberg around. Today his clientele includes both the casual hobbyist and the experienced and demanding professional. In addition to tools, Kestrel supplies related materials—for example, files, strops, and oil for honing blades—and technical information on Northwest Coast–style carving. A catalogue is available for a small charge.

PART II

Sources of the Art

Northwest Coast Native-style art has experienced a renaissance during the last thirty years and is vigorous and productive today.

Some contemporary artists have preferred to stay within traditional aesthetic conventions—those that appeared especially in the late nineteenth and early twentieth centuries—and to use traditional materials of wood, bone, stone, spruce root and cedar bark, wool, argillite, hides, silver, gold, and copper. Others have pushed out the boundaries by breaking up the traditional images into more abstract shapes, or by incorporating traditional Native forms into realistically rendered animals or landscapes, or by using new media, such as casting in paper or plaster. Many artists have adapted their art to the medium of the silkscreen print, producing limited editions that join quality with affordability for the collector.

Some of the artists producing Northwest Coast Native art are themselves members of Northwest Coast tribal groups, working primarily within their own traditional styles, while other Northwest Coast Native artists range across a variety of those coastal tribal traditions. Some Native artists have tribal origins outside of the Northwest Coast but have chosen to work within Northwest Coast styles.

Other artists producing Native-style art do not have Native origins but have been drawn to the art because of its inherent beauty and aesthetic strength. There is some controversy over the involvement of non-Native artists in the production of Native-style art. Our view, as applied in this guidebook, is that if the object produced is understood as fine art rather than as ethnographic artifact (in the latter case, as an object sought primarily because of its indigenous or specifically ceremonial use by Native people), the worthiness of the object should be judged by its faithfulness to the aesthetic traditions of the Northwest Coast and by its quality as fine art, not by the origins of the artist. Haida Robert Davidson, one of the most

149

highly regarded Native artists on the Northwest Coast, has expressed a similar view:

> I want these images to have their own strength so that a person does not have to have any knowledge in the Northwest Coast style to enjoy them. When I look at a fine piece of sculpture from Japan or Bali, it is not important to me on the meaning of that piece, but I admire the quality and craftsmanship. The importance is how the artist has put feeling into the piece and those feelings vibrate out to the viewer. I want my creations to vibrate out to the viewer and touch someone. [From an exhibition catalogue prepared by the Inuit Gallery of Vancouver, 1989]

Some of the "vibrant" Northwest Coast art, produced not only in the region covered by this guidebook but in British Columbia and southeastern Alaska as well, is the work of non-Native artists.

A further confirmation of our view is found in the fact that some tribes have actively sponsored the work of non-Native artists to assist them in the recovery of their own Native heritage: for example, David Forlines with the Quileute; David Horsley with the Snoqualmie; Duane Pasco, earlier with the Gitanmaax School of Northwest Coast Indian Art in 'Ksan, British Columbia, and more recently with the Port Gamble S'Klallam; Dale Faulstich and James Bender with the Jamestown S'Klallam; Steve Brown with the Makah and the Tlingit; and Bill Holm, widely over the years and most recently in a canoe project with the Tulalip.

In British Columbia, for years non-Native John Livingston was an integral member of the studio in Victoria headed by Kwagiulth Tony Hunt. Sometimes Native carvers have actively sought the collaboration of non-Native artists in the execution especially of larger works—for example, Nuu-chah-nulth artist Joe David with non-Native Loren White, Haida Robert Davidson with non-Native Glen Rabena, and Tlingit Nathan Jackson with non-Native Steve Brown; and Native master carvers have recruited apprentices who are not Northwest Coast Natives—for example, Haida Robert Davidson and Creek apprentice Gloria Goodrich.

Native artists sometimes commission highly regarded non-Native artists to produce art works (especially masks and rattles) for use in potlatches the Native artists will give, attesting to the authenticity of the non-Native work in discerning Native eyes. Some prominent Native artists acknowledge non-Native influence on the development of their own art—especially the influence of Bill Holm's landmark book *Northwest Coast Indian Art: An Analysis of Form* (1965) and his classes at the University of Washington from 1968 to

1985. A few Native artists apprenticed to non-Native artists early in their careers—Nuu-chah-nulth Joe David and Tsimshian David Boxley with Duane Pasco.

At the same time, non-Native artists such as Holm and Pasco are clear that their own sources of inspiration are to be found in the long tradition of Native masterworks that reaches into the present. Clearly, the interaction has resulted in mutual enrichment.

We have argued that, viewed in a fine-art perspective, the Native/non-Native distinction is irrelevant. At the same time, it is our conviction that information on the artist's heritage ought to be readily available to anyone to whom it matters. For that reason, we include it in the brief artist sketches that follow. Any gallery listed in chapters 1 through 5 will gladly provide it, and it is available from the artists themselves. We are not acquainted with a single non-Native artist in the region who is producing Native-style art for sale to the general public, who claims Native origin inappropriately, either by direct statement or by implication.

6. Artist Biographies

In the brief biographies that follow, western Washington's Native artists of non-Northwest Coast tribal origin are identified by an asterisk (*); non-Native artists are identified by a dagger (†). Names of artists of Northwest Coast tribal heritage have no distinguishing mark.

Telephone numbers are provided, in the event that a collector may want to inquire about where an artist's work is currently displayed in a gallery or what may be available for sale that is not currently displayed, or to discuss a possible commission. Buyers should not expect that work purchased directly from an artist will be at a lower price than would be charged by a gallery.

The artists named immediately below live and work within the region covered by this book. Some of the more prominent artists working in British Columbia and Southeast Alaska are listed at the conclusion of this section, to assist potential collectors with name recognition. Information provided here is intended to alert the collector to some of the artists whose work is highly regarded both by collectors and by other artists. Since our aim is breadth and representativeness rather than exhaustiveness, the absence of an artist's name should not be interpreted as a negative assessment of that artist's work.

Neither should the inclusion of an artist named in the entries below be interpreted as an endorsement by that artist of the authors' views on the Native/non-Native art controversy stated above.

Western Washington Artists

Telephone numbers in the listings were accurate at the time of publication. Should any number be found not to be current subsequent to publication,

we recommend that inquiry be made of one of the galleries listed in the preceding chapters.

† **Yukie Adams** (206/672-9204) reflects Tlingit and Haida influence in her silkscreen prints and mixed-media paintings. One of her art works was selected by the cities of Edmonds and Lynnwood as a gift to the city of Nankai, Japan. The Stonington Gallery in Seattle and the Waterfront Gallery in Juneau are places where her work can often be seen. Commissions may be arranged directly with the artist.

† **James Bender** (206/842-5396) has worked in the Northwest Coast Native style since 1971. His most public work is to be seen in Victor Steinbrueck Park, opposite the Pike Place Market in downtown Seattle (entry 3.15): two 50-foot totem poles, one in classic Haida style and the other with only two figures at its very top, a farmer and wife, representing the purveyors of home-grown fruits and vegetables to be found in the Market. Bender's output includes dramatic transformation masks and feast dishes, among other carved objects. He is particularly skilled in silver and gold engraving, especially of bracelets with Northwest Coast designs. He is represented by the Bailey-Nelson and the Stonington galleries. Commissions may be arranged directly with the artist or through the galleries.

David Boxley (360/638-1748) has pursued his work as an artist with great intensity—an intensity that has permitted him, remarkably, to complete more than forty monumental poles (five of them are described in chapters 2 and 4 of this guidebook), to say nothing of a range of other objects, in a career that did not really get serious until the early 1980s. Intensity also marks his loyalty to the heritage in which he was raised, originally in the Tsimshian enclave of Metlakatla in southeastern Alaska. While some Northwest Coast Native artists may sometimes work in styles reflecting tribal traditions other than their own, Boxley has a single-minded commitment to Tsimshian styles and images. Virtually the only objects he has chosen not to produce are drums and canoes. He was commissioned to make two identical speaker's staffs for the 1990 Goodwill Games held in Seattle, one of which was ceremonially presented to the mayor of St. Petersburg, Russia, the other of which can be seen in Seattle's Museum of History and Industry (see entry in "Museums and Tribal Centers," chapter 3). Other commissions have been given as gifts to the King and Queen of Sweden, the Emperor of Japan, the president of West Germany, and the mayor of China's second largest city. Having moved from Alaska to the Seattle area a few years ago, Boxley's work is often seen at The Legacy and at the Stonington Gallery.

Commissions may be arranged through the galleries or directly with the artist.

† **Steve Brown** (206/781-7059) is one of the most highly regarded artists throughout the Northwest Coast, known both for the quality of his own work and for his frequent collaboration with Native artists. Brown studied anthropology and art history at the University of Washington, was a student of Bill Holm, and has been close friend and associate of Holm throughout the years. He began his professional career as an artist with a staff position at the University's Burke Museum from 1969 to 1974. In 1990 he became Assistant Curator of Native American Art at the Seattle Art Museum. In the intervening sixteen years his work was centered in southeastern Alaska; and although he has concentrated on restoration and replication, his commissioned work includes jewelry and painting as well as carving.

Brown's best-known public replications are the classic Chief Shakes totem pole and house posts in Wrangell (carved in association with Tlingit artists Wayne Price and Will Burkhart). Commissioned work includes a relief panel (also with Wayne Price) at the State Ferry Terminal, and a large panel and two house posts (one with Price) at the University of Alaska, all in Juneau; and a large wall panel at the University of Alaska in Sitka. In this guidebook, Brown's work is represented in entries 2.1, 3.28, and 4.19. His jewelry is sometimes seen at the Stonington Gallery. Commissions may be arranged directly with the artist.

Randy Capoeman (206/532-7344), a member of the Quinault Nation on Washington's central coast, attributes his knowledge of Quinault culture and tradition to the influence of his grandfather, his grandmother, who was a noted basketmaker, and other members of his family. The influence of more northerly styles—Tlingit, Haida, and Kwakwaka'wakw—are clearly seen in his serigraphic prints. He acknowledges drawing inspiration from fellow Quinault Marvin Oliver, who works primarily in the Northern coastal tradition and with whom he has studied, and from the writings of Bill Holm. Capoeman's work has been displayed at Quintana's in Portland and in Seattle at the Burke Museum, the Stonington Gallery, and The Legacy, Ltd. Although he accepts commissions, he prefers to have them arranged through a gallery.

Ed Eugene Carriere (206/297-2567) was raised on the Port Madison Reservation, home of the Suquamish Tribe. He wove his first Salish-style basket at the age of fifteen, having been taught the art of traditional basket weav-

ing by his great-grandmother, who raised him. That was some forty years ago, and he is still at it. Carriere is particularly noted for Inner Puget Sound clam baskets, folded cedar bark baskets, and burden baskets. Rather than depending on commercially available materials, he gathers his own—cedar limbs, roots, bark, and grasses—and thus, while working within traditional techniques and forms, puts his own distinctive imprint on the end products, which are available directly from the artist.

† **Dudley Carter** is the only nonliving artist included among these biographies. Carter, who died in 1992 just a month short of his 101st birthday, was one of the best-known and most prolific sculptors in the Seattle area. He grew up in British Columbia logging camps operated by his family, and there became fascinated with Haida and Kwakiutl monumental art. He produced his own first pole in 1932, and was an active carver up to the time of his death sixty years later.

Carter's work is included in this guidebook for three reasons: it is, apart from anything else, a prodigious sixty-year achievement; it is for much of the public their most prominently encountered instances of monumental art with Native derivation by a single artist in western Washington; and given its prominence, that derivation and its distinctive differences from Northwest Coast Native art deserve to be noted for the record.

Bill Holm, who in earlier years worked with Carter and knew him well, says that Carter thought of his work only as wood sculptures rather than as totem poles in the traditional sense. Though in their monumental and sculptural character, and sometimes in their themes, they resemble poles of the Northern Coast, Carter was clearly not trying to mimic the Northern tradition. In some ways his poles are more kin to their Southern, that is, Salish and Nuu-chah-nulth, counterparts, in two senses. As with the South, which had no indigenous tradition of monumental totemic art and where the artist had to create his own visual language, the figures that appear on Carter's poles are often idiosyncratic rather than reflecting some standard iconography. The maned Eagle at the top of the Northgate pole is an example (entry 3.39), as are the small, maned quadruped at the top of the Blaine pole (entry 5.22) and the winged Mountain Goat on the Northwest Hospital sculpture (entry 3.40); and who can say what function, other than that it pleased him aesthetically, is served by a kind of "pineapple" design found on many of his carvings.

In another sense, too, Carter's work resembles the Southern artists' work: like theirs, his poles are primarily designed to recount a myth or legend with broad significance, rather than to display inherited crests having significance for the owner's family. And as with some of the Southern poles,

the meaning of Carter's poles is at least partly private, possessed in the mind of the artist and not available for surface discernment. In some instances Carter seems to have created his own idiosyncratic world of myth, at once like and unlike the mythical world of the Northwest Coast.

Dudley Carter's work will best be appreciated when the viewer recognizes the ways in which it both is and is not Native-style art.

Gregory Colfax (360/645-2564) sprang dramatically to public attention in 1986 when a bent-corner box of his making was chosen for the cover illustration of *Lost and Found Traditions: Native American Art, 1965-85,* the catalogue of a major traveling exhibit of contemporary Northwest Coast Native art. The box, with a three-dimensional Wolf's head and human rider protruding from the two-dimensional, Makah-style painted surface, and with a tape recorder inside the box that played Makah songs and stories, seemed a particularly apt joining of an older "lost" tradition and a newly "found" artistic imagination.

Colfax has been perhaps the central figure in the unusual artistic productivity that has marked Neah Bay's Makah artists over the last decade. His carvings are frequently displayed at the Burke Museum Gift Shop and at The Legacy in Seattle. His welcome figure greets students and visitors at the entrance to The Evergreen State College near Olympia (entry 1.8), and his work is represented at the Center for Contemporary Arts in Santa Fe. Commissions may be arranged directly with the artist.

George David (206/334-9511) had to be literally "talked into" trying his hand at carving in the Northwest Coast Native style by his older brother Joe David, who was already an established artist in British Columbia. While George had often seen and admired work by Joe David, Ron Hamilton, Duane Pasco, and others, the quality of that work was intimidating and seemed much too accomplished to emulate. His brother persuaded George that when those artists first put knife to wood, they were no more accomplished than he would be. Thus encouraged, George began to experiment, resulting in a career now twenty years in process, during which he has been producing masks, drums, rattles, poles, panels, prints, silver jewelry, and objects in ivory. Although he customarily works in the style of his own tribal group—the Clayoquot band of the Nuu-chah-nulth—on occasion he has produced an object in one of the other coastal styles.

His commissioned work has been presented to the King of Norway by the Port of Seattle and to the mayor of Kobe, Japan. His work can sometimes be seen in Seattle at The Legacy, Snow Goose Associates, the Burke Museum Gift Shop, and the Stonington Gallery. Commissions may be ar-

ranged directly with the artist or through one of the galleries.

† **Peter Dunthorne** (360/856-1455) was responsible, from 1986 to 1991, for the handsome Northwest Coast designs appearing on various kinds of button produced by the Upper Skagit people of Sedro Woolley and found in gift shops throughout western Washington. No longer associated with that enterprise, Dunthorne is now established in his own studio, producing one-of-a-kind works for galleries and working on private commissions. He has had nearly twenty years' experience as an artist in two-dimensional Northern formline style, applied to boxes and panels and designed as logos.

† **Dale Faulstich** (360/683-5233) and his Creative Art Enterprises have had a special relationship to the Jamestown S'Klallam Tribe, where he completed the totem pole that stands in front of the tribal administration building. His prints, plaques, and surface designs adorn other buildings in the tribal complex east of Sequim, and he led the team of artists that provided nearly a dozen poles, as well as panels and glass art, for the tribe's 7 Cedars Casino, just down the road from its tribal center. Faulstich's art work in wood, stone, and serigraphic prints, reflecting a range of Northwest Coast tribal styles, is featured in Northwest Native Expressions, the gallery shop operated by the S'Klallam Tribe (see entry in "Galleries and Shops," chapter 4). Over a twenty-year career, his work has enriched many private collections. He accepts commissions and prefers to arrange them himself.

Roger Fernandes (206/524-8968), a member of the Lower Elwha Klallam people, is one of the artists who has been engaged by the King County Arts Commission to complete part of a large project on the Duwamish River at the site of an old fishing weir and to provide a Native design for a Metro bus shelter (see entries 2.10 and 3.38). A professional artist, illustrator, and photographer for the last twenty years, Fernandes's smaller-scale work combines traditional Salish designs with realistic painting and drawing to depict legends and beliefs of importance in the Salish experience. These designs are often produced as limited-edition prints. Northwest Native Expressions, the gallery operated by the Jamestown S'Klallam in Blyn, features his work. Commissions may be arranged directly with the artist.

† **Jean Ferrier** (360/437-2742) is an experienced carver whose masks and other objects reflect her love of the dramatic Bella Coola style. Her work is included in private collections in Seattle, Los Angeles, and Santa Fe. Primary gallery outlets include the Stonington Gallery in Seattle, Objects of Bright Pride in Juneau and New York City, and Inside Passage Arts in

Skagway. Although her one-of-a-kind work is in wood, occasionally her designs are available on jewelry (bracelets and earrings) cast in sterling, combining design quality with affordability. Commissions may be arranged directly with the artist or through one of the galleries named above.

* **Gloria Goodrich** (206/334-1007) is an artist of Creek and Seminole heritage who began her artistic career in 1987. In traditional times on the Northwest Coast, carving was almost exclusively the work of men, but in the current renaissance of Native-style art, women have been distinguishing themselves in their work with wood, especially in British Columbia. Gloria Goodrich is one of a very few western Washington women carvers working in the Northwest Coast style. Her considerable natural talent has been enriched by a two-year apprenticeship with Haida artist Robert Davidson, as it was by earlier work with Barry Herem. Masks and rattles are among her works that are found in private collections in this country and in Canada. Commissions may be arranged directly with the artist.

John Goodwin (360/645-2109), a Makah artist, is known ceremonially as Ny-Tom, the name he signs to limited-edition silkscreen prints, drums, bent-corner boxes, button blankets, and silver engravings. His work is inspired by the legends and myths of the Makah people, who live on the westernmost tip of Washington's Olympic Peninsula and who are the southern relatives of the Nuu-chah-nulth (formerly Nootka) of Vancouver Island. In his shop, Dee-ah Screen Prints in Neah Bay, Goodwin's distinctive designs are also applied to T-shirts, sweatshirts, aprons, and caps, and increasingly to a range of designer clothing. Goodwin collaborates with his brother, Steve Pendleton, in making drums under the name of "Orca Drums," with Pendleton fashioning the frame and Goodwin providing the painted design. Pendleton came to his distinctive craft through early experience with the drumming that accompanies the songs and dances of the Makah people. In addition to their own retail outlets in Neah Bay, work by Goodwin and Pendleton is frequently seen at The Legacy in Seattle, at Northwest Native Art in Port Angeles, and at the Leona Lattimer Gallery in Vancouver, British Columbia. Commissions may be arranged directly with the artists.

† **Jay Haavik** (206/325-0469), one of Seattle's best-known artists in the Northwest Coast style, was selected by the Puyallup Tribe to design a large painted house front, including a sculptured house post and two brick relief sculptures, 9 feet in diameter and embodying Native designs, for the new Takopid Health Center near Tacoma (see entry 1.13). Haavik's venture into

nontraditional media is not new. Although his artistic reputation was originally built on traditionally styled masks, panels, boxes, and poles, more recently he has been making fine furniture embellished with Northwest Coast motifs. Other major commissions have been received from Scandinavian Airlines, the King County Arts Commission, and the Washington State Arts Commission, and his work can be seen in Edmonds Community College's branch in Kobe, Japan. In Seattle, Haavik's work is featured at the Bailey-Nelson Gallery and is frequently seen at Quintana's in Portland. Commissions may be arranged directly with the artist or through one of the galleries.

Antoinette Helmer (206/767-5334) is a Haida artist who produces traditional spruce root and cedar bark basketry. Her work is often on display at Snow Goose Associates and the Burke Museum Gift Shop. Commissions may be arranged directly with the artist.

† **Barry Herem** (206/634-2056) first developed a fascination with the Northwest Coast and its cultures twenty-five years ago when he worked on a team surveying old Native village sites along the British Columbia coast. He has been producing his own Native-style art for at least twenty years. He describes his artistic style as "generic Northwest Coast with a Tlingit emphasis." Herem is acknowledged to have pushed out the boundaries of traditional Native-style art, both in the subject matter of his silk screen prints, his most common medium, and in the media themselves. He was probably the first artist in the Northwest Coast style to use cast paper for masks and box-front designs.

Barry Herem's work in corten steel and in aluminum is now very familiar, as are his castings in bronze and in silver. He has received two major commissions from Alaska Airlines, his work is included in public and private collections across the country, and his prints particularly are available in most of the galleries included in this guidebook. Commissions may be arranged directly with the artist or through one of the regional galleries that display his work.

Ron Hilbert/Coy (206/783-7847) is an active participant in traditional Winter Ceremony dances inherited from his Tulalip and Upper Skagit forebears. Clearly, this ceremonial experience has been the shaping influence on his art, depicting as it does in narrative style the spiritual drama in the smokehouse, which few non-Natives are privileged to see. Typical of his work are the five carved, painted, and burned panels in the Center House at the Seattle Center, "Spirit Dancing in the Smokehouse" (entry 3.20); the

long cedar panel on a private residence on Eastlake Avenue East in Seattle, whose main theme is the old First Salmon ceremony, more recently revived by the Tulalip Tribes (entry 3.24); a large "longhouse" bas relief at the Daybreak Star Indian Center, depicting winter dances (entry 3.35); and a painting, "Spirit Dancing: The Practice of Our Ancestral Religion," commissioned for the Burke Museum's exhibition "A Time of Gathering" that celebrated, on the occasion of Washington State's Centennial, the State's Native heritage (the painting is reproduced in the exhibition catalogue; see chapter 10). Hilbert/Coy also credits the influence of his grandparents, Baba and Louisa Anderson, and of his mother, storyteller and Lushootseed scholar Vi Hilbert. He received formal training at the Burnley School of Professional Art and at the Cornish School of Fine Art, now teaches art at the Pratt Institute in Seattle, and is a freelance graphic artist, book illustrator, and storyteller.

† **Gerald A. (Jerry) Hill** (360/331-8876) was raised in a family whose Pacific Northwest roots go back to 1848. As a boy, he went with his family on trips to British Columbia, where he saw Native arts in their aboriginal context and met Native artists. He was further inspired by artifacts and books collected by family friends. Later he studied Northwest Coast Native art with Bill Holm at the University of Washington. His own work in that style has been exhibited since the late 1970s. Specially trained in the making of jewelry, for which he is particularly well known, in more recent years he has also been producing sculpture. He has written that, in his work, he looks for cross-cultural myths that "will help us come together as a community." His work can most often be seen at Fox's Gem Shops and at Orca Bay gallery, in Seattle, and at Childers-Proctor Gallery in Langley. Commissions may be arranged through one of the galleries or directly with the artist.

† **Bill Holm** (206/542-8486) does not produce Native-style art for the retail market. He is included in this list because of his vast influence on Native and non-Native artists alike over a period of more than twenty-five years, because important museum pieces of his Native-style work appear in chapter 3, and because, as a Western-style painter, he produces art works that take the Northwest Native culture as their subject matter.

One of the leading scholars and teachers in the field of Northwest Coast Native arts, Holm is honored as well for his expert knowledge of the Native arts of the Plateau and the Plains. Of international reputation, he is widely sought-after as a contributor to scholarly works, as a lecturer, and as a consultant. His influence has been felt ever since the appearance of his *Northwest Coast Indian Art: An Analysis of Form* (1965), which has taught more

than a generation of artists how to do traditional Northwest Coast art, with eight additional books and countless articles in the years since. Those with interests ranging from casual to intense took his courses in art history and anthropology at the University of Washington from 1968 to 1985. Throughout this entire period and into the present, he has given generous individual support and encouragement to artists and scholars.

Although Holm is a master artist in the Northwest Coast Native style, over the years his production of such works has been primarily for private purposes rather than for sale. Three of his monumental carvings are outside the entrance to the Burke Museum (see entry 3.30), and other examples of his traditional carving are found in educational exhibits inside the Burke Museum. Having originally received a Master of Fine Arts in painting, Holm retired from University teaching and curatorial responsibilities in 1985 to devote himself to work at the easel, and since that time he has consistently produced Western-style acrylics, drawings, and limited-edition prints depicting Native scenes on the Northwest Coast, the Plateau, and the Plains. Paintings and drawings are available through the Stonington Gallery; limited-edition prints of his original paintings are available from the Stonington, the Burke Museum, and other fine galleries. He continues to produce such work in his Haida longhouse-style studio. Commissions may be arranged directly with the artist.

† **David Horsley** (206/367-0275), an artist and educator, has had a long and intimate association with the Upper Inland Salish people, has been a tireless advocate of their art and culture, and has been instrumental in bringing both to wider public attention. He began his career with the carving of a series of dance masks in 1976, and some time later was invited to direct the Snoqualmie Dance Troupe. As author and educator, he continues to work within the Snoqualmie Tribe on preserving and transmitting its heritage, especially among its younger members, and has published a coloring book of Salish designs, as well as an account of the "transformer legend" of the Upper Inland Salish. As an artist, Horsley works with a variety of materials. His largest project, under the sponsorship of the King County Arts Commission, can be seen at Beaver Lake County Park, north of Issaquah. For a picnic shelter there, he and an assistant carved three 10-foot house posts, spirit figures of the kind Salish people erected to support the interior beams in a traditional longhouse (see entry 2.13). Commissions may be arranged directly with the artist.

† **Patrick Huggins** (360/856-4041) earned a double degree in architecture and anthropology from the University of Washington and later spent three

years in informal study of Northwest Coast Native art, as well as in formal classes conducted by Bill Holm and Duane Pasco. After an intensive year-long apprenticeship with Pasco in 1984, Huggins joined Pasco's studio and has assisted especially in the production of canoes and very large totem poles. An accomplished carver in his own right, his work in wood has included masks, rattles, and bowls. Huggins also produces an occasional silk screen print. Stylistically he ranges across a number of coastal traditions: Tsimshian, Tlingit, Bella Coola, Nuu-chah-nulth, and Salish. His work is most frequently displayed at the Stonington Gallery in Seattle. Commissions may be arranged directly with the artist.

Fran and Bill James (360/758-2522), mother and son, are weavers of blankets and baskets in the Lummi (Salish) style. They live on the Lummi Reservation, where Fran prepares the wool, bartered from the owner of a local flock, by washing, drying, carding, and spinning it. Bill weaves the wool on one of his six looms, using traditional Salish twill geometric patterns of stripes and diamonds. In addition to weaving blankets, Fran and Bill make ski socks and hats and sell the wool yarn by the ounce. In the spring, they gather materials for their baskets—cedar bark, bear grass, nettle fibers, fern roots, sweet grass, and rye grass. Fran weaves the baskets, again using traditional Salish techniques and patterns. Their work is available through shops in the Seattle area and by prepaid mail order, and work may be commissioned directly with the artists. Bill James is also a teacher of the Lushootseed language at Northwest Indian College in Lummi.

Anna Jefferson (360/676-2772) credits her career as a basket weaver to a dream that occurred at a time when her life was in considerable turmoil. As a result of the dream, she enrolled in Northwest Indian College at Lummi, and later realized that two of the figures she had been unable to identify in the dream were, in fact, her teachers Fran and Bill James (see above). Now Jefferson herself teaches Lummi culture and basketry at the College. More recently, she graduated in anthropology and art from Western Washington University, the first member of her family to receive an undergraduate degree. The excellence of her work as a weaver has been recognized by a solo exhibit at the Whatcom Museum of History and Art, which included baskets, hats, and cattail mats, as well as by group exhibits in galleries and other museums. She gathers her own natural materials for weaving—cattails, bear grass, sweet grass, tulles, and a variety of vines, shoots, and barks, especially cedar. Jefferson is a strong advocate for the Native American Art Association, whose purpose is to provide Native artists with a place to show and the skills to market their work. Weaving by Anna Jefferson is

frequently available in galleries in the Puget Sound region.

† **Scott Jensen** (360/734-2158) has been recognized for his authentic work in the Northwest Coast Native style by commissions from the Field Museum of Natural History in Chicago and the Whatcom Museum of History and Art in Bellingham to create reproductions of Native artifacts for use in the museums' continuing education programs. His work is exhibited permanently in Nash Hall at Western Washington University in Bellingham; in the Abashiri City Museum, Abashirir-shi, Hokkaido, Japan; and in the Niedersachsisches Landesmuseum für Völkerkunde in Hannover, Germany. Primarily a carver, Jensen characteristically produces masks and model totem poles in the Tlingit style. He is represented by the Stonington Gallery in Seattle and by Objects of Bright Pride in Juneau and New York City. Commissions may be arranged directly with the artist or through one of the galleries.

† **Debi Knight** (360/638-1364) has been described by a leading artist in the area as "the most accomplished person working in fossil ivory on the coast." However valid that comparison, there is no doubt that her ivory miniatures of Northwest Coast figures are exquisite, all the more notable for the fact that she began her career only seven years ago. Preferring to stay within traditional artistic bounds, she creates very small but remarkably detailed sculptures and jewelry depicting traditional masks, frontlets, and rattles, some stylized, some naturalistic, and often a combination of the two. As of this writing, the Stonington Gallery is Debi Knight's primary retail outlet. Commissions may be arranged directly with the artist or through the gallery.

* **The Lelooska Family** (360/225-9735 or 360/225-8828) and its studio in Ariel, Washington, have been one of the best-known sources of Northwest Coast Native-style art in western Washington for many years. The patriarch of the group, Don Smith (Lelooska, which in Nez Perce means "he who cuts against wood with a knife"), is of Cherokee descent and was adopted by the late Kwakiutl chief James Sewid. Members of the family—Lelooska, Shona Hah (Lelooska's mother), Patty Fawn (Lelooska's sister), Mariah (Patty Fawn's daughter), Tsungani (Lelooska's brother), Nakwesee (Tsungani's daughter)—produce masks and other carved sculptures, miniatures depicting various aspects of Native life, and jewelry in silver, bone, and shell. Commissions may be arranged directly through the Lelooska Gallery and Museum (see entry in "Galleries and Shops," chapter 1).

† **Jeffrey Mauger** (360/645-2231) is an anthropologist by profession, whose carving in wood and engraving in silver are done in the style characteristic of the Nuu-chah-nulth of Vancouver Island and the Makah of Neah Bay, groups with which he is closely associated. His work can often be seen at the Stonington Gallery in Seattle. Commissions may be arranged through the gallery or directly with the artist.

Spencer McCarty (360/645-2675) is one of a group of young, highly talented, and productive artists based in Neah Bay, near the tip of the Olympic Peninsula. His customary style of work reflects his own Native heritage, Makah and Nuu-chah-nulth, rendered both in traditional and contemporary forms. Deeply involved in the culture of his people, he is a song leader and a composer of new songs. McCarty, who has worked at his art commercially for ten years, is particularly known for his whistles, rattles, masks, and drums. Although he accepts commissions through galleries, he prefers to arrange them himself. His work is regularly available through galleries in Seattle and Port Angeles, and has been seen in exhibitions and collections in the Burke Museum, the Washington State Historical Museum, the American Indian Dance Theater in New York City, and the Makah Cultural and Research Center in Neah Bay.

G. Bruce Miller (360/426-4232) is a spiritual leader of the Skokomish Tribe who served as director of its first cultural program in 1971, helping to revive the First Salmon and First Elk ceremonies that earlier had been under federal government ban and founding the Twana Dance Group. His formal education in the arts began at the Institute of American Indian Art in Santa Fe (where he later taught) and continued at the California College of Arts and Crafts and the University of California, Berkeley. He is noted for his basketry and carving in traditional Skokomish styles. Fine examples can be seen at Tacoma Public Utilities (see entry 1.11) and at the Skokomish Tribal Center (see entry in "Museums and Tribal Centers," chapter 4).

James Morris (206/782-1722) comes from a distinguished Tlingit lineage. Born in the Yukon Territory, he was raised in Juneau, of the Wolf moiety under the Eagle subclan. Two of his forebears were Taku chiefs, one of the Raven clan in Juneau, another of the Juneau-Douglas Tribe. Under the name of "Kagwantan: Traditional Northwest Coast Indian Art," Morris produces work in both Tlingit and Alaskan Eskimo styles, and in widely varying forms, including masks, carved plaques, totem poles, bowls, rattles, spoons, paddles, and soapstone carvings. His work has been displayed at The Legacy, Snow Goose, Stonington Gallery, and Burke Museum Gift Shop, all in Se-

attle, as well as in galleries in Anchorage, Skagway, and Juneau. Commissions may be arranged directly with the artist or through one of the galleries.

Marvin Oliver (206/633-2468), an artist of mixed Quinault and Isleta Pueblo heritage, has an international reputation. Although his two-dimensional work has characteristically displayed an elegant Northern formline style, he has joined that tradition with a very contemporary imagination, adding embossing to prints and brass elements to wood panels. He has mixed materials in nontraditional ways—for example, cast glass sculpture with wood, bronze, and concrete—and at this writing is at work on a commission that will make landscape design an integral part of a sculptural piece. More recent work reflects his own Salish heritage. Oliver has taught at the University of Washington since 1974 and is a sometime-teacher at the University of Alaska in Ketchikan. His résumé lists eighteen instances of commissioned art in public places and eleven architectural works in both public and private settings, in addition to book illustrations and special-purpose designs. His original work is available in most Seattle galleries, as are his note cards—quality reproductions of limited-edition prints. Commissions may be arranged directly with the artist.

† **Duane Pasco** (360/779-5584) is one of the best-known and most highly regarded creators of Northwest Coast Native-style art. Early association with Native people, especially in Alaska, left a lasting impression. Beginning in the early 1960s, he painted and carved sporadically, until Bill Holm's seminal 1965 book on the form of northern Northwest Coast art turned Pasco from hobbyist to serious student and practitioner. He has been a full-time artist and teacher since 1967. His authoritative skill has been recognized by invitations to teach at the Gitanmaax School of Northwest Coast Native Art in 'Ksan, British Columbia, the Sitka Indian Cultural Center, the Ketchikan Totem Heritage Center, the American Indian Studies Program at the University of Washington, and The Evergreen State College, among others. In the Seattle area, his public carvings include poles and panels in the North and South Satellite restaurants at Sea-Tac International Airport, a pole near the Center House in the Seattle Center, and several large figures in Occidental Park. Totem poles, masks, and prints by Pasco are found in many corporate and international collections. His mastery ranges confidently across a variety of coastal styles. His work is frequently marked by a puckish sense of humor. Commissions may be arranged directly with the artist.

Melissa Peterson, Box 263, Neah Bay, WA 98357, has demonstrated her basketry skills at the Smithsonian Institution in Washington, D.C. She works in

the classic Makah tradition, having studied and replicated some half-dozen types of weaving that have been found at Ozette, the five-hundred-year-old archaeological site just south of her Neah Bay home. In addition to baskets, she has made woven hats, headbands, bark skirts, canoe mats; and more recently, she has been making drums, jewelry (both traditional and contemporary), and replications of important items from the nearby Ozette archaeological dig. Her 9-foot whaling mat has toured the country, and other work is displayed in the Makah Cultural and Research Center in Neah Bay.

Peterson personally gathers and prepares some of the materials—cedar bark, bear grass, spruce root—needed for her weaving. She teaches basket weaving in her home, where she also maintains a small sales counter.

Lillian Pullen, a Quileute artist living in La Push, was a recipient of the 1993 Governor's Ethnic Heritage Award. A tribal elder, midwife, healer, and assistant minister in the Indian Shaker Church, she was named National Indian Educator of the Year in 1989, and in 1987 was given the title of "Elder of the Whole Indian Nation" by the National Indian Education Association. One wonders how there is any time for art left over from tribal and civic activities, but Lillian Pullen has also been honored for her traditional basket weaving and, in 1992, received a Folk Arts Master-Apprentice grant award from the Washington State Arts Commission. As a teacher, she transmits the distinguished art of Salish basket weaving to a younger Quileute generation at the Tribal School in La Push.

Frank Smith (360/645-2332) is surely the dean of the living Native artists included in this guidebook. Smith, a Makah carver, began his artistic career fifty years ago, and we include six examples of his monumental work, five in Neah Bay and one in Port Orchard (see chap. 4). When he was young, he learned to carve by observing the work of established Neah Bay artists, especially Ralph La Chester and a man known as Young Doctor, whose work is celebrated in the Makah Cultural and Research Center. Smith carves and paints, and welcomes commissions, which can be arranged directly with the artist.

† **Tom Speer** (206/644-8470) first won recognition in 1966 for his talent in Northwest Coast Native-style art as a senior at Bellevue's Newport High School, where a design of his was selected as a finalist in a juried show. It was an omen of the recognition he would receive as a more mature artist. Two influences have been important in shaping his understanding of the Native art tradition. One was Lummi artist Joe Hillaire, who served as an

adviser to Scouting's Order of the Arrow, to which Speer had been elected. Hillaire taught the Scouts about Coast Salish songs, dances, ceremonies, and visual arts, and through him they participated in the annual "Chief Seattle Days" in Suquamish. The other influence was Bill Holm, whose courses Speer elected at the University of Washington and for whom Speer served as a teaching assistant in art history.

Speer's first major commission, in 1969, involved designing and painting murals for Ivar's Salmon House (entry 3.28), followed in 1970 by his work on the Kwakiutl house posts being restored for what was then the Sea Monster House at the Pacific Science Center. Those posts are currently displayed in the Hauberg Collection at the Seattle Art Museum. Speer's public work can also be seen in the two 1982 murals he painted for the Rocky Point Marine Mammal Exhibit of Tacoma's Point Defiance Zoo (entry 1.12). His prints and carvings, produced over the years, are to be found in many private collections, and his work as a graphic designer is represented in the logos of local corporations. The artist may be contacted directly for commissioned work.

† **Davey Stephens** (360/866-7680) is at home in styles as diverse as those of the Columbia River groups in the far south and the Chugach, at the boundary between the Tlingit and the Eskimo, in the far north, though he has a special affinity for the Tlingit and the Bella Coola. His work is marked by imagination—originality that is, at the same time, linked with the best in the tradition—and by the refinement of his carving and painting. Masks, bent-corner boxes, bowls, drums, and rattles are among the objects he produces. His work can often be seen in Seattle at the Bailey Nelson, Stonington, and Snow Goose galleries. Commissions may be arranged directly with the artist.

Micah Vogel (360/645-2818), who represents a rising younger generation of Neah Bay artists, is following in the tradition of his mother, weaver Melissa Peterson, and of his carving mentor, Greg Colfax. Although at this writing his production is limited, his masks and two-dimensional designs show evidence of a talent that will become more visible as time goes on.

† **Loren White** (360/895-2468) is an experienced and accomplished carver, whose work ranges from delicately detailed and carved miniature images in ivory or cast in sterling, to house posts and totem poles. He has often collaborated on monumental creations with Duane Pasco and with Nuu-chah-nulth Joe David. Although he is at home in a variety of coastal styles, his work often shows Nuu-chah-nulth influence, a group with which he has

had long and close association. One of his favorite Nuu-chah-nulth images is Pook-ubs, a masked figure in the Winter Ceremonial, representing the spirit of a drowned whaler; it often takes form in White's carving and painting. His work is represented in major private collections and is sometimes on display at the Stonington Gallery. Commissions may be arranged directly with the artist.

Andy Wilbur (360/426-5016). This artist, a member of the Skokomish (Twana) Tribe and one of the better-known Salish carvers, is self-taught and has been producing work for sale since he was eighteen. Even earlier, from the age of twelve on, he did basket weaving under the guidance of two well-known Skokomish weavers, Louisa Pulsifer and Emily Miller. His earliest carving work was in imitation of the Northern Northwest Coast styles, primarily because those were what he saw in museums. As a student in the Native American Studies Program at The Evergreen State College in the mid-1980s, he assisted Makah artist Greg Colfax in carving a 12-foot welcome figure for the College, and for the first time was introduced to his own Southern coastal tradition. Now he teaches carving and painting and works to encourage the revival of Salish arts. His own production includes bent-corner boxes, totem poles, drums, rattles, paddles, masks, bowls, and button blankets. Andy Wilbur operates his own Haitwas Gallery at West 3510 Skokomish Valley Road, Shelton, Washington 98584. His work may also be seen at Snow Goose Associates.

British Columbia and Southeast Alaska Artists

Following is a select list of British Columbia and Southeast Alaska artists who are actively producing Northwest Coast art and whose work is frequently in galleries in western Washington, as well as in Vancouver and Victoria. Anyone's list of the most distinguished artists from north of the border would, we are convinced, include these names. Information is provided about the media with which each is primarily associated. Although now somewhat dated, additional biographical material may be found in *The Legacy: Tradition and Innovation in Northwest Coast Indian Art,* by Macnair, Hoover, and Neary (University of Washington Press, 1984); *Northwest Coast Indian Graphics: An Introduction to Silkscreen Prints,* by Hall, Blackman, and Rickard (University of Washington Press, 1981); and *Robes of Power: Totem Poles on Cloth,* by Jensen and Sargent (University of British Columbia Press, 1986). (For annotations on the first two references, see chapter 10.)

Galleries will be able to supply more information, not only about these artists but about others whose work also represents the best in the coastal tradition. British Columbia (BC) or Alaska (AK) and tribal identifications are in parentheses following each name, and in cases where an artist signs his or her work with a Native name, that name is also noted.

Patrick Amos (BC, Nuu-chah-nulth), carving, prints

Dempsey Bob (BC, Tahltan/Tlingit), carving, prints

Doug Cranmer (BC, Kwagiulth), carving, prints

Joe David (BC, Nuu-chah-nulth), carving, paintings, prints

Reg Davidson (BC, Haida), carving, jewelry, prints

Robert Davidson (BC, Haida), bronzes, carving, jewelry, prints

Nancy Dawson (BC, Kwagiulth), carving, fabric

Danny Dennis (BC, Tsimshian), carving, jewelry, prints

Beau Dick (BC, Kwakwaka'wakw), carving, prints

Frances Dick (BC, Kwakwaka'wakw), prints

Freda Diesing (BC, Haida), carving, prints

Pat Dixon (BC, Haida), argillite carving

Anna Ehlers (AK, Tlingit), Chilkat weaving

Dorothy Grant (BC, Haida), fabric

Stan Greene (BC, Coast Salish), carving, prints

Ron Hamilton (Native names: Hupquatchew, Ki-ke-in)(BC, Nuu-chah-nulth), carving, jewelry, prints

Roy Hanuse (BC, Kwakwaka'wakw), carving, prints

Jack Hudson (AK, Tsimshian), carving, prints

Calvin Hunt (BC, Kwagiulth), carving, jewelry, prints

Stan Hunt (BC, Kwagiulth), carving, jewelry, prints

Tony Hunt (BC, Kwagiulth), carving, jewelry, prints

Tony Hunt, Jr. (BC, Kwagiulth), carving, jewelry, prints

Richard Hunt (BC, Kwagiulth), carving, prints

Nathan Jackson (AK, Tlingit), carving, jewelry, prints

Phil Janze (BC, Tsimshian), jewelry

Greg Lightbown (BC, Haida), argillite carving

John Livingston (BC, non-Native), carving, prints

Gerry Marks (BC, Haida), carving, jewelry, prints

Tim Paul (BC, Nuu-chah-nulth), carving, jewelry, prints

Susan Point (BC, Coast Salish), prints, castings, carving, jewelry

Wayne Price (AK, Tlingit), carving

Glen Rabena (BC, non-Native), carving, prints

Bill Reid (BC, Haida), bronzes, carving, jewelry, prints

Cheryl Samuel (BC, non-Native), Chilkat and Raven's Tail weaving

Russell Smith (Native name: Awasatlas)(BC, Kwagiulth), carving, prints

Deborah Sparrow (BC, Coast Salish), weaving

Norman Tait (BC, Tsimshian), carving, jewelry, prints

Art Thompson (BC, Nuu-chah-nulth), carving, jewelry, prints

Roy Henry Vickers (BC, Tsimshian), prints

Francis Williams (BC, Haida), carving, jewelry, prints

Terry Williams (AK, non-Native), carving, jewelry, prints

7. Native Tribes of the Northwest Coast

The interconnected cultures that are commonly designated as Northwest Coast extend from the mouth of the Columbia River in the south to just north of Yakutat Bay in southeastern Alaska, and along that entire length, from the coastal ranges west, including both mainlands and off-shore islands.

The objects of Native art included in this guidebook may represent artistic cultures from anywhere in this region, though those objects are now located in western Washington. The following names and locations may help users of *Northwest Coast Native and Native-Style Art* to familiarize themselves with the distinctive peoples whose heritage Northwest Coast art celebrates.

Western Washington Tribes

With the exception of the Makah, who are related to the Nuu-chah-nulth on the west coast of Vancouver Island, the following tribes are generically known as Coast Salish. Those marked with an asterisk (*) are landless and currently lack federal recognition. In appropriate cases, the general location of reservation lands and, in all cases, the mailing addresses and telephone numbers are provided below. The names listed are those preferred by the tribes themselves.

Confederated Tribes of the Chehalis Reservation (4,215 acres, on Route 12, about seven miles west of Interstate 5), P.O. Box 536, Oakville, WA 98568 (360/273-5911)

* **Chinook Indian Tribe**, P.O. Box 228, Chinook, WA 98614 (360/777-8303)

* Cowlitz Indian Tribe, 1417-15th Avenue, #5, Longview, WA 98632 (360/577-8140)

* The Duwamish Tribe of American Indians, 140 Rainier Avenue South, Suite 7, Renton, WA 98055 (206/776-5185)

Hoh Indian Tribe (443 acres between Kalaloch and La Push on the central coast), HC 80, Box 917, Forks, WA 98331 (360/374-6582)

Jamestown S'Klallam Tribe (trust land at Blyn on Sequim Bay), 1033 Old Blyn Road, Sequim, WA 98382 (360/683-1109)

Lower Elwha S'Klallam Tribe (443 acres, near Port Angeles), 2851 Lower Elwha Road, Port Angeles, WA 98363 (360/452-8471)

Lummi Indian Business Council (13,500 acres on the peninsula southwest of Bellingham), 2616 Kwina Road, Bellingham, WA 98226 (360/734-8180)

Makah Indian Nation (44 square miles around Neah Bay, northwestern-most tip of the Olympic Peninsula; related to the Nuu-chah-nulth on the west coast on Vancouver Island), P.O. Box 115, Neah Bay, WA 98357 (360/645-2201)

* Marietta Band of Nooksak Indians, 1827 Marine Drive, Bellingham, WA 98226 (360/734-8180)

* Mitchell Bay Indian Tribe of San Juan Island, P.O. Box 444, Friday Harbor, WA 98250 (360/378-4924)

Muckleshoot Indian Tribe (3,600 acres near Auburn), 39015-172nd Avenue Southeast, Auburn, WA 98002 (360/939-3311)

Nisqually Indian Tribe (5,000 acres east of Olympia, on the Nisqually River), 4820 She-nah-num Drive Southeast, Olympia, WA 98513 (360/456-5221)

Nooksak Tribe (2 acres, with 2,060 acres held in trust, near Lynden), P.O. Box 280, Deming, WA 98244 (360/592-5176)

Port Gamble S'Klallam Tribe (1,301 acres on the east shore of Port

Gamble Bay, northwest of Kingston), P.O. Box 280, Kingston, WA 98346
(360/297-2646)

Port Madison. *See* Suquamish

Puyallup Tribe of Indians (18,061.5 acres east of Tacoma), 2002 East 28th
Street, Tacoma, WA 98404 (206/597-6200)

Quileute Nation (one square mile at La Push, on the north coast), P.O. Box
279, La Push, WA 98350 (360/374-6163)

Quinault Indian Nation (196,645 acres on the central coast), P.O. Box 189,
Taholah, WA 98587 (360/276-8211)

* **Samish Indian Nation,** P.O. Box 217, Anacortes, WA 98221 (360/293-6404)

Sauk-Suiattle Indian Tribe (23 acres near Darrington), 5318 Chief Brown
Lane, Box 1, Darrington, WA 98241 (360/436-0131, 435-8366)

Shoalwater Bay Indian Tribe (one square mile plus tidelands on the
southern coast, north shore of Willapa Bay), P.O. Box 130, Tokeland, WA
98590 (360/267-6766)

Skokomish Indian Tribe (4,987 acres at the south end of Hood Canal),
North 80 Tribal Center Road, Shelton, WA 98584 (360/426-4232)

* **Snohomish Tribe of Indians,** 1422 Rosario Road, Anacortes, WA 98221
(360/293-7716)

Snoqualmie Tribe (preliminary federal recognition, 1993; land designation
unresolved), Box 280, Carnation, WA 98014 (206/333-6651)

Squaxin Island Tribe (2,175 acres at the south end of Puget Sound), South-
east 70 Squaxin Lane, Shelton, WA 98584 (360/426-9781)

* **Steilacoom Tribe of Indians.** P.O. Box 88419, 1515 Lafayette Street,
Steilacoom, WA 98388 (206/584-6308)

Stillaguamish Tribe of Washington (formal land designation unresolved;
tribe owns 60 acres north of Marysville), 3439 Stoluckquamish Lane, Box
277, Arlington, WA 98223 (360/652-7362)

The Suquamish Tribe (7,800 acres in and around the town of Suquamish on the eastern shore of the Kitsap Peninsula and along Agate Passage), P.O. Box 498, Suquamish, WA 98392 (360/598-3311)

Swinomish Indian Tribal Community (10 square miles across the slough from La Conner), P.O. Box 817, La Conner, WA 98257 (360/466-3163)

Tulalip Tribes (22,000 acres west of Marysville; original bands included Snohomish, Snoqualmie, and Skykomish), 6700 Totem Beach Road, Marysville, WA 98270 (360/653-4585)

Upper Skagit Indian Tribe (130 acres near Sedro Wooley), 2284 Community Plaza, Sedro Wooley, WA 98284 (360/856-5501)

* Wahkiakum Band of the Chinook Tribe, P.O. Box 66, Skamokaway, WA 98647 (360/795-3903; 795-8603)

Coastal British Columbia Culture Groups

In each instance below, the primary designation is the one currently pre-ferred by the Native people themselves. Territorial limits are not precisely defined.

Bella Bella. *See* Heiltsuk

Bella Coola. *See* Nuxalk

Coast Salish, south and southeastern Vancouver Island, adjacent southern British Columbia mainland, and islands between; also related to Coast Salish in western Washington

Coast Tsimshian, Portland Inlet to Milbanke Sound; also related to the Tsimshian (or Tsimpshean) on Annette Island, Alaska

Gitksan (earlier known as Tsimshian), inland along the Skeena River

Haida, Queen Charlotte Islands off northern British Columbia coast

Haisla, inland along Douglas Channel, Gardner Canal, and Princess Royal Channel, from Kitimaat to Kitlope

Heiltsuk (earlier known as Bella Bella), Milbanke Sound to Rivers Inlet

Kwagiulth. *See* Kwakwaka'wakw

Kwakiutl. *See* Kwakwaka'wakw

Kwakwaka'wakw (earlier known as Kwakiutl, Southern Kwakiutl, and Kwagiulth), northern tip and northeastern coast of Vancouver Island, mainland along Queen Charlotte and Johnstone Straits, and adjacent islands

Nishga (earlier known as Tsimshian), along the Nass River, Portland Inlet, and Portland Canal

Nootka. *See* Nuu-chah-nulth

Northern Kwakiutl, earlier name for Haisla, Nuxalk (Bella Coola), Heiltsuk (Bella Bella), and Oowekeeno

Northern Wakashan, earlier name for Haisla, Nuxalk (Bella Coola), Heiltsuk (Bella Bella), and Oowekeeno

Nuu-chah-nulth (earlier name for Nootka and WestCoast), west coast of Vancouver Island, from Kuyoquot Sound to San Juan Harbor; also related to the Makah on the northwestern tip of Washington's Olympic Peninsula

Nuxalk (earlier known as Bella Coola), an inland enclave on the upper Dean and Burke channels and the Bella Coola River

Oowekeeno, inland from Fitz Hugh Sound and including Rivers Inlet and Oowekeeno Lake

Southern Kwakiutl. *See* Kwakwaka'wakw

Tlingit, a narrow enclave along the Stikine River (most Tlingit live in southeastern Alaska)

Tsimshian, an earlier designation for Coast Tsimshiam, Nishga, and Gitksan

WestCoast. *See* Nuu-chah-nulth

Southeastern Alaska Tribes

Kaigani Haida, southern portion of Prince of Wales Island

Tlingit, Yakutat Bay to the Portland Canal

Tsimshian (or Tsimpshean), small reservation around Metlakatla on Annette Island

PART III

Resources

Persons who have more than a passing interest in Northwest Coast Native and Native-style art will want to know how, in addition to individual viewing and collecting, they can continue to enlarge their knowledge and experience.

Although the opportunities are somewhat limited, there is no substitute for seeing Northwest Coast Native art in use, actively displaying its dramatic power and conveying its attendant mystery. In a society that had no written language, art was a primary means of communication, embodying in permanent and often dramatic form the myths, the values, the powers and privileges, the connections with both the natural and the supernatural worlds, that were also transmitted by more fragile and forgettable oral means.

Although Northwest Coast languages have no word for "art" as such, the coastal peoples lived in an art-saturated culture. The most common objects—combs, fishhooks, spoons, bowls, storage containers—were frequently elaborated and embellished with carving and painting, and were constant reminders of identity and heritage.

Monumental art, in the form of screens and of carved supporting posts on the insides of longhouses, of totem poles outside the houses, and of large, painted house fronts, created an impressive and instructive visual environment.

Other forms of art—ceremonial robes, masks, rattles, and other ritual paraphernalia—were displayed only on the most solemn or the most festive occasions. Because the ceremonies are serious—even sacred—business, outsiders may not enter without invitation, so it is rare for non-Natives to have the privilege of viewing Northwest Coast Native art in its ceremonial context within Native communities themselves. Nevertheless, there are times and places in which groups of Native people share their songs, sto-

ries, dances, and related ceremonial art with a wider public. Anyone who is seriously interested in Northwest Coast Native art will do well to take advantage of such occasions, for it is especially in its ceremonial use that the art almost literally comes alive! Chapter 8 will help to identify such occasions.

Coastal art aficionados in western Washington are particularly fortunate in the educational opportunities offered here: in art history, which treats both its traditional and contemporary expressions, and in studio instruction, which aims at learning how to produce the several art forms themselves. The degree of formality in this learning ranges from courses in area colleges and universities to occasional lecture programs in galleries and museums to membership organizations with newsletters. Chapter 9 catalogues many of those opportunities.

Finally, some readers will want to find resources, in books other than this guidebook and in audiovisual materials, for individually initiated study and enrichment. The recommendations and annotations in chapter 10 offer a substantial start.

8. Where to See the Art in Use

What follow are suggestions of places that offer an opportunity for experiencing Northwest Coast Native art in ceremonial context. In addition to these instances of occasional live performance, readers will also want to refer to some of the videotapes listed in chapter 10; especially, "In the Land of the War Canoes," "The Box of Daylight: A Tlingit Myth of Creation," and "Spirit of the Mask," which provide strong traditional and contemporary visual images of coastal art in use. They are the best available substitute for being there.

The Lelooska Foundation, 165 Merwin Village Road, Ariel 98603 (360/225-9735 or 225-8828). This is clearly the place to go for those who want to see at least one form of Northwest Coast ceremony in a setting and a style closely approximating the Native event itself. A cedar-plank Ceremonial House, modeled after a Kwakiutl longhouse, is the setting for "Masks, Myths and Magic," a two-hour presentation of traditional dance with Northwest Coast ceremonial dress and masks.

In the fire-lit house, Chief Lelooska (Don Smith, a Cherokee adopted by the late Kwakiutl Chief James Sewid), and a dance troupe comprised of members of the Lelooska family, replicate parts of the Kwakiutl Winter Ceremonial—the traditional T'seka (Red Cedar Bark Dance) and Tla'sala (Peace Dance). Fantastic creatures—HokHok, Crooked Beak of Heaven, Bukwus, and Tugwid are only a few—appear in masked form from behind the dance screen or through the entrance of the house from the woods just beyond, circle the fire with movements that reach far into the past, and disappear again. Between dances, Chief Lelooska provides narration that recounts related myths and historical information. According to Lelooska, this performance, originally developed with the assistance of Chief Sewid and his family and presented with their authorization, "is designed to give the au-

dience an understanding of Northwest Coast Indian culture, as well as a feeling of intimate participation in the living history of the area." The program is presented periodically throughout the year. Reservations are required, and interested persons should call the Foundation to determine dates, times, and admission fees. Since the benches inside the Ceremonial House are simple and warmth comes only from the central fire, pillows and blankets are advised.

An adjoining museum, holding Lelooska's personal collection of objects from the Northwest Coast and other Native cultures, and the Lelooska Gallery (see chapter 1), are open before and after the performance. Although these scheduled evenings are designed for individuals and families, similar daytime presentations for school children are available by arrangement. Telephone inquiries are invited.

Tillicum Village, access by boat from Piers 55 and 56 on Seattle's Elliott Bay waterfront (206/443-1244). Blake Island State Park, located eight miles across Puget Sound from Seattle, between Bainbridge and Vashon islands, is the site of Tillicum Village. A private for-profit venture founded in 1962, it gives tourists and locals a two-hour introduction to the Northwest Coast Native culture, along with a salmon dinner prepared in the traditional Native way.

The main structure at Tillicum Village is a large cedar longhouse, decorated with traditional painted forms and flanked by a variety of totemic sculptures. Inside is a gift shop, often a Native artist at work, and an enormous dining room and stage on which, at the conclusion of dinner, a professionally designed dramatic production utilizes masks, drums, rattles, button blankets, and chants to recount some of the myths and traditions of the Northwest Coast people.

Tillicum Village is open from May through mid-October, with daily evening performances on weekdays and additional performances on weekends. Performances at other times of the year are by special arrangement.

The Carter Family Marionettes, Northwest Puppet Center, 9123 15th Avenue Northeast, Seattle 98155 (206/523-2579). This is a rather different way of experiencing Northwest Coast culture—thoroughly charming as well as authentic. The Carter Family Marionettes have gained international recognition for their production of "Q'we·ti: Tales of the Makah Tribe." In this production, the clever trickster, Q'we·ti, whistles and perpetrates pranks as he guides us through the vivid lore of the Makah people who live on the far northwest tip of the Olympic Peninsula. The beguiling marionette's escapades are dramatizations of old tales that traditionally taught Makah

Entrance to Tillicum Village, Blake Island

youngsters their heritage and values. Wry humor permeates Q'we·ti's adventures—and misadventures—whether he is in the belly of a Sea Monster or innocently romancing Octopus Lady who has something more dangerous than romance on her mind.

The Makah Cultural and Research Center at Neah Bay is consultant and co-producer of this program with the Carters. Makah elders Helen Peterson and Helma Ward have collaborated as storytellers, and tribal members John and Edith Hottowe have composed and performed the chanting and drumming.

Puppets used in the production, carved in cedar by Duane Pasco, are superb examples of the articulated devices that have enhanced the ceremonies of coastal societies for centuries.

"Q'we·ti: Tales of the Makah Tribe" is performed seasonally at the Northwest Puppet Center and at area festivals and fairs, and performances may be sponsored by private groups. Call the Center for the performance schedule and for information about sponsoring arrangements.

Museums

Western Washington's two major museums for Northwest Coast Native art, the Seattle Art Museum and the Thomas Burke Memorial Washington State Museum, offer occasional public programs that feature traditional dancing with associated ceremonial regalia, and sometimes storytelling, by Native people. These programs are usually coincident with special exhibits of Native arts and artifacts. Museum members receive routine announcements of such opportunities. Others can get information about them by regularly calling the information line for the Seattle Art Museum (206/654-3100) and the Burke Museum (206/543-5590), by watching the weekend-activity supplements in the *Seattle Times* and the *Seattle Post-Intelligencer*, and by consulting the activities columns in the *Seattle Weekly*.

Galleries

Galleries that have a special interest in Northwest Coast Native and Native-style art sponsor occasional public programs of Native dancing and storytelling. Like the museums, these programs are usually associated with special exhibitions that feature the work of a single contemporary artist or a group of associated artists. Two Seattle galleries in particular—The Legacy, Ltd. (206/624-6350) and the Stonington Gallery (206/443-1108)—have distinguished themselves by providing such programs.

Ask to have your name placed on the mailing lists of galleries that feature works of interest to you. There is no charge, and it will assure your receipt of timely information about special exhibits and associated events.

Public Festivals and Powwows

Public festivals and powwows, sponsored by tribal entities and other Native organizations, are major social and ceremonial events in the lives of Native people.

The festivals—"Makah Days" at Neah Bay is an example—are typically two- or three-day celebrations of the life and traditions of a particular tribe, which may involve canoe races, bone games, salmon bakes, arts and crafts demonstrations and sales, and one or two evenings of dancing in traditional Northwest Coast styles and costumes. Public attendance is invited.

Powwows are not native to the Northwest Coast. They come from Plains/Plateau traditions and practices, though in recent years they have

taken on a kind of pan-Indian character, drawing participants from many tribal groups over a wide geographical area. Evidence of this pan-Indian cast and of the value attached to associations that cross mountains and traditions is seen in the fact that powwows are occasionally sponsored by western Washington tribal groups. Northwest Coast people sometimes participate in Native dress, but they only rarely dance in any Northwest Coast style unless they are presenting a special demonstration or program. Some Northwest Coast Natives who participate in powwows do so in Plains or Plateau dress.

A powwow is marked by a continuing sequence of dances through much of each day, offering an opportunity for participants to wear their most distinctive and festive dance and ceremonial dress. Some dances are for distinctive age groups, some are for special kinds of costume, and some are competitive. While the dancers express joyous exuberance, their dancing is also serious, as evidenced, for example, by the fact that if feathers should come loose from a costume and fall to the ground during the course of a dance, the fallen object must be retrieved in a ritually proper manner and the dancer must make some formal reparation for the offense before the assembled crowd of dancers and observers.

In addition to dancing, powwows often feature booths for the sale of Native arts and crafts and Native foods. Sometimes general admission to the powwow site is free, sometimes a small fee is charged.

The following groups, among others, regularly conduct public festivals and powwows. Times and locations may vary from year to year, and a call to determine a place and date convenient to the visitor is advised.

South: Portland to Tacoma

Chehalis Tribe (360/273-5911), "Chehalis Tribal Day," in Chehalis

Puyallup Tribe (206/597-6200), Labor Day powwow, east of Tacoma

City of Seattle

Seattle Aquarium and Tribal Communities of the Pacific Northwest (206/386-4300), Annual Salmon Homecoming Celebration

Seattle University Native American Student Council (206/296-6000, x6070)

University of Washington American Indian Student Commission (206/543-9242)

Daybreak Star Center, United Indians of All Tribes Foundation (206/285-4435), in Discovery Park

American Indian Heritage School, 1330 North 90th Street, Seattle (206/298-7895)

United Indians of All Tribes Foundation, "I Wa Sil" Youth Program (206/343-3111)

Kitsap/Olympic Peninsula

Squaxin Island Tribe, Annual "Sa'He'Wa'Mish Days" Pow Wow and Art Fair (360/426-3442)

Suquamish Tribe (360/598-3311), "Chief Sealth Days," near Suquamish on the east side of the Kitsap Peninsula

Makah Tribe (360/645-2201), "Makah Days," at Neah Bay on the tip of the Olympic Peninsula

Quileute Tribe (360/374-6163), "Elders Week," a summer festival in La Push on the northern Olympic coast

Quinault Tribe (360/276-8215), summer "Chief Taholah Days," in Taholah on the central Olympic coast

Shoalwater Bay Tribe (360/267-6766), south of Westport on the south coast

North: Everett to Blaine

Tulalip Tribe (360/653-4585), "Teen Health Powwow" in the spring, "Kla-How-Ya Days" on the Labor Day weekend, in Tulalip west of Marysville

Swinomish Tribe (360/466-3906), annual public summer powwow given by the Paul family, in Swinomish across the slough from La Conner

Western Washington University Native American Student Union (360/650-7273), in Bellingham

Lummi Tribe (360/384-1489), "Stommish Festival," in June at Gooseberry Point near Lummi, northwest of Bellingham

In addition to its annual powwow, the Daybreak Star Center conducts an art mart and salmon bake, as of this writing, on the second Saturday of each month, from 11 A.M. to 4 P.M. during a part of the year. On some of those occasions there is a performance of Native dances, often by the local Cape Fox Dancers, a Tlingit group, with the use of related ceremonial dress and objects. Call the Center (206/285-4425) to confirm times and dates.

9. Opportunities for Formal Learning about the Art

Educational Institutions

The area's largest resources for formal learning about Northwest Coast Native art can be found at one of the smallest educational institutions, the Northwest Indian College, with an enrollment of 250 students, and at the State's largest institution, the University of Washington, enrolling 33,000 students.

Northwest Indian College

The Northwest Indian College, 2522 Kwina Road, Bellingham 98226 (360/676-2772), is located on the Lummi Indian Reservation, some ten miles from downtown Bellingham. It exists for the purposes of providing an accessible and affordable post-secondary education especially for Native people and of transmitting the Native culture to succeeding generations. Both purposes are served by the extensive program of Northwest Coastal Indian Studies offered by the College, which is designed (1) to provide historical and cultural understandings, (2) to assure continuing competence in the traditional Native arts, and (3) to preserve distinctive cultural practices.

Historical and cultural understandings are addressed by such courses as "Survey of Northwest Coastal Indian Culture," "Lummi History/Herstory," and "Pacific Northwest Coastal Indian Art History." The practice of Native arts is encouraged by an astonishing array of studio courses, including "Pacific Northwest Indian Knitting," "Pacific Northwest Indian Spinning," "Button Blanket Class," "Design" (two-dimensional formline design), "Sculpture" (three-dimensional traditional forms), "Pacific Northwest Basketry," "Pacific Northwest Indian Wood Carving," "Indian Wood Carving Masks," "Indian Wood Carving Small Totems," "Toolmaking," "Design and

Northwest Indian College Learning Assistance Center totem pole, carved by Joseph Hillaire and restored by Dale James

Opportunities for Formal Learning about the Art 189

Carving of Canoe Paddles," "Single Canoe Carving," "Six-Man Canoe Carving," and "Eleven-Man Canoe Carving."

Cultural practices are taught in courses in "Lummi Language," "Canoe Maintenance and Repair," "Coastal Salish Recreation Games/Songs," "Gathering Traditional Foods and Materials," "Indian Songs and Dances," "Introduction to Coastal Traditional Dance," and "Introduction to Coastal Indian Celebration."

In this small college, not all courses are offered each term. For current information, an inquiry to the Admissions Office is advised.

Northwest Indian College has a policy of open admission, irrespective of prior educational experience and without regard to ethnic derivation, although preference is given to Indian students who can provide proof of tribal enrollment. Tuition for Washington State residents is modest, courses may be audited, and "special" students may be admitted whose purpose is personal enrichment rather than credit toward a degree. Additional information is available from the Admissions Office.

University of Washington

The University of Washington, Northeast 45th Street and 17th Avenue Northeast, Seattle 98195 (206/543-2100), offers opportunities for formal learning about Northwest Coast Native art and culture in a variety of instructional units within the University, at both undergraduate and graduate levels, with a choice of credit and noncredit arrangements. Course offerings change from term to term and year to year. In what follows, names of specific courses, while authentic as of this writing, are for illustration only, and interested persons should consult the relevant departments in advance for reliable information on what is being offered in any given term.

School of Art, Division of Art History (206/543-4876). "Northwest Coast Indian Art," cross-listed with Anthropology, is designed as an introduction to the coastal Native arts from precontact times to the present.

"Northern Northwest Coast Native American Art: Methodologies in Stylistic Analysis" is a more advanced and intensive examination of the distinctive formline style of Haida, Tlingit, Tsimshian, and Northern Wakashan traditions.

Courses that cover a wider geographical range—"Survey of Native American Art," which treats traditions north of Mexico; "Thematic Studies in Native American Art," whose theme changes from year to year; "Seminar in North American Indian Art," whose content also varies; and even more broadly, "Survey of Tribal Art" and "Seminar in Tribal Art"—all include

some attention to the Northwest Coast and provide a useful opportunity for comparing tribal traditions in and beyond North America.

Department of Anthropology (206/543-5240). In addition to the course shared with the Art History Division, courses in anthropology and archaeology study the cultures that produce and are reflected in the distinctive Native arts. "Native North American Societies" examines representative cultures from ten culture areas, and "Prehistory of the Northwest Coast" looks at cultural origin, development, and variation from early migrations to the nineteenth century.

Specialized courses in museology focus on the organization and operation of institutions designed, among other purposes, to preserve and represent the artistic heritage of Native peoples.

American Indian Studies Center (206/543-9082). This center is affiliated with the Department of Anthropology. Its aim is broadly interdisciplinary. Social science courses, dealing with history, law, and sociology; humanities courses that study languages, literature, and philosophy; and studio and performance opportunities in music, dance, and the visual arts are all joined in the common interest of a deeper understanding of the culture and experience of America's First Peoples.

Courses specifically related to the subject of this guidebook are "Indian Art of the Northwest Coast"; "North American Indians: Pacific Northwest," which deals with the ethnography of the area; and "Wood Design," a studio course on Northwest Coast Native-style sculpture.

University Extension (206/543-2300). Extension courses are specifically designed to meet the ongoing personal and professional needs of the general public. In most instances, formal admission to the University is not required, and both credit and noncredit courses are offered. Most Extension courses meet during evening hours and on weekends.

Recently a five-credit course on "Northwest Coast Indian Arts" was offered in both autumn and spring quarters. A related three-part series on "The Broken Circle," including "Current Social Issues and the American Indian" (autumn), "The Cross and Sacred Pipe," the encounter of Christian missions and Indian communities (winter), and "Voices of the Raven" (focusing on a different tribe each spring), filled in the larger cultural context.

ASUW Experimental College (206/543-4375). Sponsored by the Associated Students of the University of Washington, the Experimental College is described as "the Northwest's largest student-run, non-profit, alternative edu-

cational institution . . . dedicated to providing low-cost, noncredit enrich-
ment opportunities and to meeting the diverse interests of the Seattle com-
munity."

Most courses meet during evening and weekend hours. Course lengths
and fees vary widely. During the current year, a course on "Northwest
Coast Art—Past and Present," introducing coastal art and culture, was of-
fered on a Saturday morning. A more extensive course on "Northwest Coast
Art—Contemporary" was offered both in autumn and in winter terms,
meeting weekly for two evening hours over a four-week period.

How to Take Advantage of University of Washington Opportunities.
Noncredit courses offered by University Extension and by the Experimental
College require only a simple registration and payment of the appropriate
course fee.

Credit courses offered in Art History, Anthropology, and American In-
dian Studies, such as those described above, may be elected in several ways:

1. Students who have been regularly admitted to the University with for-
mal undergraduate or graduate status, and who have paid the tuition ap-
propriate to that status, may elect these courses by meeting the necessary
prerequisites.

2. Individuals who have not been formally admitted to the University
may qualify to elect these courses on a space-available basis by completing
a relatively simple registration as nonmatriculated undergraduate students,
or as nonmatriculated graduate students. Those who are admitted on a
nonmatriculated basis pay the regular course tuition, take course examina-
tions, and receive grades and academic credit. Auditor status may be avail-
able but there is no reduction in the course fee. Nonmatriculated admission
is administered by the office of University Extension.

3. Individuals who are sixty years of age and older may be admitted to
such courses, also on a space-available basis, through University Extension's
ACCESS Program, which is even simpler and entails a modest fee. Not all
courses are available through ACCESS, and there is a limit of two courses
per quarter per person.

For information on undergraduate nonmatriculated admission, call 206/
543-6160; for graduate nonmatriculated admission, call 206/543-2300, ex-
tension 425; and for information on ACCESS, call 206/543-2320.

Other Important University Resources. Although somewhat less formal
than organized courses, two other University of Washington resources—the
Thomas Burke Memorial Washington State Museum and the University of
Washington Press—make possible significant learning about Northwest

Coast Native art. There is no more effective way to learn than by direct experience of the art itself.

The Burke Museum (206/543-5590) makes possible contact with some of the finest examples of that art, both by displays from its own permanent collection and by distinguished visiting exhibitions (see chapter 3, "Museums and Tribal Centers," for additional details). Especially through museum membership, the learning that comes simply from repeated exposure to masterworks is available as often as one is willing to take time to enter that place. Occasional lectures, often connected with exhibitions, and even more occasional workshops, add interpretation and detail.

The Burke Museum has developed a special curriculum for elementary students. Called "First Nations," its activities encourage them to learn about and practice traditional arts of basket weaving, woodcarving, canoe-making, and button blankets that distinguish Northwest Coast cultures. Small groups of students accompanied by an adult leader are invited to guide themselves through the Burke's exhibits, using the curriculum and materials provided at the door. To sign up for a class visit, call the Burke's Education office at 206/543-5591.

The University of Washington Press (206/543-4050) provides superb resources for significant self-learning. It is, without question, the country's preeminent publisher of works on Native American art and culture generally, and on Northwest Coast Native art and culture most especially. It is no accident that in the brief and highly selective bibliography offered in chapter 10 of this guidebook thirteen of the sixteen volumes cited are published by the University Press. Interested persons should request that their names be placed on the mailing list for notices of new publications.

Other Post-Secondary Institutions

Although formal coursework in Native studies is less frequent in other educational institutions—usually not more than one or two courses in each place—they are accessible in locations spread throughout western Washington. The following list names the institutions and the department or departments within which courses were offered at the time of publication. Telephone numbers are listed for convenience in confirming course offerings and in determining admissions arrangements.

Bellevue Community College, 3000 Landerholm Circle, Southeast, Bellevue 98009 (206/641-0111). Anthropology

Clark College, 1800 East McLoughlin Boulevard, Vancouver 98663 (360/694-6521). Anthropology

Everett Community College, 801 Wetmore, Everett 98201 (206/259-7151). Anthropology

The Evergreen State College, 2700 Evergreen Parkway Northwest, Olympia 98505 (360/866-6000). Native American Studies Program; Expressive Arts

Green River Community College, 12401 South East 320, Auburn 98002 (206/833-9111). Anthropology

North Seattle Community College, 9600 College Way North, Seattle 98103 (206/527-3600). Anthropology; Art History

Olympic College, 16th and Chester, Bremerton 98310 (360/478-4544). Anthropology

Pacific Lutheran University, 12180 Park Avenue South, Tacoma 98447 (206/531-6900). Anthropology

Pierce College, 9401 Farwest Drive, Southwest, Tacoma 98498 (206/964-6500). Anthropology

Seattle Central Community College, 1701 Broadway, Seattle 98122 (206/587-3800). Anthropology

Seattle Pacific University, 3307 Third Avenue West, Seattle 98119 (206/281-2000). Anthropology

Seattle University, 12th and East Columbia, Seattle 98122 (206/296-6000). Sociology/Anthropology

Shoreline Community College, 16101 Greenwood Avenue North, Seattle 98133 (206/546-4101). American Studies

Tacoma Community College, 5900 South 12th Street, Tacoma 98465 (206/566-5000). Anthropology; Humanities

University of Puget Sound, 1500 North Warner, Tacoma 98416 (206/756-3100). History

Western Washington University, 516 High Street, Bellingham 98225 (360/ 676-3000). Anthropology; History

Whatcom Community College, 237 West Kellogg Road, Bellingham 98226 (360/676 2170). Anthropology, Art; History

Opportunities in Other Learning Settings

North Cascades Institute, 2105 Highway 20, Sedro Woolley 98284 (360/ 856-5700). Founded in 1982, this nonprofit Institute is devoted to environmental education, which includes the human richness of the North Cascades area as well as its natural varieties and resources. To that end, youth programs, school outreach, teacher training, and elderhostels are organized; of perhaps greatest interest to users of this guidebook are field seminars, offered intensively from May through October, with a few seminars in mid-April and in November and December.

The catalogue current at the time of this writing listed four programs "from a Native perspective." They include three days on "Columbia River Indians and Their Land"; two days on "Skagit River Indians and Their Land;" two days on "Cordage: Working with Natural Fibers," dealing with traditional Salish basketry skills; and three days on "The Spirit of Native American Writing."

Seminars are based at National Park Service or Forest Service campgrounds, resorts, or Washington State Park Environmental Learning Centers, at locations that range from Bellingham and Orcas Island to the Columbia River. Academic credit is available for some seminars through Western Washington University. Families can be accommodated. For information on current seminars, tuition, and other details, write or call the Institute for a copy of its annual "Field Seminars" catalogue.

Olympic Park Institute, 111 Barnes Point Road, Port Angeles 98362 (800/ 775-3720). The mission of this nonprofit educational organization is "to inspire environmental stewardship through educational adventures in Nature's classroom," a mission that includes attention both to the distinctive flora and fauna of the Olympic Peninsula and to the human environment, including its First Peoples with their cultural richness. Each year, for more than a decade, the Institute has offered a broad range of "Olympic Field Seminars," taught by highly qualified instructors. The annual course announcement consulted at the time of this writing listed fifty-six such seminars between late April and early October, most involving two nights and three days at the Institute's Rosemary Inn Campus on Lake Crescent,

west of Port Angeles. Among them were seminars on Northwest Coast Indian art; on the techniques of Makah cedar bark basketry, Native wood-carving, and the making of drums and bentwood boxes; and on the archaeology and ethnobotany of the region. In some courses, arrangements may be made for academic credit through Western Washington University. For information on courses and costs, request a copy of the annual "Olympic Field Seminars" brochure.

Wolf Dancer: A School of Northwest Coast Art and Craft, Route 1, Box 1762, Lopez Island 98261 (360/468-2103). Greg Blomberg, proprietor of Kestrel Tool (see entry in "Galleries and Shops," chapter 5) located on Lopez Island in the San Juans, has developed an enviable reputation as a maker of fine, traditional blades for use by Northwest Coast carvers. Blomberg's interest in Native-style art goes well beyond the tools to the arts themselves, and he has created Wolf Dancer as a place where those arts are taught and learned. A series of five or six three-day seminars—customarily during January, February, and March, usually 9 A.M. on a Friday through noon on a Sunday—may teach the principles of formline design, the carving of bowls or masks or rattles, the fashioning of bent-corner boxes, or the weaving of cedar bark. Seminars are designed so that each participant completes an individual project within the two and a half days. Instructors often include such highly regarded artists as Steve Brown, Scott Jensen, Loren White, Barry Herem, Phyllis Pearson, and Blomberg himself. Write or call for details.

Sources of Basketry Instruction. From time to time, basketry instruction is available through tribal auspices. Recently, the Makah (Neah Bay), the Jamestown S'Klallam (near Sequim), the Lummi (near Bellingham), the Tulalip (near Marysville), the Muckleshoot (near Auburn), the Skokomish (near Hoodsport), and the Suquamish (near Suquamish) have offered this opportunity.

Interested persons should call tribal museums or cultural affairs offices for more specific information.

Travel to the Origins of Northwest Coast Native Art

Several tour operators offer travel to current and former Native sites, in Washington's San Juans and along coastal British Columbia, often accompanied by staff members competent in the anthropology and art history of these areas, as well as naturalists familiar with the local flora and fauna.

Inquiries concerning itineraries, costs, and staff resources can be made to the following operators:

Seminars Afloat/The Resource Institute, 2319 North 45th Street, #139, Seattle 98103 (206/784-6762). Northwest Coast Native art and the natural setting in which it has arisen—ocean, straits and rivers, mountains and islands, cedars and indigenous animals—are inseparably intertwined. This unique organization makes it possible to learn about the coastal Native culture by experiencing art and environment in their natural unity.

A variety of ships are leased by the Institute, depending on the character of a given cruise. All ships provide for an ample galley, have a library and space for slide-lecture presentations, and carry inflatable dinghies and sometimes kayaks for exploration in local waters and onshore. Cruises typically last from four to fourteen days and are accompanied by experienced interpreters of both the local ecology and the local culture.

Recent seasons have included "Camas, Clover and Cattails," four days through the San Juan Islands with ethnobotanist Nancy Turner in search of plants important in the traditional life of the Straits Salish people; "Weaving Fire," also a four-day cruise through the San Juans, this time with noted weaver Cheryl Samuel, who offered a shipboard workshop on Raven's Tail weaving, a ceremonial form that produced elegant robes for use by Tlingit chiefs up to the early 1800s; "The First Storytellers," fourteen days through Tlingit country in southeastern Alaska, with master storytellers Nora and Richard Dauenhauer; "The Heart of the Inside Passage," ten days with artist Barry Herem, on a cruise from Ketchikan, Alaska, to Port Hardy, British Columbia; "The Outside Coast," thirteen days on the west side of Vancouver Island, led by artist Duane Pasco; and "Islands at the Edge," twelve days from Ketchikan to the Queen Charlotte Islands, again with artist Barry Herem.

Cruises and interpreters vary from year to year. The Resource Institute is glad to add the names of interested persons to the mailing list for its annual catalogue.

Bluewater Adventures, #202-1656 Duranleau Street, Vancouver, British Columbia V6H 3S4 (604/684-4575). The "Island Roamer" is a 68-foot ketch, with eight passenger cabins, showers, lounge and library, and fully equipped galley. At the time of this writing, Bluewater was offering eight summer trips to the Queen Charlotte Islands (Gwai Haanas), home of the Haidas; four trips to the northern end of Vancouver Island; three to southeastern Alaska; and single sailings from Port Hardy to Hartley Bay, and from Prince Rupert to Bella Bella.

Ecosummer Expeditions, 936 Peace Portal Drive, Box 8014-240, Blaine, WA 98230 (360/332-1000), and 1516 Duranleau Street, Vancouver, British Columbia V6H 3S4 (604/669-7741). Sea kayaking is the specialty of this tour operator. All of the tours are suitable for novice paddlers; some are suitable for children; and all benefit from outdoor and camping experience. At this writing, announced trips include fourteen days in the Queen Charlotte Islands and seven days around Ninstints, a World Heritage site on Anthony Island. Other itineraries include Inuit country and still others feature canoeing and trekking.

Museums

Museum membership is an important way to pursue an interest in art or ethnography at greater depth. Such membership usually brings invitations to events and exhibits, and sometimes provides access to organizations formed around the special interests of its members. There are two such resources in Seattle and one in nearby Portland: the Burke Museum (see page 193), the Seattle Art Museum, and the Portland Art Museum. Readers are urged to explore the specialized educational opportunities offered by other museums within their reach.

Native American Art Council, Portland Art Museum, 1219 Southwest Park Avenue, Portland, Oregon 97205 (503/226-2811). Residents of southwestern Washington, as well as Oregonians, will find advantage in affiliating with this active special-interest group. Its activities are similar to those noted for Seattle's Native Arts Council below, except that Portland's group does not include Oceania within its artistic purview and it is more active in sponsoring trips to other museums and to places peculiarly associated with the production of Native American arts. Special exhibits, lectures, and workshops are regular features of its membership activities. *Alert,* the Council's newsletter, keeps members informed of current program opportunities.

Native Arts of the Americas and Oceania Council, Seattle Art Museum, Box 22000, Seattle 98122 (206/654-3136). The Native Arts Council at the Seattle Art Museum provides special programs and services for museum members interested in the Native arts of North America, Meso-America, and Oceania. Working through the Council Office, which coordinates the activities of several special-interest groups, the Native Arts Council's Executive Committee plans a series of programs throughout each fall, winter, and spring, which present prominent artists and art history experts usually for

slide lectures, and sometimes for demonstrations, on some aspect of the Native arts in the broad area designated by the organization's title, including most especially the Northwest Coast. Lectures are usually presented at the museum, though sometimes other locations are chosen.

The *Native Arts Council Newsletter,* one of the benefits of membership, is published six times a year and gives program announcements, news and information related to the Native arts, both locally and nationally, relevant book notices and book reviews, auction reports, and events listings. Membership in this group is an excellent way to expand one's knowledge of the Native arts, to meet artists, art historians, and the museum's curators, and to have regular informal association both with active collectors and with those of more casual interest.

Galleries

Galleries are not only places for the display and sale of works of art, but are also important sources of art education. That education takes place informally, of course, as we visit galleries to browse—to acquaint ourselves with older and newer works, and with artists and their distinctive styles, feeling quite free, with no obligation to purchase, to ask the gallery staff for information or interpretation as we wander through.

Some galleries have an even more explicit educational mission, sometimes providing lectures by artists and art experts, sometimes offering occasions to see artists at work, sometimes presenting opportunities to see art's cultural context through dance and storytelling. Here are three galleries with a strong educational purpose; others are worth seeking out. These will gladly add your name to their mailing lists to receive special-event announcements. Each is described more fully in chapter 3.

Sacred Circle Gallery, Discovery Park (206/285-4425).

The Legacy, Ltd., 1003 First Avenue, Seattle 98104 (206/624-6350 or 800/729-1562).

Snow Goose Associates, 8806 Roosevelt Way Northeast, Seattle 98115 (206/523-6223).

Stonington Gallery, 2030 First Avenue, Seattle 98101 (206/443-1108).

10. Annotated Guide to Selected Resources

Books

The starred books are out of print. Copies are often found in local library collections, and used copies are sometimes available in galleries and used-book stores.

Helen Abbott, Steven C. Brown, Lorna Price, and Paula Thurman, editors, *The Spirit Within: Northwest Coast Native Art from the John H. Hauberg Collection.* Rizzoli/Seattle Art Museum, 1995.

Two books are indispensable for home viewing of the finest that Seattle museums have to show in Northwest Coast art. Bill Holm's *Spirit and Ancestor* presents the best of the Burke Museum. The *Spirit Within* is eminently worthy to represent the gemlike Hauberg Collection of the Seattle Art Museum. Its 303 pages include fine color photographs (by Paul Macapia) of every piece in the collection, with interpretive annotations. Photographs by David Neel show Kwakwaka'wakw pieces from the collection in actual use. The book is enriched with essays by Nora Dauenhauer (Tlingit), Robert Davidson (Haida), Gloria Cranmer Webster (Kwakwaka'wakw), Joe David (Nuu-chah-nulth), Hauberg Collection curator Steven C. Brown, and Burke Museum curator Robin Wright. John H. Hauberg writes a Preface, and Bill Holm, Burke Museum curator emeritus, contributes an Afterword.

* Erna Gunther, *Art in the Life of the Northwest Coast Indians.* Portland Art Museum, 1966.

Although, as we have noted elsewhere in this guidebook, there was no word for "art" in the Northwest Coast Native languages, the coastal people lived in an aesthetically saturated culture. The late Erna Gunther, an an-

thropologist who had been director of the Burke Museum, produced a book that describes the culture and its art in daily occupations—dress and accessories, social ceremonial, secret societies and dances, and relations with the supernatural—and as a commercial product.

⊹ Edwin Hall, Margaret Blackman, and Vincent Rickard, *Northwest Coast Indian Graphics: An Introduction to Silk Screen Prints.* University of Washington Press, 1981.

The silk screen print, whose use by Northwest Coast Native artists began in the 1950s, has grown into a flourishing market and has made quality Northwest Coast Native art accessible even to collectors of modest means. Each year brings a growing number of younger artists into that market and makes limited edition prints the most widely available and affordable fine-art medium. Anthropologists Hall and Blackman and screen printer Rickard (of Pacific Editions in Victoria, British Columbia) show how this form fits into the historical development of the Native coastal arts, and provide both color and black-and-white illustrations of the work of many of its most accomplished practitioners.

* Bill Holm, *The Box of Daylight: Northwest Coast Indian Art.* Seattle Art Museum and University of Washington Press, 1983.

For a major exhibit at the Seattle Art Museum, Bill Holm gathered 200 of the most impressive old Northwest Coast pieces, largely from private collections across the country. It is doubtful that anyone with less stature than Holm could have wheedled these valuable classics away from often-reluctant collectors for the four-month-long show. They represent every culture on the Northwest Coast. Holm's fine, full annotations make this far more than a coffee-table book, and expert interpretive essays by Aldona Jonaitis, Peter Corey, Nancy Harris, and Robin Wright add to its value.

Bill Holm, *Northwest Coast Indian Art: An Analysis of Form.* University of Washington Press, 1965.

This is the single most indispensable book for anyone with a serious interest in northern Northwest Coast art. For the first time, Holm's study systematically identified the aesthetic rules that underlay the traditional art of the Northern Coast (i.e., from Bella Coola to Yakutat Bay), and to a lesser degree have influenced the Southern Coast as well. Holm also created much of the basic vocabulary that artists, scholars, and collectors have since been able to use in talking about this art. With Holm's book, aspiring Native artists themselves have found access to their own heritage. For readers with a more general interest, the books by Macnair, et al., and Stewart

will provide a less technical introduction to the tradition.

* Bill Holm, *Smoky-Top: The Art and Times of Willie Seaweed.* The Thomas
Burke Washington State Memorial Museum Monograph 3. University of
Washington Press, 1983.
 Unlike any other book on this list, Holm's study of the work of the
Kwakwaka'wakw master gives the reader an opportunity to see the product
of a single artist. Born about 1873, Willie Seaweed's work spanned the pe-
riod from perhaps 1914 to his death in 1967. The 1983 exhibit at Seattle's
Pacific Science Center, for which this book is the catalogue, contained 134
objects, including 87 masks, which are among the most dramatic to be
found in a remarkably dramaturgical culture. Other objects are screens,
drums, rattles, paintings, house fronts and panels, and totem poles. More
than 120 are Willie Seaweed's work; a few others are by his son Joe and a
few were joint father-and-son projects. Holm writes: "that near-century [of
Seaweed's life] spanned a period of the greatest social, economic, and tech-
nological change . . . that can be imagined. And yet Willie Seaweed and
many of his people kept concepts alive in spite of that change and the ac-
tive opposition of every outside authority that forced its way over them. He
lived to see his art honored by those same authorities" (p. 34).

* Bill Holm, *Spirit and Ancestor: A Century of Northwest Coast Indian Art at the
Burke Museum.* University of Washington Press, 1987.
 This book is equally distinctive, in that it deals exclusively with a single
distinguished collection, one housed at the Thomas Burke Memorial Wash-
ington State Museum on the campus of the University of Washington in
Seattle. Holm, long-time curator of Northwest Coast Native Art at the
Burke, selected one hundred of its finest pieces in recognition of the
Museum's centennial in 1985-86. His graceful and informative annotations
of each piece, and the dramatic full-page photographs of each by Eduardo
Calderon, make this an intellectual and visual delight.

* Bill Holm and Bill Reid, *Indian Art of the Northwest Coast: A Dialogue on
Craftsmanship and Aesthetics.* Institute for the Arts, Rice University, 1975,
distributed in the United States by the University of Washington Press and
in Canada by Douglas and McIntyre. (Also published by the Institute under
the title *Form and Freedom: A Dialogue on Northwest Coast Indian Art* [1975]).
 This is one of the most intriguing books of the entire list. Holm, the
scholar, and Reid, the Haida artist, sat down in front of more than one
hundred classic Northwest Coast objects, gathered for an exhibit at Rice
University, and shared their remarkable information and insight in a con-

versation that was recorded and subsequently published. The informality of their interchange has been retained in the text, and what communicates most effectively is their enormous enthusiasm and love for the objects, each of which is pictured in the book. If it were still in print, this "dialogue on craftsmanship and aesthetics" could be recommended as the best introduction to Northwest Coast Native art because, better than almost anything else, it conveys the spirit of that art.

Aldona Jonaitis, editor, *Chiefly Feasts: The Enduring Kwakiutl Potlatch*. University of Washington Press, 1991.

The Kwakiutl people, who lived along the northeastern shore of Vancouver Island and on the adjoining islands and mainland, were arguably the most flamboyant artists and dramaturgists on the Northwest Coast, and the potlatch was a primary purpose for that art and the focus of their drama. This book presents the Kwakiutl collection of the American Museum of Natural History and tells how art and ceremony were, and are (potlatching continues), joined in the life of this enduring people. The book has its own drama in stunning color photographs of the collection.

Aldona Jonaitis, *From the Land of the Totem Poles: The Northwest Coast Indian Art Collection at the American Museum of Natural History*. University of Washington Press, 1988.

In this book, Jonaitis takes a broader view, encompassing the entire sweep of the Northwest Coast, from the Salish north of the Columbia River to the Tlingit of southeastern Alaska. She recounts the story of the remarkable AMNH collection, and the not always admirable methods of its early Native and non-Native collectors. And she shows how, after a period early in this century when the objects were viewed rather indifferently as curios, Northwest art was "rediscovered" as art by the Native people themselves, not less than by others, and was revived from the 1960s onward in what can only be called a contemporary renaissance. Again, a large number of fine color photographs enhance this volume.

Peter L. Macnair, Alan L. Hoover, and Kevin Neary, *The Legacy: Tradition and Innovation in Northwest Coast Indian Art*. University of Washington Press, 1984.

Originally the catalogue of a 1971-72 exhibition at what is now the Royal British Columbia Museum in Victoria, this book has outlived that original purpose and continues to be one of the most handsome (with the exception of historical photographs, illustrations of the art are entirely in color), most affordable (at this writing about $20), and most comprehen-

sive introductions to Northwest Coast Native art. It offers an account of the physical and cultural setting within which the art arose, a brief summary of the design principles that are more fully treated in Holm, a gallery both of traditional classics and of contemporary pieces, and information about individual artists whose work appears in that gallery. Unfortunately for the completeness of this fine book by staff members of a Canadian museum, it presents the best of Canadian coastal art but omits the distinguished contribution of Tlingit artists from Southeast Alaska, thus shortening the cultural continuity that extends to Yakutat Bay and implying an inadequate definition of the "Northwest Coast Indian Art" promised in its subtitle.

Hilary Stewart, *Looking at Indian Art of the Northwest Coast.* University of Washington Press, 1979.

This popular guide helps to teach the interested observer how to "read" Northwest Coast Native art. Stewart describes and illustrates the basic design components—for example, the distinctive ways in which bodies, faces, arms, legs, claws, and wings are depicted—and shows how these components come together in both two- and three-dimensional forms, in paintings and on totem poles, to shape the natural and supernatural creatures that populate this distinctive and highly sophisticated art. Stewart also distinguishes among the several tribal styles that are practiced on the coast.

Hilary Stewart, *Totem Poles* and *Looking at Totem Poles.* University of Washington Press, 1990, 1993.

In these two volumes, Stewart has produced a guide specifically designed to interpret the Northwest Coast's distinctive monumental art. She provides detailed drawings of more than one hundred publicly accessible poles in British Columbia and Southeast Alaska, each one accompanied by identification of the creatures, figures, objects, and legends depicted, as well as of the artist who carved the pole. Stewart explains how to recognize commonly depicted creatures and objects. The drawings are supplemented by photographs of poles being raised and in their larger environments. Much of the content of these two volumes is the same. The 1990 version is larger, has a cloth binding, and contains a section on the distinctive cultural styles characteristic of the several tribal groups on the coast. The 1993 version omits that section but is in paperback, of smaller size, and fits easily in a car's map compartment for trips north of the border.

Wayne Suttles, editor, *Northwest Coast,* vol. 7 of *Handbook of North American Indians.* Smithsonian Institution, 1990.

This volume of 777 large-format pages is the most comprehensive re-

source available on the culture of the Native Northwest Coast, encompassing its history, geography, art, linguistics, ethnography, and archaeology. As such, it provides the larger setting within which Native coastal art emerged, was practiced, and changed in response to both internal and external circumstances. This is also among the most authoritative works available, bringing together essays by 59 recognized specialists and offering a bibliography that runs for 93 pages.

Robin K. Wright, editor, *A Time of Gathering: Native Heritage in Washington State.* University of Washington Press, 1991.

This book is distinctive, in that it deals exclusively with the Native arts of Washington State: both the Makah and the Salish tribes, whose homes were and are between the Cascades and the Pacific; and the Plateau people (Yakima, Kalispel, Colville, Spokane), whose homes were and are east of the Cascades. One hundred masterworks, from the Burke Museum and from other collections around the world, here stunningly photographed in color, attest to their makers' aesthetic genius. Articles, many by Native artists and scholars, give an account of the culture that produced the art. This book and the Burke Museum exhibit it catalogues were produced to celebrate the 1989 centennial of Washington's statehood.

Periodicals

American Indian Art Magazine, 7314 East Osborn Drive, Scottsdale, Arizona 85251 (602/994-5445).

This handsome quarterly publication, printed on high-quality coated stock, is a "must" for anyone with even a semi-serious interest in Native American art. Its articles, written by specialists in various aspects of that art, are remarkably readable and devoid of off-putting jargon. Article illustrations are frequently in full color. Almost as engaging as the articles are the illustrated advertisements, also frequently in color, of dealers in Native arts and artifacts from all across the country. Regular features provide information about auctions and gallery and museum exhibits. As this is written, an annual subscription is $20; single copies are $5.

Native Peoples, Media Concepts Group, Inc., 5333 North Seventh Street, Suite C-224, Phoenix, Arizona 85014-2804 (602/252-2236).

This vividly colorful magazine is "dedicated to the sensitive portrayal of the arts and lifeways of native peoples of the Americas." Published quarterly, it is a joint project of the National Museum of the American Indian/

Smithsonian Institution and several other museums specializing in the Native arts. It publishes essays on and by Native Americans and features articles on contemporary Native culture, including the arts. As this is written, the annual subscription is $18; single copies are $4.75.

Recordings

American Indian Voices Presents Johnny Moses, and *Red Cedar Circle, Fire Circle Songs* (Johnny Moses, Box 1210, La Conner, WA 98257).

Johnny Moses, well known especially throughout the Puget Sound region, is a master storyteller in the Salish tradition. On these two cassette tapes he tells traditional stories about Octopus and Crow, Boogie Woman, Grandma Cedar Tree, Bear and Ant, and many others, and adds stories of more contemporary vintage.

Ida Halpern, editor and recorder, *Indian Music of the Pacific Northwest Coast* (Folkways Ethnic Library, 1967).

This two-record LP set presents music of the Kwakiutl, sung by chiefs and elders. Selections represent songs about totems and crests (Wolf, Grizzly Bear, Raven), songs from the potlatch, and songs from everyday life. A 36-page insert provides information about the distinctive Kwakiutl musical forms, about the singers, and about each of the songs, and provides musical notation for five songs in the collection. Ida Halpern was a musicologist and professor at the University of British Columbia.

Willard Rhodes, editor and recorder, *Music of the American Indian: Northwest (Puget Sound)* (Motion Picture, Broadcasting and Recorded Sound Division, Library of Congress, revised edition 1984).

This cassette-tape recording, performed by Native singers, includes songs from western Washington tribes—Skagit, Lummi, Klallam, Quinault, and Makah. It also includes songs in Chinook Jargon, the intertribal trade-language used throughout the Northwest Coast, and songs from the Shaker Church, a distinctive Salish form of Christian worship. An accompanying pamphlet offers background essays on Puget Sound Native music and interpretations of individual songs.

Videotapes

American Indian Voices Presents Johnny Moses (Johnny Moses, Box 1210, La Conner, WA 98257).

~~This is a video version of the cassette tape cited above.~~

The Box of Daylight: A Tlingit Myth of Creation (Pacific Communications and Marketing, Juneau, AK, 1990).

This is a dramatic reenactment of the Tlingit myth of the way light— sun, moon, and stars—came to the world through the cleverness of Raven, the Trickster. Professionally produced and taped by Native people, the video runs for 8 1/2 minutes.

Indian America: A Gift from the Past (Media Resource Associates, 3615 Wisconsin Avenue, Northwest, Washington, D.C. 20016, 202/362-0110).

Five hundred years ago a massive springtime mudslide buried several huge Native homes under tons of clay. Centuries later a storm uncovered part of this ancient village of Ozette, near present-day Neah Bay on the far western tip of Washington's Olympic Peninsula. For several years now, archaeologists have been carefully excavating the site, which has yielded some of the oldest extant artifacts on the Northwest Coast. Using location footage, archival film, artifacts from the dig, and marionettes, the Makah people show, in this 57-minute video, how these discoveries have cast important new light on their ancient culture.

In the Land of the War Canoes: A Drama of Kwakiutl Life in the Northwest (Milestone Film and Video, 275 West 96th Street, New York, NY 10025).

This 1914 classic was produced and filmed by famed photographer Edward S. Curtis under the more sensational title of *In the Land of the Headhunters*. It is a somewhat melodramatic story of love and revenge among the Kwakiutl, staged and costumed by Curtis with Native actors to depict life in an earlier period. The film was a financial disaster for Curtis, and for all practical purposes was lost until George Quimby found the only surviving print at Chicago's Field Museum in the late 1940s. Later, in Seattle, Quimby collaborated with Bill Holm, an expert on the Kwakiutl culture. Over a period of several years they restored the old print, and in 1972 a group of Kwakiutl people were brought together by Holm to add music and dialogue. They watched sequences of the film, and spoke and sang spontaneously and extemporaneously. The resultant recordings, edited by Holm, were later dubbed by filmmaker David Gerth and his assistants. The restoration, completed in 1973, has now been made available for popular distribu-

tion on VHS. The process of Curtis's original filming has been chronicled by Holm and Quimby in *Edward S. Curtis in the Land of the War Canoes: A Pioneer Cinematographer in the Pacific Northwest.* (University of Washington Press, 1980), which will serve as a useful companion to the video.

Spirit of the Mask (Atlas Video, Inc. 4915 St. Elmo Ave., Bethesda, MD 20814).

This 50-minute tape offers vivid and tantalizing excerpts from some of the most important ceremonies, especially of the Kwakiutl and Nuu-chah-nulth people: of the Hamatsa, the highest-ranking dance privilege conferred by the Kwakiutl, and of other dances featured in a potlatch, including scenes from a recent potlatch given jointly by Kwakiutl–Nuu-chah-nulth hosts. Dancers in the video are drawn from some of the most distinguished Kwakiutl families. The natural Northwest Coast settings, something of the history of the ceremonies, and the preparation of the dancers add to the impressiveness of the ancient traditions that are here given contemporary expression. Narration is provided by Canadian anthropologist Wade Davis. Authors of this guidebook found the six-minute excursus on "new age" uses of masking at the Esalen Institute a distraction in an otherwise admirable production.

Index

Boldface numbers refer to illustrations.

Abbott, Helen, 200
Adams, Yukie, 153
Ahvakana, Larry, 28
The Alaska Indian Arts, Inc., 58, **58**
Alexander, Morrie, 65, 138-39, **139**,
 141, 142
Ambiguity, xvii-xix
Amos, Patrick, 121, 169
Ancestral Spirits Gallery, 121
Anderson, Baba, 160
Anderson, Eric, 119
Anderson, Louisa, 160
André, Jean, 119
Anti-potlatch law, xiii
Archaeological evidence of culture,
 xvi-xvii
Austin-McKillop, Mardonna, 91
Averill, Lloyd, **40**

Backstrom, Jeanette, 47
Backstrom's Indian and Eskimo Art,
 47
Bailey, Bill, 135
Bailey, Ken, 89
Bailey Nelson Gallery, 89, 153, 159,
 167
Balch, Lord James, 107
Barbeau, Marius, 142
Barde, Wendy, 21
Barr, Lee, 43
Bassetti, Fred, 119
Batdorf, Carol, 143

Baxter, Otis N., 59
Beardsley, Dick, 113
Beasley, Mick, 75
Beasley, Rick, 75
Bellevue Community College, 193
Bender, James, 62, 89, 122, 150, 153
Blackman, Margaret, 201
Blanchett, Jacquetta, 63
Blomberg, Greg, 148, 196
Bluewater Adventures, 197
Bob, Dempsey, 169
Boldt, Judge George, 128
Boxley, David, 28, 35-36, 41, **42**, 86,
 101, 105, 150, 154, 196, 200
Boyd, Bruce, 89
Broadway Center for the Performing
 Arts, 19
Broadway Theater District Task Force,
 19
Brown, Charles, 54
Brown, Steve, 32, **32**, 45, 63, 67, **67**,
 70, **87**, 91, 111, 150, 154, 196, 200
Brown, William H., 54
Bruce Boyd/Curioseri, 89
Burke Museum, ix, **xxvii**, xxxiii, 62,
 63, 73-74, **74**, 86-89, **87**, 89-90,
 160, 184, 192-93
Burke Museum Gift Shop, 90, 154,
 156, 159, 164
Buse, Delbert, 129
Buse, Norman, 129
Butler Collection, 24

Calderon, Eduardo, 202
Cape Fox Dancers, 187
Capoeman, Randy, 154
Carpenter, Cecelia Svinth, 12
Carpenter, Edmund, xvii-xviii
Carriere, Ed Eugene, 154-55
Carter, Dudley, 34, 44, 66, 75, 81, 97,
 131, **137**, 137-38, 145, 155
The Carter Family Marionettes, 182-
 83
Cedar Tree Associates, 132
Charles, Al, 141, 142, 143, 144-45
Charles, Gordon, 141
Charles, Steve, 92
Charlie, Bennie, 115
Childers-Proctor Gallery, 160
Clark College, 194
Claymore, Phil, 145
Coastal peoples: by cultural groups,
 xv
Coe, Leven, 113
Colasurdo, Bruce, 47
Colasurdo, Linda, 47
Colfax, Gregory, 15, **16**, 39, **40**, 121,
 156, 167, 168
Cook, Carl, 101
Cooke, Floyd, 108
Corey, Peter, 201
Corpuz, Frank, 102-3, **103**
Cranmer, Doug, 169
Cultie, Richard, 117
Curtis, Asahel, 26, 71
Curtis, Edward S., 28, 47, 60, 61, 66,
 71, 90, 207
Curtright, Jack, 29
Curtright, Jane, 29
Curtright Gallery of Tribal Arts, 29

Dauenhauer, Nora, 197, 200
Dauenhauer, Richard, 197, 200
Daugherty, Richard, 105
David, George, **100**, 101
David, Hyacinth, 60
David, Joe, xxvii, 61, 121, 150, 151,
 169, 200
Davidson, Reg, 121, 169
Davidson, Robert, xxii, xxvii, xxxv,
 61, 91, 121, 149-50, 169, 200
Davis, Wade, 208

Dawson, Nancy, 169
Daybreak Star Center, 160, 187
Dee-ah Screen Prints, 123
Dennis, Danny, 169
Design elements, xx-xxiv
DeWilde, Mr., 120
Dick, Beau, 169
Dick, Frances, 169
Diesing, Freda, 170
Dixon, Pat, 170
Downtown Seattle Transit Project, 56
Dunthorne, Peter, 157

Ecosummer Expeditions, 198
Edenshaw, Charles, 79
Ehlers, Anna, 170
Escher, M. C., xxxiii
Everett Community College, 194
The Evergreen State College, 15, **16**,
 194

Faulstich, Dale, 106, 108, 121, 150,
 157
Fernandes, Roger, 40, 80-81, 157
Ferrier, Jean, 21, 157-58
Fitzgerald, James, 53
Flury, James, 90
Flury, Lois, 90
Flury & Company, 90
Ford Foundation, 139
Forks Timber Museum, 120-21
Forlines, David, 114, 150
Formline design: principles of, xxii-
 xxiii, xxxiv-xxxv
Fox's Gem Shops, 160
Fuller, Richard E., 66
Fuller, Mrs. Eugene, 66

Garfield, Viola, 13, 54
George, Skip, 101
Gerber, Anne, 77
Gerth, David, 207
Gierlich, Jon, 40
Gitanmaax School of Northwest Coast
 Native Art, 64
Glock, Charlee Parker, 20
Glover, Will, 132
Gobin, Joe, 45
Goodrich, Gloria, 150, 158
Goodwin, John (Ny-Tom), 91, 123, 158

Grace, Leslie, 91
Grant, Dorothy, 91, 170
Granum, Douglas, 20, 21
Greene, Stan, 170
Green River Community College, 194
Greg Thompson Productions, 60
Crocco, Gerald H., 115
Gunther, Erna, 200

Haavik, Jay, 22, **23**, **82**, 83, 89, 91,
 158-59
Hagan, John, 58
Haglund, Ivar, 70
Hall, Edwin, 201
Halpern, Ida, 206
Hamilton, Ron (Hupquatchew), 170
Hanuse, Roy, 170
Harley, Clinton, 83
Harris, Nancy, 201
Hat-lick (Hillaire), 144
Hauberg, John H., 200
Hauberg Collection. See John H.
 Hauberg Collection
Heinmiller, Carl W., 58
Helmer, Antoinette, 159
Helmke, Susan, 92
Herem, Barry, **xxi**, 60, 89, 91, 159,
 196, 197
Hewson, Wayne, 41, 105
Hilbert, Vi, 55, 69
Hilbert/Coy, Ron, 65, 68, 77, 101,
 159-60
Hill, Gerald (Jerry) A., 160
Hillaire, Ben, 140
Hillaire, Joseph, 99, **140**, 141, 142,
 144, **189**
Hinds, Hugh H., 33
Holm, Bill, xx, **xxiii**, **xxvii**, **xxxii**,
 xxxiv, **xxxv**, 70, 73, **74**, 79, 87, 88,
 138, 150, 151, 160-61, 200, 201,
 202-3, 207-8
Hoover, Alan L., 203-4
Horne, Francis, 69
Horsley, David, **xxxvii**, 43, 150, 161
Hottowe, Edith, 183
Hottowe, John, 183
Howmet Realty, 145
Hudson, Jack, 54, **87**, 88, 170
Huenke, Annette, 121
Huggins, Patrick, 161-62

Hunt, Calvin, 170
Hunt, Richard, 170
Hunt, Stan, 170
Hunt, Tony, 61, 150, 170
Hunt, Tony, Jr., 170

images, descriptions of, animal, **xxv**-
 xxvii; cosmic, xxx; human, xxiv-
 xxv; material, xxxi-xxxiii;
 mythical, xxvii-xxx
Improved Order of Redmen, 126

Jackson, Nathan, 63, **64**, 76, 150, 170
Jackson Street Gallery, Ltd., 90
Jacobs, Melville, 146
James, Bill, 121, 162
James, Fran, 121, 162
James, Dale, 138-39, **139**, 142, **189**
Janze, Phil, 170
Jay, Tom, 44
Jefferson, Anna, 162
Jefferson County Historical Society
 Museum, 118
Jensen, Scott, 142, 146, 163, 196
John, Jimmy, 77, **78**, 79
John H. Hauberg Collection, 85, **85**,
 167, 200
Johnson, Abner (Goocheesh), 76
Johnson, Harold "Brick," 106
Johnson, Michael, 70
Johnson, Ron, 117
Johnson, Tony, 45
Jonaitis, Aldona, 201, 203
Jones, Jake, 101-2
Jones, Jerry, 45, 129
Jones, John Paul, 15

Kallappa, Joe, 120
Kanim, Jerry, 46
Kasko, Ed, 58
Katherine White Collection, 85
Kelly, Tom, 83
Kenojuak, 28
Kestrel Tool, 148
Ketchikan Totem Heritage Center, 165
King County Arts Commission, 41,
 45, 53, 63, 80
King County Public Library, Carna-
 tion Branch, **32**
Kingwatsiak, Iyola, 28

Kitsap, Chief, 96, 102-3, **103**
Kitsap County Historical Museum, 117
Knight, Debi, 163
Kool-Keet, Moses, 73
Kuppler, Oscar, 120
Kwina, Chief Henry, 147

La Tienda Folk Arts Gallery, 90
Leary, Mary B., 83
Leask, Robert, 41, 105
The Legacy, Ltd., 91, 153, 154, 156, 158, 164, 184, 199
Legends Gallery, 148
Lelooska, Chief (Don Smith), 10, 25, 163, 181-82
Lelooska Family, 163
The Lelooska Foundation, 60, 181
Lelooska Gallery and Museum, 28-29, 163, 182
Lévi-Strauss, Claude, xvii, xviii
Lightbown, Greg, 170
Livingston, John, 150, 170
Lovik, Greg, 123
Lovik, Steve, 123
Lushootseed Research, 69
Lynden Pioneer Museum, 147

McCarty, Spencer, 164
MacDonald, George, xvi
Macnair, Peter, 201, 203-4
MacRae, Ken, 29
MacRae's Indian Book Distributors, 29
Makah Cultural and Research Center, xviii, 118-19, **120**, 123, 183
Mariah (Lelooska), 163
Marks, Gerry, 170
Martin, Mungo, 63, 146
Marvin Oliver Gallery, 91
Mauger, Jeffrey, 164
Melville, Bonita, 122
Metro: "1% for Art" program, 80
Mike, Richard, 108
Miller, Bruce, 15, 18-19, 115, **116**, 117, 164
Miller, Emily, 115
Mitchell, Bill, **136**, 137
Mobil Foundation, 144
Morris, James, 164
Morse, Frank, 27
Morse, Samuel G., 71

Moses, Henry, 41
Moses, Johnny, 206, 207
Moses, Kelly, 130
Moses, Kenny, 69
Mowatt, Victor, 64
Muldoe, Earl, 64
Museum of History and Industry, 35, 86

Nakwesee (Lelooska), 163
Neary, Kevin, 203-4
Neel, David, 200
Neidinger, Bill, 71, 99
Nelson, Diane, 89
Non-Native artist controversy, 149-51
North by Northwest, 121
North Seattle Community College, 194
Northwest Coast: cultural definition of, xv, 172
Northwest Crafts Center, 91
Northwest Indian College, 188-90, **189**
Northwest Native Art Gallery, 122-23, 158
Northwest Native Expressions, 121-22, 157
Nyberg, Folke, 132

Ohno Landscape Construction Company, 58
The Old General Store, 47
Oliver, Marvin, xxxviii, 14, 33, 39, 41, 53, 62, 77, 83-84, **84**, 91, 122, 165
Olson, Arlen, 109
Olson, Donna Lynn, 109
Olympic College, 194
Olympic Park Institute, 195-96
"1% for Art" program, 41, 65, 80, 83
Oonark, Jessie, 28
Orca Bay gallery, 160
Orca Drums, 123, 158
Oregon Historical Society, 124-25
Ormbrek, Mr. and Mrs. Richard, 79
Orr, Caroline, 40
Orthography. *See* Terminology
Ozette archaeological site, xvii, 105, 119, 207

Pacific Lutheran University, 194

Pantages Theater, 19
Paquette, Len, 69
Pasco, Duane, xxxviii, 11, 36, 38, **38**,
56, **57**, 61, 64, 71, 91, 97, **98**, 138,
150, 151, 165, 183, 197
Patkanim, Chief, 126
Patty Fawn (Lelooska), 163
Paul, Alex, family, 127, 132, **134**, 135
Paul, Tim, 170
The Paul H. Karshner Memorial
Museum, 27
Peabody, Russell V., 140
Pearson, Phyllis, 196
Pechiney Company, 145
Pendleton, Steve, 123, 158
Pérez, Juan, xiii
Peter, Mrs. William, 131
Peterson, Art, 132
Peterson, Helen, 183
Peterson, Melissa, 165-66
Peterson, Paul, 117
Peterson, Pete, 117
Pierce College, 194
Pierre, Jack, 66, 139
Ploegman, Jim, 34-35, 115
Point, Susan, 17, 40, 41, 56, 63, 91,
170
Pond, Percy, 73
Pope, Andrew J., 105
Pope & Talbot, 105
Pope Resources, 105
Porte, Dan, Jr., 69
Porte, Eunice, 69
Portland Art Museum, 24, 198
Port of Seattle, 58
Powell, Tracy, **136**, 137
Powwows, 184-87
Price, Lorna, 200
Price, Wayne, 171
Priestly, Steve, 80
Primitiveness, xvi-xvii
Pullen, Lillian, 166
Pulsifer, Louisa, 115
Putnam, John A., **87**

Quimby, George, 207-8
Quintana's Galleries, 28, 154, 159

Rabena, Glen, 150, 171
Rasmussen Collection, 24

Reid, Bill, 121, 171, 202-3
The Resource Institute. *See* Seminars
Afloat
Reyes, Lawney, 76
Rhodes, Willard, 206
Rialto Theater, 19
Rickard, Vincent, 201
Roeder, Captain Henry, 141
Roosevelt, Franklin D., 131-32
Royal British Columbia Museum, **82**

Sacred Circle Gallery of American
Indian Art, 92
Samish Potlatch Gifts, 147-48
Sampson, Martin J., 131
Samuel, Cheryl, 171, 197
Schell, Paul, 63
Schoppert, James, 53
Schultz, Solomon, 141
Scow family, 63, 88
Seattle (Sealth), Chief, 11, 55, 69, 96,
100, 100-101
Seattle Art Museum, 45, 85, **85**, 92,
184, 198-99
Seattle Arts Commission, 51, 53, 63,
64
Seattle Central Community College,
194
Seattle Pacific University, 194
Seattle Public Library, Broadview
Branch, **84**
Seattle University, 194
Seaweed, Willie, 202
Seminars Afloat/The Resource
Institute, 195
Sequim Museum and Arts Center, 118
Sewid, James, 163, 181
Sheard, W. F., 21
Sheldon, Charles R., 129
Shelton, Chief William, 17-18, 126-
27, **127**, 128, 129
Shona Hah (Lelooska), 163
Shoreline Community College, 194
Siner, Sean, 144
Sitka Indian Cultural Center, 165
Skagit County Museum, 146
Skokomish Tribal Center, 115, **116**,
117
Smiley, Jane, 112

Smith, Don. *See* Lelooska, Chief (Don Smith)
Smith, Frank, **104**, 105, 109, 110, 120, **120**, 166
Smith, George, **82**, 83
Smith, Jaune Quick-to-See, 40
Smith, Jerry, 63
Smith, Liz, 121
Smith, Russell, 63, 171
Snoqualmie Dance Troupe, 161
Snoqualmie Valley Historical Museum, 46
Snow Goose Associates, 92, 156, 159, 164, 167, 168, 199
Snyder, Bill, 22
Sparrow, Deborah, 171
Speer, Tom, 19, 70, 166-67
Standley, J. E., 51
Steilacoom Tribal Cultural Center and Museum, 26
Steinbrueck, Lisa, 92
Steinbrueck, Victor, 62
Stephens, Davey, **xxxi**, 89, 115, 167
Stevens, Governor Isaac, 55
Stewart, Hilary, 10, 201, 204
Stone McLaren, 20
Stonington, Nancy Taylor, 93
Stonington Gallery, 92-93, 153, 154, 156, 157, 161, 162, 163, 164, 167, 184, 199
Stylistic variations by cultural group, xxxiii-xxxvii
Suquamish Museum, 117
Surrealism, xviii
Suttles, Wayne, 204-5
Swan, James Gilchrist, 83, 118
Swanset, George, 145
Symmetry and asymmetry, xix-xx

Tacoma Community College, 194
Tacoma Public Utilities, 11-12, 18-19
T'Chits-a-ma-hun, 107
Tait, Norman, 171
Talbot, Captain William C., 105
Terminology: inconsistencies in, xxxviii
Theater on the Square, 19
Thomas, Cliff, 58
Thomas, Dan, 144
Thomas, George, 144

Thomas Burke Memorial Washington State Museum. *See* Burke Museum
Thompson, Art, 91, 108, 171
Thorn, Chester, 21
Thurman, Paula, 200
Tillicum Village, 182, **183**
Tookoome, Simon, 28
Traditions and Beyond, 93
Transformation, xvii-xix
Tribes Nature and Native American Art and Tea Company, 93
Tsang Partnership, Inc., 22
Tsonakwa, 28
Tsungani (Lelooska), 25, 163
Turner, Nancy, 197

Ukas, Tom, 67, **67**
University of Puget Sound, 194
University of Washington, x, 62, 73-75, 86-89, 150, 188, 190-93
University of Washington Press, 193

Vancouver, Captain George, 55
Vickers, Roy Henry, 171
Vinniski, Alexander, 121
Vogel, Micah, 167
Vroman, Adam Clark, 90

Wallace, Chief John, 71-72, **72**
Ward, Helma, 183
Ward, Jack, 113
Ward, Oliver, 121
Washburn's General Store, 123
Washington State Capital Museum, **25**, 25-26
Washington State Historical Society Museum, 26-27
Waterhouse, Joseph, 102-3, **103**
Watson, Kenneth G. (Greg), 26, 46
Watson, Luke, **82**, 83
Watson, Steve, 90
Webster, Gloria Cranmer, 200
Weisenbach, Robert, 22, **23**
West Seattle Rotary Club, 51
Westby, Marcus, 112, **112**
Western Washington University, 195, 196
Whatcom Community College, 195
Whatcom County Museum of History and Art, 138-39, **139**, 146-47

White, Katherine. *See* Katherine
 White Collection
White, Loren, 108, 150, 167-68, 196
White, Richard, 56, 99
White River Historical Museum, 45-
 46
Wilbur, Andy, 15, 16, 25, 26, 115,
 117, 122, 168
Wilbur, Bert, 117
Wilbur, Ruth, 25, 26
Wilke, Lance, 26, 111
Williams, Alex, 77
Williams, Clyde, Jr., 128, 129
Williams, Francis, 171
Williams, Herman, 33
Williams, Herman, Sr., 128
Williams, Terry, 171
Winter, Lloyd, 73
Winter Dances, xxx
Wolf Dancer: A School of Northwest
 Coast Art and Craft, 196
Wright, Robin, 55, 200, 201, 205

Yeomans, Don, 91, 121
Yolaikia, 28
Young, Robin, 51, 52
Young Doctor, 119